BOOT CAMP

A step-by-step guide for professional wedding and portrait photographers

Second Edition

Kevin Kubota

Amherst Media, Inc. ■ Buffalo, NY

■ ABOUT THE AUTHOR

Kevin Kubota acquired his interest in photography from his father, Stephen Kubota, as a teenager in the late 1970s. In 1990, Kevin committed to photography as a full-time profession and began Kubota PhotoDesign. His wife, Clare Kubota, joined the business as the studio manager in 1996.

Kevin's natural technical curiosity and acumen led him to pursue digital imaging and Photoshop with constant ardor. His early adoption of digital cameras and conversion of the studio into a full-digital workflow gave him the experience base to begin instructing other photographers in making the digital conversion.

In 2000, KubotalmageTools.com was born, and Kevin became a popular speaker at major photographic conventions. In 2002, Nikon asked him to speak for them at the

WPPI convention in Las Vegas. He then formed the Digital Photographers Bootcamp*, an intensive weeklong program and one of the first of its kind to teach all aspects of converting to a digital studio. This popular program is currently held two or three times a year in Bend, Oregon, and other more exotic locations—like Tuscany, Italy. He also teaches at professional development schools throughout the United States and Canada.

KubotalmageTools.com also produces training DVDs, album-creation software, and Photoshop action sets, simplifying many of Kevin's most popular Photoshop techniques. The Kubota Image Tools products have won some of the industry's top awards, including the Hot One Award (three times) and the Readers' Choice Award.

Kevin is known not only for his technical knowledge and ability to teach it in an easy-to-understand manner, but also for his artistic imagery, which has been recognized nationally in magazines, books, and advertisements. In 2007, *American Photo* named Kevin one of the top ten wedding photographers in the world.

Copyright © 2009 by Kevin Kubota. All rights reserved.

Published by: Amherst Media, Inc. P.O. Box 586 Buffalo, N.Y. 14226 Fax: 716-874-4508 www.AmherstMedia.com

Publisher: Craig Alesse

Senior Editor/Production Manager: Michelle Perkins

Assistant Editor: Barbara A. Lynch-Johnt

Editorial Assistance from: John S. Loder, Carey A. Maines, Charles A. Schweizer

ISBN-13: 978-1-58428-243-3

Library of Congress Control Number: 2008926663

Printed in Korea.

10 9 8 7 6 5 4 3 2 1

No part of this publication may be reproduced, stored, or transmitted in any form or by any means, electronic, mechanical, photocopied, recorded or otherwise, without prior written consent from the publisher.

Notice of Disclaimer: The information contained in this book is based on the author's experience and opinions. The author and publisher will not be held liable for the use or misuse of the information in this book.

CONTENTS

1. INTRODUCTION	Creating Reusable Adjustment Presets
The Benefits of Digital	(and Other Tips)34
Keys to Success6	Importing, Renaming, and Backing Up
Every Book Has a Purpose	Images in Lightroom
	Editing and Organizing Images in Lightroom 41
2. DIGITAL ESSENTIALS	Adjusting and Enhancing Images in Lightroom 43
The New Digital Paradigm	More on Develop Mode
Digital Capture	Tweak Your Favorites in Phototshop
RAW vs. JPEG: The Main Event	Finishing Touches Before Export51
The "RAW JPEG"	Batch Process or Export Your Images
Megapixels and Resolution	Presentation
3. CREATIVTY AND INSPIRATION	6. COLOR MANAGEMENT55
Where Does it Come From?	Color in the Digital World
The Creative Process	Pieces of the Color Puzzle
Techniques for Creativity and Inspiration	Color Spaces
Say "Boom" While Watching the World13	
Projects	7. PHOTOSHOP ESSENTIALS62
Use Creative Tools	The Basics
Be a Groupie	Working Efficiently in Photoshop
Inspiration from Giving	The Photoshop Workflow
	8 Bits vs. 16 Bits
4. DIGITAL CAPTURE TECHNIQUES	Evaluating Overall Image Quality
Every Camera Has a Personality	Convert to Black & White from Color
Acting Like a Digital Photographer20	Add Color to a Black & White Image
	Save a Master File in PSD Format
5. WORKFLOW24	Prepare to Print
Overview	
Downloading/Organizing	8. PHOTOSHOP CORRECTIVE TECHNIQUES79
Recommended Storage Setups	Underexposure Fix
Catalogs vs. Viewers	Clarify Cuts the Haze82
Adobe Lightroom	Hot Yellow Fix
Setting Preferences in Lightroom	Retouching Basics83

Swapping Body Parts	The Batch Dialog Box102
Digital Liposuction	Creating a Basic Action
	Creating a Droplet
9. PHOTOSHOP ENHANCEMENTS	
Handcolored Black & White Images90	11. PRINTING AND PRESENTING
Softening with KevSoft90	Creating the Perfect Mood
Digital Fill Flash and Digital Dark91	Presentation Ingredients
Cleaning Up the Eyes and Teeth93	
Selective Focus	12. THE BIG PICTURE
High-Speed Black & White Film96	Make Time to Give Back
Vignette? You Bet	The Keys to Success
Borders and Edges	
	Resources
10. PHOTOSHOP ACTIONS	Troubleshooting
The Actions Palette	Index

ACKNOWLEDGMENTS

This is the second edition of *Digital Photography Boot Camp*. I am very grateful to my faithful readers and for all of the wonderful comments I've received on the first edition. Though the concepts and ideas from the first book have not changed, really, the tools and software that we use in some instances have changed, and the update reflects our latest evolution in the digital world, spotlighting the new tools and techniques we use. Across the board, everything is faster and much simpler.

We don't always think about all the ways in which people in our lives contribute to who we've become. Sometimes their influence is subtle or built slowly over time. Sometimes it's a great big slap in the face that awakens a side of you that you never knew existed. Sometimes you don't realize that the struggle you had with someone would have a positive effect on you in time. I've compiled a short list of key people who have influenced my life and career significantly. It is by no means comprehensive.

- Mom, for representing everything that is good in life. Your honesty and integrity are second to none.
- Dad, for infusing me with a love for photography and an insatiable thirst for knowledge.
- George Carranza, the first professional photographer I really admired. He taught me about style and good business sense.

- His eye for detail and quality, while exuding a comfortable, laid-back attitude, created a successful business model.
- Chuck Shahood, a fine commercial photographer who took me under his wing as an assistant. His impeccable eye for detail and quality control often left me questioning my sanity.
- Craig Strong, a mad scientist and creative soul of the highest order. Craig is the inventor of the Lensbaby and a constant inspiration to me.
- My fellow photographers and workshop attendees, for teaching me and inspiring me to keep teaching.
- Kecia Kubota, my sister and "Make It Happen" manager. Her incredible eye for detail and natural people skills make her invaluable to our business—and more importantly, to all the lives she touches.
- My sons Kai and Nikko, the most precious creatures in the world to me. They inspire me to look at the world with wonderment and curiosity. May they always remind me to enjoy life's simple pleasures.
- Clare Kubota—my wife and truly better half, who keeps me in line. I love you for all you do and who you are.

1. INTRODUCTION

Be daring, be different, be impractical, be anything that will assert integrity of purpose and imaginative vision against the play-it-safers, the creatures of the commonplace, the slaves of the ordinary.

-Sir Cecil Beaton, British photographer and designer

hen I originally wrote this book, I opened with a story about a photographer who wanted my opinion on whether digital was as good as film. At that time, photographers were still skeptical—some had taken the digital plunge, others were holding out, keeping dry at the side of the pool. Those who took the plunge are now expert swimmers, so to speak, and the others eventually dove in (or were pushed) and are splashing around, trying to catch up. Fortunately, there is much more education and information available now, so becoming digitally proficient is almost as easy as, well, falling in a lake.

So what was the answer to the photographer's question? "No," I told him, "it's better." Today, not many photographers dispute the quality of digital. Does it look like film? Probably not, and it probably never will. But most of us have gone beyond trying to emulate the "good ol' days" of film and now appreciate digital photography for what it is. It is a beautiful, evolving, limitless medium. There's no reason to discuss film any longer. We've moved on.

One of the things I love best about digital is that because it is constantly evolving, we are forced to keep learning. This is not a hindrance but a benefit. The Japanese have a term, "kaizen," which means continuous improvement, or growth. It is a philosophy that can benefit all facets of business and personal life. If we are not growing, we are dying. Digital keeps us young, even if it makes us prematurely gray.

■ THE BENEFITS OF DIGITAL

Let's cut right to the chase. Digital has myriad benefits, not all of which can be listed here. Here are a few that can be easily brought up in polite dinner conversation:

Benefits for the Photographer:

- Multiple originals. Never send irreplaceable film via mail. Create as many backups as necessary.
- Substantial materials cost savings. Shoot as much as necessary to get the image you need. No more film, processing, and proofing expenses. Reduce your environmental waste production.
- *Instant review/job insurance*. You know the job is in the bag before you even set the camera down. Share images with clients in-camera to ensure their approval.
- *Creativity enhancer.* Try new ideas, shoot more, experiment. Increase confidence in your creative abilities.
- Consistency in printing. Reproduce a print the same way from day to day or month to month. Avoid worries about lab inconsistencies and changing personnel.
- *Studio control over printing and final look.* Prints can be given the studio's "look" with simple Photoshop techniques. Print on demand with in-studio printers.
- *Myriad creative output options*. This facet of digital will keep you excited about your work and enjoying the impact of multimedia presentations.

Benefits for the Client:

- *More creative images to choose from.* Your gain here is their gain too.
- *Clean, retouched, custom-printed images.* Clients receive the best-quality images possible.
- More exciting ways to view their images. Options include slide shows, DVDs, web sites, e-mail, etc.
- More emotional impact with multimedia presentations.
 You can add impact to your presentations by pairing music and images.

- Print-ready images in CMYK. You can provide separation services for commercial clients.
- Clients receive your full artistic vision—if you choose to give it to them. They will place a higher value on your products and services.

■ KEYS TO SUCCESS

Artistic and Technical Mastery. I love Leonardo da Vinci. Well, actually I love what he did and represented. He nurtured all his different skills and became exceptional in many areas; he was artistic *and* technical. Likewise, digital imaging requires a good balance of artistry and technical understanding. When these two worlds are carefully combined, amazing results can arise. We'll assume that most of you have a good sense of artistry. But, even if you're really, really awful at the technical aspects, you can learn enough to be a mini da Vinci (or manage the staff you hire to handle your technical work).

The Right Mindset. Your confidence in your abilities is reflected in your performance and sensed by any observers. This directly translates into their increased, or reduced, confidence in your performance. When we display fine examples of our digital work and direct our conversations toward content in the images, rather than what they are made with, we emphasize our abilities to capture beautiful moments, artistic scenes, and create pleasing compositions with professional lighting awareness. We should not put undue value on the equipment we use or the medium we capture with. It's still about the images, and content is still more important than pixel count.

Ask for What You Want. One of the concepts I share with other photographers when doing presentations is a "just ask" mindset: ask for what you want and don't fear the consequences. I wasn't always good at this. Then, I submitted some of my wedding work to a trade magazine. They ran a feature on me, and also connected me with Nikon, who asked to use my images in advertising. They also asked me to do a presentation at the Wedding and Portrait Photographers International's (WPPI) annual convention. After this, I soon began receiving requests to speak at conventions nationwide. My life and business have never been the same since these doors opened.

The more we share, the more we learn, so I decided to share everything I could think of about digital and our business, and the results have been surprising. Did the competition use the information to their advantage? Yes. Did it hurt my business? No. My business continued to grow every year.

■ EVERY BOOK HAS A PURPOSE

This book is the by-product of a very successful workshop I developed in 2001 called the Digital Photographers Bootcamp®. The four-day, intensive program was designed to give digital photographers a veritable "big picture" of the working digital studio—from setting up the studio, to setting up the camera, to taking the images, organizing and enhancing them, and finally to printing and presenting them. This book pulls directly from the workbook given to Bootcamp attendees. While nothing beats a live, interactive workshop, this book is the next best thing.

Though this book is packed with technical information and practical hands-on tips, I've purposely kept the techniques simple and to the point. You should be able to jump to a section, find the technique or information you need, and get down to business. While our photography business has consisted mainly of wedding, portrait, and commercial clients, the systems and techniques can be applied to almost any photographic discipline. Similarly, whether you charge \$5 or \$500 for an 8x10-inch print, the techniques can save you time and money and raise your image quality.

My intention for this book is to provide quality, detailed technical information while inspiring photographers at all levels to look closely at their lives and businesses to see where improvements might be made. It was supposed to be a technical manual with a "secret" inspirational message hidden within—but I guess the secret's out now. Photography is one of the best businesses/lifestyles around. Enjoy the ride!

DOWNLOAD ACTIONS

Throughout this book, you'll find references to downloads that are available to readers. To access these, visit the publisher's web site at www.amherstmedia.com, click on the title of this book, and enter the password K1873. A complete set of custom actions is also available for purchase from the author at www.kubotaimagetools.com.

2. DIGITAL ESSENTIALS

Digital capture has in a sense loosened photography by demanding less, not more, technological expertise from photographers. This, surely, is a good thing: shifting photographic skills more to the visual and imaginative, and away from the technical. —*Michael Freeman*

■ THE NEW DIGITAL PARADIGM

This chapter will cover the most essential digital skills and concepts, which may be new to you, if you're coming from a film background. If you're new to digital, making the transition may be daunting at first, but hang in there; you'll be a guru in no time. Photographers who have a background in stock photography may find the transition quite natural and an amazing productivity booster.

The concepts that will be introduced are part of an interrelated system. As seen in the graphic below, the system can be broken down into four phases. Steps taken in one phase of the process are often done to facilitate movement through the next phase. Sometimes it's not completely obvious why we do something to, or with, an image until we move closer to the final presentation. Bear with me, there is a method to this madness! Take the time to refine your skills in each area. Balance is the key to becoming a Digital da Vinci!

The details will be covered in the following chapters, but here's a brief look at the phases of the digital system.

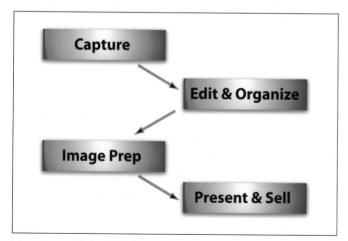

The phases of the digital system.

■ DIGITAL CAPTURE

With negative film, photographers could overexpose their shots by as much as three or four f-stops, and labs could save the images. Digital cameras are not as forgiving of exposure mistakes, especially overexposure. Retraining yourself to make accurate exposures is an essential first step. Expose for the highlights and err on the side of underexposure, if at all. Moderately underexposed or overexposed images (up to two f-stops sometimes) can be made printable, especially when captured in RAW format.

Capture also includes modifying your camera settings for the best final-image quality. Most cameras come from the factory with default settings that make your images look good when they first pop up on the screen. Manufacturers set them up for the lowest common denominator. They don't expect you to read this book and become a more refined user. Keep in mind that some of the camera settings we'll recommend for final image quality may make images look less appealing straight out of the camera, but the payoff comes when making final, retouched, color corrected, enhanced, and enlarged images.

■ RAW VS. JPEG: THE MAIN EVENT

Digital images come in two basic flavors, RAW and JPEG. Each camera manufacturer has their own proprietary RAW format (with extensions like .nef, .crw, .raf, .tif, etc.). Adobe has also developed a generic RAW format, .dng. Ideally, Adobe would like all camera manufacturers to adopt this format as the native camera format. If this happened, we'd all have theoretical world peace (at least with the RAW file format wars), and RAW software manufacturers could more easily update their software to work with all future camera files. The .dng format also conve-

niently stores the adjustment information inside the file itself, instead of as a separate file, like XMP (discussed later). There is currently an option to convert any manufacturer's RAW file format to .dng using Photoshop or Adobe Lightroom (also discussed later in the book).

RAW files contain the data straight from the camera's sensor, without in-camera software manipulations. This leaves the door open to modify image settings later, in the comfort of your studio, rather than at the time of the shoot. Some of the settings that can be modified later include white balance, hue and saturation, contrast, and sharpening. Many digital photographers don't take the time to do a proper custom white balance at the time of the shoot (we'll deal with you later!), but capturing in RAW enables you to correct for this after the fact.

Benefits:

- RAW files give the best exposure latitude, tonal range, and postproduction options. These are true "digital negatives."
- Most image adjustments (except ISO) can be changed in the post-capture workflow.
- Adjustments to RAW files are nondestructive and can be modified and changed at any time without degrading the original image quality. All adjustments are stored as settings alongside the actual image data.

Considerations:

- The files require longer write times in-camera and when downloading to the computer.
- RAW files require considerably more storage space.

FILE TYPE	RESULTING SIZE	IMAGES STORED ON A 2GB CARD
12.1 MP JPG Fine	.5.7 MB	
12.1 MP RAW compressed in camera	.13.3 MB	150
12.1 MP RAW uncompressed	.18.8 MB	106

Approximate statistics based on Nikon D3 camera files. (*Note*: Formatted cards do not allow full use of advertised storage.)

IPEG files, in comparison, are significantly smaller and slightly faster to write from camera to card. This is because JPEG files are compressed to make them an efficient image-transfer format. This compression compromises image quality, creating subtle but visible artifacts that can become more pronounced with image manipulations and adjustments. Care must be taken in capture and postproduction to maximize image quality when shooting JPEGs.

■ THE "RAW JPEG"

We capture every image in our studio in RAW and have never looked back. If you must capture in JPEG, though, there are a few things to keep in mind. We tested various camera settings and evaluated their effect on image quality when typical corrections and enhancements were applied in Photoshop. Our goal was to create a "raw JPEG" file—one that is as close to its original state when captured by the image sensor as possible. The following are the settings we consider essential.

• *Sharpening off (or as low as possible)*. Real RAW files do not have any sharpening applied to them in the camera. Therefore, we turn sharpening off. Sharpening should always be the last step in an imaging workflow,

Two images taken with the same exposure. The RAW file (right) captures more detail in the highlights and shadows and provides better color rendition than the JPEG (left).

- especially after any needed image interpolation. It can't be the last step if it's done in the camera!
- Contrast set to low. This protects against capturing an image with with blown-out highlights and blocked-up shadow detail. A low-contrast image can easily be brought into full contrast range in Photoshop, whereas an image with too much contrast is nearly impossible to completely recover from.
- *ISO as low as possible*. The higher the ISO, the more shadow noise becomes apparent. Always use the lowest ISO possible for the given shooting conditions.
- Make a custom white balance for each scene. To do this, use a device like the ExpoDisc or a gray/white card (see chapter 4 for details). Making a perfect white balance can be quick and easy—and the benefits are great. Images will have true, vivid colors, with little or no color correction work necessary. Skin tones will look warm and healthy. Since JPEG files should ideally receive as little post-capture correction as possible, getting the white balance right in the camera will mean a major improvement in image quality.
- Select the highest-resolution JPEG setting and least compression. In most cameras, this means using JPEG fine mode and a high quality setting. Even full-resolution JPEG files are small when compressed, so there's very little reason to shoot in a lower-resolution mode. Give yourself the most information to work with and use high resolution.

Many of these settings will be covered in more detail in chapter 4.

■ MEGAPIXELS AND RESOLUTION

This is the fun stuff. No, really—you'll be an expert in no time. While not the most exciting aspect of digital imaging, understanding your megapixels and resolution is key to understanding how to deliver images to clients, labs, magazines, etc. It's also important to understand so that you can properly enlarge (via interpolation, see chapter 7) an image when necessary for wall prints.

Let's see how simple we can make it. A 6MP camera has roughly six-million pixels. When you open an image in Photoshop, only the total pixel dimensions—*not* the resolution—determines the file size! Many people get worried when they see 72 pixels/inch in the Resolution box.

A low-contrast scene shot with auto contrast ruins the image. Low-contrast mode would have softened the lines and shadows under the eyes. Fortunately, this can be improved in Photoshop.

Not to worry. Resolution has nothing to do with the actual size or quality of your image until it is printed.

You can change the resolution to anything you want, without hurting the original image quality, as long as you don't change the actual pixel dimensions. The output size of the image is, however, directly related to the resolution. In other words, if you want higher resolution, the pixels will be printed closer together (for a less pixelated-looking image) and won't cover as much total area. This means the printed dimensions will go down proportionately.

When we change the resolution, we simply change how densely the pixels are displayed. A 3008x2000-pixel image will be printed at 42x28 inches when set to 72 pixels/inch; when the image resolution is set to 300 pixels/inch, the printed dimensions will go down to 10x6.6 inches. If the same image is set to 250 pixels/inch, the printed dimensions will go to 12x8 inches. Catch the drift?

To better illustrate the relationship between resolution and image quality, let's use a metaphor: Imagine a stretchy fabric. In this 8x10-inch piece of fabric the threads are laid out so as to give us 300 threads per inch—just like the fancy sheets at the linen stores, nice and silky. The threads are so tightly woven together that you can barely see them and the appearance is smooth and uniform. This is our image at 300 pixels/inch.

Now, let's take the stretchy fabric and pull it from the sides so that it now measures 16x20 inches. As you can imagine, you'll now start to see the gaps between those threads as they are pulled apart. If we counted and measured them, we'd see that they are now spaced at 150

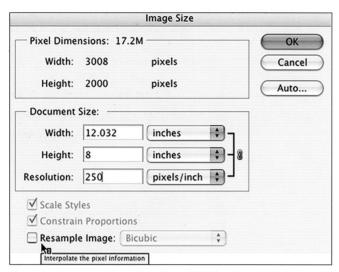

Photoshop's Image Size dialog box. Turning Resample Image off allows you to see relationships between size and resolution.

Image Size			
Pixel Dimensions: 99.1	M (was 17.2M) —		ОК
Width: 7219	pixels	€78	Cancel
Height: 4800	pixels	• 1°	Auto
Document Size:			
Width: 24.064	inches	⊇ 7₃	
Height: 16	inches	. ¬"	
Resolution: 300	pixels/inch	•	
Scale Styles			
Constrain Proportions			
Resample Image: Bio		•	
✓ Scale Styles ✓ Constrain Proportions ✓ Resample Image: Bic	ubic	•	

Photoshop image size dialog with Resample Image turned on.

threads per inch instead of the original 300 threads per inch. These gaps are like pixelation in a low-resolution image.

We can theoretically stretch or squash this fabric to any size we want—and each time the density of the threads changes proportionately—but we never actually add threads or take any away. The number of threads (pixels) of the original fabric (image) never changes, they are just observed (printed) differently.

But what if you need a different size and resolution combination? No problem, this is where Photoshop uses its brain and brawn. When you need an image with different size/resolution specifications than what you get in the above scenario (e.g., you want a 16x20-inch print, but with 300 pixels/inch resolution, instead of the natural 150

pixels/inch), Photoshop will will add or subtract pixels to maintain the original look and detail of the image as much as possible. This is called resampling or interpolation.

Keep in mind that whenever you resample an image, you sacrifice some image detail. However, the loss is usually acceptable (often unnoticeable), and it is the only way to achieve the goal of matching a size and resolution that is not in the natural proportions. There are three basic approaches to enlarging images:

- 1. Up-size (interpolate) the image prior to opening it in Photoshop. This is done using RAW workflow software like Adobe Lightroom or Adobe Camera Raw (ACR). The enlarged file is then enhanced, corrected, and saved from Photoshop. This method is easiest if your output size is known in advance.
- 2. Use interpolation software, like Genuine Fractals by OnOne software, after working on the normal sized image in Photoshop. This is a great solution when you've already worked on and enhanced an image in Photoshop and then decide you need to make a larger image for a big print, or you need to make smaller and larger prints from the same file.
- **3.** You can also simply use Photoshop to up-size or downsize your image. In chapter 7, we'll discuss the best ways to do this.

Since most digital camera files now are upwards of 10 megapixels, you have an abundance of pixel information to work with and can usually achieve excellent up-size interpolation results by simply enlarging the file after it's been enhanced.

People often wonder, "How large can I print my digital images?" The answer is simple, "How large is your printer?" In less impertinent terms, that means there's no *limit* to the size print you can make. Generally, the further you take the image from its natural size, the more apparent sharpness you lose. However, we've made billboard images from a 2.7MP camera before and they look great—at the proper viewing distance. Obviously, a higher-resolution original will give better detail.

If you use the proper capture settings, resample your image properly, and keep in mind your appropriate viewing distance for the size of the print, surprisingly good results can usually be achieved.

3. CREATIVITY AND INSPIRATION

Creativity is allowing yourself to make mistakes.

Art is knowing which ones to keep.

-Scott Adams

■ WHERE DOES IT COME FROM?

In keeping with our concept of balance, or the Digital da Vinci model, we must remember to nourish our creative needs amidst all this techno-babble. Technical efficiency can be a very satisfying thing, but the real spine-tingling, goose-bumping experiences come from the creation of a really awesome image.

When you are in the groove, you're shooting and everything is just flowing. You find yourself aware of everything happening around you. You turn just in time to capture a wonderful embrace across the room. Your exposure is dead on. You get a gut feeling and wheel around, only to immortalize another perfect moment as a father embraces his daughter with a tear streaming down his cheek. You get a wild idea to pull your bride and groom outside just as the sun is setting and climb in the back of a classic convertible. They love the idea and you create some of your favorite images. When you're in the groove, everything just flows. It seems effortless, and the ideas just seem to pour through you.

There is a classic book by Mihaly Csikszentmihalyi called *Finding Flow* (Basic Books, 1998). In it, he describes this concept of flow as a sort of nirvana state that happens when we are completely absorbed in something we are very skilled at. It is like being on autopilot, where you no longer have to think about how to perform, you are just absorbed in the performance. Your skills are so highly developed that they are second nature and you can react automatically.

This is what happens when we are so comfortable with the technical aspects of our craft that we can focus purely on capturing the perfect moments. Our intuition, immensely valuable to us as photographers, can be heard

Clare Kubota used an unconventional technique to create a beautiful and energetic image.

loud and clear. We can respond to hunches without the distraction of how we are going to pull it off technically.

To hear our creative voice, we have to silence the technical chatter as much as possible. This comes with experience, but it helps to remind yourself that learning the technical skills will help you be more creative as well.

Does this mean we have to be technical geniuses to be creative? No, not at all. I've seen wonderfully creative work from amateurs and beginning professional photographers with very limited technical knowledge. But the more they refine their technical skills, the more creative they become. It only gets better.

■ THE CREATIVE PROCESS

In photography, as with any other creative process, there is a simple system to help get your juices flowing. In creative writing, the final product is built in three stages:

- 1. Free write. This is the process of letting your ideas flow to paper. No concern is given to grammar, completeness, or final usage—just open the door and let it flow. No idea or statement is too crazy.
- **2. Edit.** Now we take a step back and start to edit. Rearrange sentences if necessary, make sure everything makes sense. Pick better words and refine your descriptions. Pull out unrelated or undeveloped ideas.
- **3. Rewrite.** Fine-tune and put the piece into its final presentation form.

With digital photography, we use a similar process:

- 1. Free shoot. Let your imagination go wild. Try any idea that comes to mind. No concern should be given to limiting your exposures, within reason. Often when trying to capture a fleeting moment, taking three to five shots in a row will deliver that one perfect image. Don't hold back.
- 2. Edit. With the powerful tools we have for organizing and batch processing images, this task becomes less daunting. Delete the experimental images that didn't work, the fluff shots, and the warmups. Edit down your images and save only the best of the best.
- **3. Prepare to present.** The presentation is extremely important with photography. Use Photoshop to extend your creative vision. Think of how your images can best be displayed or shared. Will a slide show with music enhance the mood? Clean museum-style mats? High-quality framing?

Before digital photography, the process was similar, but we were always aware that each shot cost money in film and processing. Subconsciously, we occasionally held back. Also, we couldn't immediately see the results of our experiments, and subsequently we didn't get as excited about them or push ourselves to try more.

Editing down 2000 or so proofs or slides is time-consuming. With digital, we can breeze through the shots, mark them, hide or show what we want, enlarge or reduce, categorize, sort, etc. It's a much more streamlined and controlled process. Making similar enhancements on film images was impractical or expensive at best. Each image had to be scanned, and the Photoshop skills for making the enhancements or corrections were not widely known. Everything is different now.

Lastly, the presentation methods were limited. We put together contact sheets, a stack of proofs, and a typical album or folio. If we wanted to go beyond the basics, considerable effort or expense was involved. Now, like Superman with his kryptonite shackles removed, we have the power to do amazing things. It's good to work digitally.

■ TECHNIQUES FOR CREATIVITY AND INSPIRATION

Inspiration and creative ideas can come to us in many forms. Some great methods photographers use to nourish their creative souls include:

- Going to the movies—any excuse is good, right? Isn't that a business write-off?
- Going to museums and art galleries.
- Reading industry magazines and trade publications.
- Taking "observation trips" to sit and watch people perhaps at a coffee shop.
- Reading novels that are exquisitely written so as to evoke vivid scenes in your imagination.
- Traveling to foreign countries. Nothing stimulates the mind like immersion in an entirely new culture.
- Listening to music. Create a music video in your head. Imagine the characters, the mood, the lighting, and the angles you would shoot it with. Thinking like a cinematographer can have a positive effect on your still photography. Think of ways to capture movement and make one shot flow into the next.

In addition to those mentioned above, the following are in-depth techniques that we use to boost creativity and stay inspired.

■ SAY "BOOM" WHILE WATCHING THE WORLD

This is the process of using a verbal trigger to connect your mental practice with physical performance. The idea that mental practice enhances performance is not new; in fact, many studies through the years have proven it to be true, with athletes in particular. Here's an example study from *Research Quarterly* (vol. 38, 1967):

Three groups of students practiced free throws in basketball for twenty days. Their performance was tested at the beginning and end of that time period.

- Group 1—physical practice—they improved 24 percent!
- Group 2—no practice—no improvement at all.
- Group 3—mental practice and imagination only they improved 23 percent!

What we can deduce from this is the fact that visualization is a critical tool for enhancing performance. This rings true with photography as well. The key, however, is to connect your visualization to the act of photographing. This is done with the verbal trigger, "boom."

Here's how it works: When you watch the world, make a habit of taking time to imagine how you would photograph it. Watch the interactions between people, the subtle movements and gestures, the key moments when the peak of action will occur. Practice your timing and anticipation. Think about the lens you would use and the lighting; then when a moment presents itself, say "boom!" Okay, now you don't have to shout it out and give away your stealth advantage, just say it quietly to yourself.

This verbal trigger makes a connection between what you see and pressing your camera shutter button. When you pick up your camera, say "boom" quietly to yourself again during the normal process of photographing and the connection is further strengthened.

Anticipation and timing are keys to good photography, and this exercise directly improves upon both. It can be done any time, all the time, and the benefits will grow the more you practice.

■ PROJECTS

Give yourself projects and self-assignments. It keeps you alive, creatively speaking. Remember when you studied

photography in school, or started to learn it yourself? The projects were the catalyst for great ideas and portfolio pieces. They were a chance for you to do whatever you wanted, within the scope of the assignment, without the constraints of a client's expectations. Of course, we soon realized that it's not always like that in the real world—but we don't have to lose that creative excitement.

Self-assignments allow you to freely experiment with new ideas and concepts and to reconnect with the reasons you love photography.

Self-assignments are key to keeping your creative ball rolling. It's all too easy to get caught up in the day-to-day "job" of producing images for a fee. We can't forget, however, that we also love what we do and need to stay motivated. Self-assignments allow you to freely experiment with new ideas and concepts and to reconnect with the reasons you love photography. A well-executed project or self-assignment will almost always produce a new portfolio piece.

One great way to do projects is to work with your photographer friends. Set up a monthly meeting and rotate responsibility for coming up with the monthly project. Everyone does the shoot together, or separately, and shares their ideas and results. This type of group effort helps to break down those barriers to working and sharing with other photographers. Your closest competition can also be your best friend—it's actually better that way.

Here are some project ideas:

Movie Scene Re-Creation. When watching movies, we often see beautiful lighting or compositions. We don't always take the time to analyze them, however, to learn from what we see. Try renting or buying a DVD you like with great photography, then pause the disc at a beautifully lit scene or interesting composition and analyze it. What do you like about it? Is it the mood or the unique angle of the lighting? Maybe it's a special color effect or treatment. Now, take this mental picture with you and work to recreate the key elements of it. This is a great exercise to help identify what moves you in images, then to translate what you see into a new image of your own.

Emotion Scavenger Hunt. Photo hunts are great fun. They train you to find new ways to see the world and to be creative under (slight) pressure. Try making a list of emotions instead of objects and pick five or ten for a group or solo hunt. Look for emotions like elation, melancholy, peaceful, excited, sultry, etc. Don't limit yourself to looking for emotions in people; they can also be captured in the mood of a place or scene.

Instead of taking the typical overview shot, try to convey the feeling of the place, or its essence, with very tight detail shots.

Detail Collages. Instead of taking the typical overview shot of a place or scene, try to convey the feeling of the place, or its essence, with very tight detail shots. Think intimate and moody. It is often the little details that make a place (or person) so unique and interesting, not so much the big picture. Tell the story with ten or twenty images, then put them together as a collage. Chances are, you'll feel a deeper connection to your subject this way and will remember it much better.

Blur the Details. This project feels amazingly refreshing if you have always been a very controlled, technically accurate shooter. Instead of capturing images that are tack sharp, force yourself to take a series of blurry or out-of-focus shots. The great thing about this exercise is it forces you to focus (not literally) on composition, light, shadow, color, and form. You can think more cinematically and capture movement. Try a whole series of images this way; you may be surprised at how much you like it!

Photograph the Alphabet. Look for each letter in abstract images all around you. You can do this while on a vacation or visiting a new location. Get creative and resist the obvious! For example, for the letter *B*, you might photograph a bumblebee. For *Z*, maybe it's someone sleeping. You get the idea. When complete, you'll have twenty-six images that will make a great collage print. Put these up on your studio walls to remind yourself that you need to think creatively.

Of course, the list could go on and on. Brainstorm a little and come up with your own challenges. Make it a routine, and you may never find yourself bored or at a loss for new ideas again.

■ USE CREATIVE TOOLS

Professional Lenses. As professional photographers, we want our images to look nothing like Uncle Harry's. Chances are, Harry is using a 35-70mm zoom lens with an f/4.5-f/5.6 aperture and an on-camera flash.

One way to separate your images from the amateurs', other than taking better photos, is to leave no room for comparison to a "consumer" camera image. Try using wide-angle lenses in the 12–24mm range, fisheye lenses, or 85mm and above. Also use as large an aperture as you feel comfortable with—f/1.4 to f/2.8 if possible. Even group shots can be taken with an 85mm lens if you position yourself far enough away, and the results are beautiful.

Consider a Lensbaby. What's a Lensbaby? I'm glad you asked. This is a funky lens that allows for manual control of tilt and swing effects. The simplicity of the lens and the beautiful, organic-looking effect it gives is very refreshing in our high-tech world. The sweet spot of focus can be placed anywhere in the frame, and the other areas go out of focus. The resulting images have soft, diffused edges that look as though there is motion blur and have a dream-like feel. (See Resources for contact information.)

Lensbaby images have a soft, dreamlike feel.

TTL Flash. Some cameras, like the current Nikon line, include the ability to use off-camera, wireless TTL flash. This is an awesome tool for creative lighting effects as well as for creating more professional-looking standard lighting setups. By taking the main flash off the center of the camera, you can create more depth with dimensional lighting that defies typically flat on-camera flash looks.

Ideally, two flash units are used. Both should be capable of wireless TTL control. All major professional camera manufacturers offer their own version of wireless TTL.

With Nikon, the SB800 is a dynamite flash unit and is extremely versatile. The first unit is held, by the photographer or an assistant, to the side of the camera, at anywhere from 20 to 45 degrees from the camera, and slightly above eye level. This is the main light and should be set for normal exposure or down $\frac{1}{3}$ or $\frac{2}{3}$ of a stop. The second flash unit is the fill light and is mounted on the camera. Set this light to 1 to $\frac{1}{3}$ stops below normal. Since TTL is used, great exposures are practically guaranteed. From the camera position, you can control the power of each light and achieve the balance you want after just a test shot or two.

I commonly hold the main light off to the side with one hand while photographing with the other hand. If you are working alone and have some time to set up, try positioning the main light on a tall tripod or light stand. This is a great, portable solution for lighting quick portraits because the setup is easy to move and there are no cables or power cords to deal with or trip over.

Use a Monopod. Find ways to get your camera into unexpected locations. One fun idea for wedding or party receptions is to mount the camera on a monopod. Then, use a wide-angle or preferably a fisheye lens and set the camera to self-timer mode with a three- to five-second delay. Focus lock the camera at a typical subject distance,

Get a new perspective by selecting an unexpected camera angle.

release the shutter button, and lift the camera high above the crowd for a bird's-eye view. What fun!

Integrate Point & Shoot Digital Movies. Bring along a compact camera that captures movies. Many current models are inexpensive and can capture full-motion, full-sized video clips (30fps @ 640x480). The point here is not to take the job of a videographer but to capture just a few little details and moments. A parting shot on the dance floor or a few great clips of people laughing are always a hit. Some cameras even have a time-lapse feature that can be used to capture the setup, use, and breakdown of a ceremony site or reception area. These are fun little tidbits to include in a slide show or DVD for the wedding client.

■ BE A GROUPIE

Shadow Shoot. If you can find the right photographer to allow you to shadow them, then this is a lot of fun. The purpose is not to be an assistant, or even to "watch" what they do, but to allow you the chance to shoot without the pressure of the job. You can shoot from the sidelines, capture completely candid images, and focus on timing, anticipation, and creative angles. Try some new exposure or lighting tricks. The key is not to get in the main photographer's way. You may also want to offer your images to the photographer to sell to their client—but don't ever try to sell your images to the client directly. This is not for

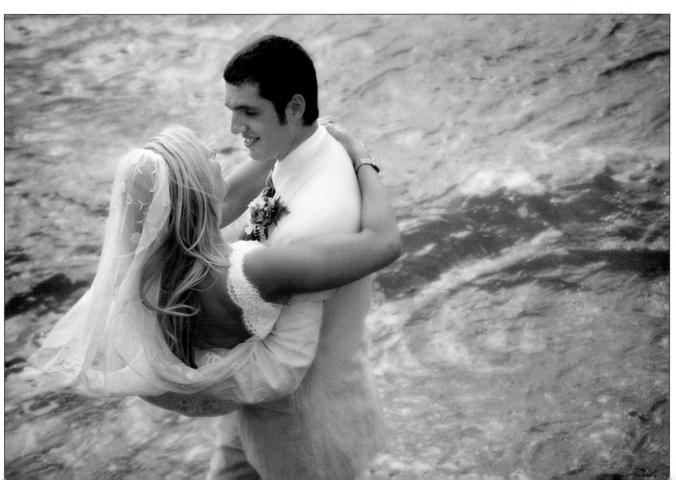

Developing your intuition can help you read your clients better and capture their true personality.

profit but purely for the practice and the experience of seeing and shooting differently.

Sacrifice Yourself. Be a slave for a day. It's good for you. Be an assistant and watch how another photographer works. Offer your services for free. You'll get ideas you never thought of, no matter how experienced you are. You may also discover that you are already doing some things a lot better than you initially thought, which can be a great confidence booster.

Team Shoot. Rally up a few of your photographer buddies or buddettes and plan a shooting date. Hire a model together, if needed. Pick out a great location or subject matter and plan for the shoot just like it was a real job. Acquire props, a makeup artist, and a wardrobe if necessary.

You can almost always come up with portfolio-quality images, and it's great fun as well. Staying fresh and excited about photography is key to long-term success. Find ways to keep the ideas and energy flowing.

Start a Group. This might be done with the same associates that you team shoot with. Plan a meeting, maybe once a month. At each, a different member can come up with a presentation for the group. They can share a new technique they've learned or style they've seen. If someone is less experienced, they can initiate a stimulating discussion on a particular photographic topic or famous photographer's work. Sharing is caring, and nothing but good can come of it in the grand scheme of things.

Develop Your Intuition. As Jonas Salk said, "Intuition will tell the thinking mind where to look next."

This is one of the key skills you can master and use for every part of your business. Learning to recognize and listen to your intuition will help you to read your clients better and capture their true personalities. It will alert you when a key moment is about to happen—even if you aren't consciously aware of its significance. Your intuition will also help you with business decisions and career moves. The power of intuition is underestimated and often misunderstood.

Intuition is not a mystical kind of superpower—it's a real and practical skill we all possess. Not everyone recognizes or trusts it, however, so it often takes some practice to make it work in day-to-day situations. The first important step toward tapping into it is to believe in it. Take it seriously. Once you're over the hump of thinking, "this is crazy hippie stuff," you can amaze yourself.

Some may prefer to call it "gut instinct." Sometimes it's difficult to put a concrete value on something so intangible, but learning to recognize and trust in your intuition can literally change your life and business. It's happened to me many times. In fact, most of the major career and life decisions I've made have been done from a "hunch"—a seemingly far-fetched idea that just popped into my head. Instead of ignoring it or rationalizing it away, I started to develop a virtual scenario in my head to see what could happen if I really followed through. The key is to keep the negative, self-doubting thoughts out of your head. Those little monsters!

Here are just a few examples of where my life or business was changed for the better by trusting my intuition—

not for the purpose of being boastful, but simply to share how intuition really is effective.

I met my wife, as a teenager, through a youth program called Civil Air Patrol. I still have no idea why I decided to attend the first meeting—the program was geared toward training teens for ROTC programs—which I had absolutely no interest in. As a teen, it was unlike me to want to go to any organized activity, but for some reason I went—and there she was. That was in 1983, and we've been best friends, husband and wife, and business partners ever since. I couldn't imagine my life without her. What drew me to that first meeting?

In 1995, we had a thriving photography business in Southern California. Business was steadily growing and we had developed a good reputation in our area. We took a road trip and stumbled upon a small town in Oregon, where we stopped to rock climb, then have dinner. We took a walk after having dinner in a quaint restaurant, and said to each other, "Let's move here."

A few months later we had bought a house in Bend and moved with no idea what to expect for the business. It was a very small town compared to the one where we lived in Southern California, and we wondered if we could even come close to the income we were accustomed to before.

After the first year in Bend, our business nearly doubled, and it has grown steadily ever since. I now realize that so many of the innovations and good business decisions we made grew from necessity—from being in a remote location. Moving to Bend was one of the best decisions of our lives, and it was based purely on intuition.

In 1998, I started to get a taste of digital cameras and immediately felt that this was our future. I didn't "wait and see" but dove right in. Although we learned many things the hard way, we learned them well. Because of our early adoption of and experience with digital, we were able to offer a product that very few other photographers were offering at the time. We also learned enough to start training other photographers in the art of digital, which has also been a wonderful complement to our photography business. Had I not trusted my gut and jumped in, despite the odds against immediate success, would I be writing this book today?

Soon after we started shooting digital, my style changed immensely, and I felt for the first time like I could really photograph the way I loved to. I followed a very small

voice in my head that told me to send images in to a magazine for review. This was very out of character for me at the time. But my intuition said to do it, and I did. The years ever since have been like a whirlwind of exciting opportunities and new experiences. Doors magically opened and wonderful people walked in. I can trace it all directly to that intuitive voice telling me, "Take a chance, share your work."

Making Intuition Work for You. The hardest part of tapping your intuition, beyond learning to trust it, is learning to recognize it. Then, what do you do? Do you act on every little crazy voice in your head? Will they take away your house and family and commit you to a padded room with nothing but a cheap PC and Photoshop 3.0? Oh, horrors no! Here's a simple system for making it work:

Recognize the Thoughts. You can usually recognize an intuitive thought or idea by how seemingly random it may appear. It's not necessarily something you've worked up to or developed, it just pops in your head. It may even appear as a totally random thought like "walk into that store" when you are heading somewhere else. Intuitive thoughts often lead you places; they are not always the answer in and of themselves. Such leading thoughts are most useful when photographing.

Brief Analysis. Stop, look, and listen. Give the thoughts some thought. This should be done when a full-blown concept or idea, rather than a "leading" thought, hits you. Contemplate the worse-case versus best-case scenarios. If this idea actually worked, what would be the benefit? If it failed miserably, what would you stand to lose? If the potential wins outweigh the losses, then move to the next stage.

If this idea actually worked, what would be the benefit? If it failed miserably, what would you stand to lose?

Develop the Idea. Now it's time to write the idea down and talk it over with others you trust. Be sure, however, that your "board of directors" are not intimately involved with the results, or their opinions will be biased. Unless you know they are intuitive by nature or can listen with an open mind, hold off on sharing your ideas—just for a

while. When you have a firmer plan, with detailed pros and cons, present the idea. It's a good practice to keep a journal with all your ideas and the basic details that support or develop the project.

Put It into Action. If the idea has passed the last test and still looks feasible, make it happen. Take the first step now. If you wait, the energy behind the idea diffuses, and it's difficult to recover. We slip back into our daily routine and habits—where we are comfortable—and the grand idea slips slowly away. Change is hard. One of the ironies in life is that change is hard, yet change can be so good. Remember this: just because you start something doesn't mean you can't change your mind later. It's okay to abandon a project if you learn or feel that it really isn't working. If this idea came from intuition, there's a good chance that you have learned something valuable in the process or have been led to something even more significant. Your first intuitive thought may not always be the final answer you need.

Act on Intuitive Impulses. Impulses, or leads, are a little different than ideas. They don't always give much more information than "talk to that person" or "walk down this

pathway instead." There often is no obvious reason for the thought. This is what separates them from an educated intuitive lead. For example, you may be at a party and already know that a certain person in the room would make a good business contact. Your gut tells you to go introduce yourself. This is an educated lead, and there is nothing wrong with that. Recognizing an intuitive lead is equally, if not more, important. With intuitive leads, there is rarely an obvious reason for the hunch. It remains to be discovered.

We can use this type of impulsive intuition regularly when photographing. Don't be afraid to act on an impulse when you're scratching your head for fresh images at a shoot. Worrying about what the client will think if the idea sucks will rob you of your originality.

Some of the most creative and successful people in the world are simply acting on and following intuitive impulses that others choose to ignore.

■ INSPIRATION FROM GIVING

One of the strongest forms of inspiration can also come from giving your photography services away. Some of the

> most poignant and meaningful letters or comments of gratitude come from the people who receive your services through charitable work. There is immense power in a heartfelt thank you.

One thing we've noticed as well: when you realize what an impact your work has on the lives of everyday people, you simply put more value on your gift in your own mind. This is an important factor for both business success and, even more importantly, feeling that your life has purpose. It has often been said that even more satisfying than money is the feeling that what we do matters. Wow, heavy stuff.

heavy stuff.

Don't be afraid to act on an impulse when you're scratching your head for fresh images at a shoot.

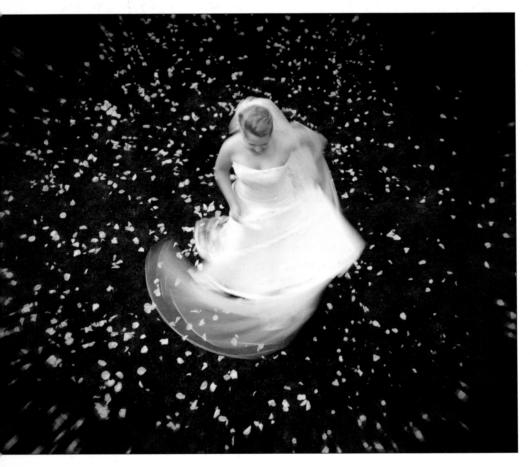

18 DIGITAL PHOTOGRAPHY BOOT CAMP

4. DIGITAL CAPTURE TECHNIQUES

The creative act lasts but a brief moment, a lightning instant of give-and-take, just long enough for you to level the camera and to trap the fleeting prey in your little box. —Henri Cartier-Bresson

■ EVERY CAMERA HAS A PERSONALITY

Get to know your camera. It's a relationship worth investing a little time in. An essential part of being able to shoot intuitively is knowing your equipment and camera settings so well that you don't have to think about them much. Each camera is significantly different in its operation and image characteristics. We often talk to photographers who don't even realize all the great features their cameras have. Though it isn't possible to cover every possible setting and characteristic of every digital camera, there are some basic guidelines that are helpful and generally applicable no matter what camera you use.

In order for any lousy image to be blamed on the photographer, not the equipment, we need to dial our cameras in, prior to taking them out to play. The ideal way to capture is to go RAW. This is the best way for beginners as well as advanced digital photographers to ensure they have the most image information to work with. This is obviously invaluable for those who are still perfecting their exposure technique, as there is some cushion in a RAW file to compensate for improper exposures—much more so than with JPEG. When capturing RAW, the most important setting to remember is your ISO and a proper exposure (or reasonable facsimile). All other adjustments can be fine tuned later using software. Here are some camera settings to double-check before each shoot:

- 1. Set image numbering to continuous. This way, numbering doesn't restart at zero each time a card is loaded.
- 2. **Time sync multiple cameras.** You can set the clock on your cameras, with accuracy to the second, and this time stamp will be embedded in your image EXIF

- information as it's shot. With multiple cameras time synched, they can be loaded into the cataloging program, sorted by capture date, and then all the images—from all cameras—will appear chronologically. They can then be batch renamed in this order so that the new numbers are continuous and chronological.
- 3. **Know how to read your histogram.** Every pro camera will show you a histogram for any image you've shot. The histogram is useful for evaluating exposure.

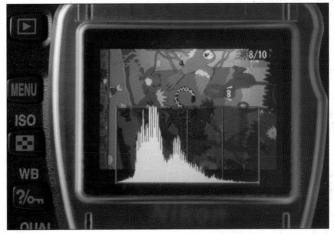

A perfect histogram showing a full range of values from the shadow point on the left to highlights on the right. Notice that the bumps of the histogram do not extend past the left or right edges, indicating no detail is lost.

4. Set your review screen to show the flashing highlight warning. This is an invaluable feature on all current pro cameras. It will quickly show you, via flashing areas on-screen, what parts of the image are overexposed and contain no image data. You can quickly make a decision whether to lower your exposure to recapture that detail or accept the blowout. Most people leave this on as the default.

5. Check your image sensor for dust. Dust on your image sensor will rear its ugly head in the form of soft black spots on the images. It will appear in the same spot on every image and is most noticeable at smaller f-stops (like f/8–f/22). Test for dust by setting the f-stop to the smallest available and making an exposure while pointing at a featureless white wall or paper. Set the camera to manual focus, focus at infinity, then move up about six inches from the white wall or paper. Add ²/₃ f-stop of exposure compensation. Now shoot. Open the image in Photoshop and inspect for soft black spots.

If your sensor is dusty, it should be cleaned by an authorized camera repair center. With that said, you can clean it yourself with a variety of available sensor cleaning products. For regular removal of light dust, we love DustAid. This liquid-free product removes light dust via a special adhesive patch and is very easy to use. It also passes through airport security because no liquid is needed. See Dust-Aid.com for details. If your CCD has hardened spots or liquid stains, then you'll need a product like Sensor Swab, available from most camera retailers. See www.photosol.com for detailed instructions for each camera.

- 6. Format media cards in-camera prior to every shoot. More than just deleting old files, formatting is the best way to ensure a clean directory structure for new images. It can reduce the chances of lost images or file-writing problems.
- 7. Use the "notes" field in your camera. Some cameras, like the current Nikons, allow you to enter custom text in your camera that will be embedded in the image's EXIF info. This information can be viewed in programs like Lightroom and Photoshop. It helps when you want to isolate images from one camera for processing or simply to trace possible camera problems. You may find it helpful to insert the camera serial number and a photographer's name, as this can facilitate tracking images in a multi-camera shoot. We use this text: s/n 1234599 Kevin. By default, this information will be attached to every image this camera takes, until changed or disabled. Note that many current cameras automatically embed the serial number, so, instead, you may want to put custom text in the notes like, "Live Aloha!"

For those still capturing JPEG, the following settings will help. Some of these settings were mentioned in the previous chapter, but let's expand on those a bit, as they are important.

- Set contrast or tone to low. This will protect your images from losing detail in highlight and shadow areas.
- 2. Set color mode to Adobe RGB if available. This color setting captures richer colors and a wider color gamut. It's a particularly good choice if you plan to convert your images to CMYK. Even if you plan to print to a machine like the Frontier or Noritsu (often referred to as "sRGB printers," though their true color profiles are quite different), Adobe RGB can give you better results overall.
- **3.** Turn sharpening off or to the lowest setting. Sharpening is purely a software enhancement and should be saved for the final step in the image workflow.
- 4. Use a custom white balance. Learn how to make one. Each camera is slightly different, but all allow you to dial in a perfect white balance using a white/gray card or an ExpoDisc. Read your camera manual to see how it's done, then practice so you can do it quickly on the job. It pays off in *big* dividends with your final image quality and color consistency.

With your camera settings dialed in, you can rest assured that you are getting the most from your camera. Now you can focus on technique.

■ ACTING LIKE A DIGITAL PHOTOGRAPHER Some of these tips are unique to digital capture, and s

Some of these tips are unique to digital capture, and some are general helpful tips for any photographer.

1. Shoot several images in a row when attempting to capture key moments. Exercising control is not always a good thing. With digital, you can free yourself. Often, that peak of the action or perfect expression will happen within a hundredth of a second. Taking just one shot severely limits your chances of isolating that perfect moment in time. Fire three in a row and you may find that the second or third frame is the one you like best.

WHITE BALANCE

Setting white balance is probably a fairly new concept for the photographer making the transition to digital. It is simply the process of telling our camera the color of our light source or letting it try to figure it out using auto white balance. Unfortunately, though the auto white balance improves with every new camera generation, random results can occur when the camera makes this decision for you.

The auto white balance feature works properly when you are photographing an average scene with an average mix of colors. Though you will encounter such instances, life is not that average. Say you're taking a photo of an average scene, and the auto white balance feature works just fine. All of a sudden, a UFO lands and a very green martian jumps into your frame. Whoa! Your camera then decides the scene is too green and adds magenta. Bummer. Your beautiful green martian is now a sickly gray and the tabloids refuse to run it—it's not "realistic." Everyone knows martians are green!

This real-life tragedy could have been avoided with a simple preset or custom white balance. Presets are the icons on your camera for cloudy, tungsten, sun, etc. While using one of these may not give you perfect white balance, it is usually fairly close, and at least it won't be influenced by sudden changes in your color scene—like a martian.

Better yet, make a custom white balance. Using a neutral gray or white card, or a tool like the ExpoDisc, you can tell the camera exactly what the color of the light is, and the martian will glow in all its green beauty. To create a custom white balance, set the camera to custom WB mode (you'll need to look up the specifics for your camera in the manual), then simply point the camera at the neutral object, filling the frame with that object, and capture an image. Your custom white balance will be set based on the light falling on that neutral object.

If you are capturing RAW, however, you have more flexibility to fix white balance problems later in the workflow. All you really need is something neutral in your scene to use as a reference later on (it doesn't have to fill the frame). You can pop

2. Check images on the LCD when the lighting is critical, but don't get in the habit of peeking too often—you may miss what's going on around you. You should feel comfortable enough to know that you have a good exposure without looking at every shot.

a gray or white card in the scene, or in the previous example, we could simply use the spaceship as a reference point since it's medium metallic gray—like most spaceships.

Here's how it works:

- 1. Set the camera to Auto WB. This will get you a decent white balance; often it will be just right.
- **2.** Load the image or series of images, shot under the same lighting conditions, into your workflow software.
- **3.** Click on the neutral object in your image with your custom white balance eyedropper and presto, the image is corrected. The martian will thank you.

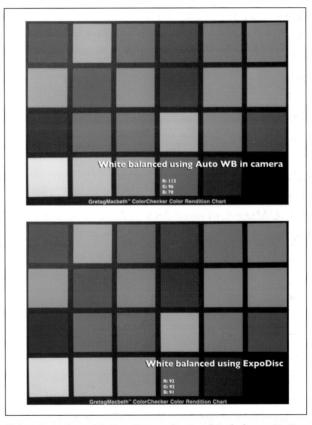

Color chart shot with ExpoDisc and auto white balance. Notice the RGB values on the gray patch. The ExpoDisc chart is nearly perfect, but the auto white balance is way off.

3. Share an image or two with your client every now and then. This is a great confidence builder for both of you. Often when creating images, the client has no idea what you're seeing and how cool it may be.

When they see the shot, it's like a switch turns on in

A warm gel over the on-camera flash gave a pleasing color balance with the tungsten room lights. The flash power was reduced to avoid the "flashed" look. The camera's white balance was set to tungsten.

- them; "Oh, wow!" they say, "I had no idea that's what it would look like." Of course they didn't, or they'd all be photographers. This little sneak peek will help you earn their confidence and give you a little more leverage for trying new ideas with them.
- 4. Pose if you must, but be on guard. Often the best, most relaxed expressions happen when the client thinks you aren't watching them. It's not a conscious thing they do, it just comes naturally when they let down their guard. We often do "suggestive" posing, which is not as kinky as it sounds. Really this means we'll give a suggestion for a pose or position, then let the client naturally fall into it. We might tweak the pose a little, but we try to avoid grabbing and repositioning body parts too much. This avoids poses that really don't reflect the client's personality and results in more natural-looking images.

The second part of this tip is equally important: Keep shooting when the client thinks you've already captured the "pose." Look for out-takes (this is when

- they relax, laugh, and interact with others). These are the real moments that are often the ultimate goal of the posing—they just don't know it yet. Many photographers overlook these moments, thinking they aren't what they wanted—but shouldn't they be?
- 5. Demonstrate your energy and willingness. There's a fine line between making a spectacle of yourself and putting the client at ease. Let's use a wedding couple as an example. They generally come to us because they are looking for fun, expressive, emotional images—yet sometimes when we get right down to it, they aren't much fun, expressive, or emotional at all. Yes they are! Well, most people are. Usually it takes a certain comfort level with the photographer before they will let down their guard. When you show energy and are not afraid to be a little silly, they start to mirror you. They won't do things that aren't natural to them, but they will start to open up. If you're a stick in the mud, they will be too. Don't be shy; be the mirror for the energy you want to capture.

6. Experiment with various exposure methods and use exposure compensation. Using aperture priority allows for control over the look of the image, which is primarily determined by the f-stop. The camera's meter does an excellent job in most cases.

When confronted with a tricky lighting situation, the exposure compensation dial comes to the rescue. We've set our cameras so that the exposure compensation can be adjusted in \(^1/_3\)-stop increments by simply turning the thumb wheel. No extra buttons need to be pushed. This makes for instant compensation in any situation and an almost guaranteed good exposure. Exposure is checked on the histogram on the LCD screen—a method that's quicker and more accurate than using a handheld meter. When the mountains of the histogram are pushed off the left side of the scale, "plus" exposure compensation is needed. When they are off the right side, "minus" exposure compensation is needed. With experience, the perfect amount of compensation can be dialed without having to check the histogram at all.

- 7. Natural-looking flash comes with finding balance. The TTL flash systems on most cameras work quite well. Using flash is no different with digital than with film. The real benefit of digital reveals itself when multiple flash units are used and off-camera TTL is employed. Now we can check the results instantly, so give some thought to trying more interesting flash setups. With wireless TTL, you can take your flash off the camera and create more depth in your single-flash lighting. Try setting it at a low power (try –1 f-stop) and using it like a fill light on flat-lit scenes and overcast days. When an off-camera flash is positioned high and to one side, it looks like nice crisp sunlight, without the harsh shadows.
- 8. One great trick that commercial photographers use is to gel the flash to match the color of the ambient light. This can be used, for instance, when shooting under tungsten light indoors. You may want to use some flash to help illuminate your main subject, but also use a slow enough shutter speed to capture some of the natural warmth in the room. Using a normal flash will work, but the subject, illuminated primarily by the flash, will look very different in color temperature from the background. By putting a warm amber

- gel over the flash and setting the white balance to tungsten, the foreground and background will both be the same color temperature and the overall feel will be much more natural. Check out www.sticky filters.com for a great removable adhesive filter that works with any flash. To recapture some of the tungsten warmth, adjust the white balance to make it slightly warmer. Most cameras allow for minor variations from each white balance preset.
- 9. Wouldn't it be great if there were a secret formula for great smiles? Sharing images, posing and watching, demonstrating energy, and smiling yourself will help, but here's another tip: have someone stand next to you so they can smile at the subject. It could be the groom, a friend, or your assistant. I often ask the groom to stand next to me when I photograph the bride. I talk about how beautiful she looks, and how the light is perfect, and he generally agrees. This is his cue, and any groom worth his weight in plastic shoes will start laying on the compliments—and she'll smile beautifully.

A compliment, a smile, and eye contact will get you anywhere. Hey, it got me my wife!

When the client is not focused on the camera and is relaxed, real smiles happen. Compliments and eye contact can achieve this objective. Try this experiment: walk up to anyone, look them in the eye, and smile a genuinely warm smile. They can't help but smile back! You may even get a date or two. A compliment, a smile, and eye contact will get you anywhere. Hey, it got me my wife!

5. WORKFLOW

Home computers are being called upon to perform many new functions, including the consumption of homework formerly eaten by the dog. —*Doug Larson*

■ OVERVIEW

"Workflow" is an industry buzzword that became popular with the advent of digital cameras. Digital photography is exciting, to say the least, but it also requires us to manage thousands of image files on our computers.

Though Photoshop contains a built-in image browser, called Bridge, it is not a true cataloging program like Adobe Lightroom, Apple Aperture, or Microsoft Expression Media. (We'll discuss the difference between a catalog and a viewer a bit later.) Each program has its

Download via copy/paste

Load in to iView

Renumber files with Job #

Save Catalog

Backup to CD/DVD

Batch process to low res

Final edit and categorize

Batch correct and convert

Create "Tweaks"

Backup edited catalog and new files

Present Images, print proofs, make DVD, etc.

This chart shows the stages that the images pass through from initial download to final presentation. Each step will be detailed in the following sections.

strengths, but our tool of choice is Adobe Lightroom. It has the best balance of intuitive controls, speed, features, and excellent integration with Photoshop. Though Microsoft Expression Media (formerly iView MediaPro) is an excellent cataloging program, it doesn't currently offer the RAW image processing tools that Lightroom and Aperture offer.

The workflow system outlined in this chapter is ideal for high-volume event photography like weddings, bar mitzvahs, school photos, etc., but it is just as effective for small jobs. It is useful for everything from business headshots, to family portraits, to stock photography. At first the system can seem intimidating, daunting, and unnatural—especially for those new to digital. It's worth the effort, however, to learn and apply the system. In the long run, it can save many hours in production time, and simplify retrieving older files.

There are four key stages in the workflow process:

- downloading/organizing
- image storage
- editing
- consistent backup to disc

■ DOWNLOADING/ORGANIZING

A Download System. Simple organizer bins make the task of downloading and backing up your memory cards foolproof. In our studio, as memory cards are brought in from the shoot they are placed in a bin labeled Ready to Download. Once the images have been copied to the computer, the memory cards are placed in a bin labeled Need to Back Up. These cards cannot be touched or reused until the backup process is completed and verified. Once

done, they are moved to the Ready to Clear bin. Once in this bin, they can be reformatted and reused at any time. Though this system is quite simple, it can avoid confusion and help ensure a bulletproof process for image backup.

Organizing Your Images on the Computer. Storing thousands of digital images requires a systematic and consistent filing system to avoid wasted time, frustration, and hair loss. A simple system for organizing your client jobs on the computer is described later in this chapter.

Long-Term Storage of Your Digital Images. The type of storage system used will depend on overall studio volume and initial budget constraints. Consider how many images will be shot in an average month, for the average job, and choose a system accordingly. Keep in mind that new digital photographers usually underestimate the number of images they will be shooting. Once you go digital, you realize the value and fun in shooting more. In addition, with each new generation of camera, resolution goes up and file storage needs inflate accordingly. Your future file storage needs will probably be much greater than you initially estimate. Buy now for three times more storage than you think you currently need.

■ RECOMMENDED STORAGE SETUPS

Moderate-Volume Studio. If your business falls into this category, you'll want to ensure that you have one main imaging computer with at least 2 GB of RAM. A large internal hard drive is not as critical, as all jobs will be stored on external hot-swap hard drives.

Also, you'll need at least a two-bay hot-swap RAID type hard drive system connected externally via FireWire or SATA. Two bays allow for one to be used as the backup drive to mirror the main drive. Ready-to-go RAID hard drive cases are readily available. What's RAID? It's an acronym. Okay, seriously, it means a Redundant Array of Independent Drives. What it *really* means is the use of two or more drives, where some of the drives are set to mirror your data as you write it to the main drive. It works automatically, so the user only sees one main drive on the computer—business as usual.

There are several flavors of RAID, known as RAID 0, 1, 3, 5 etc., but the most common for backup is RAID 1, also known as mirroring. In this configuration, you install two drives, and when you write data to one drive it is automatically written to the second drive simultaneously.

This setup is simple, but not always the most cost effective because you have to purchase two identical drives and can only use the storage space of one.

A better solution is RAID 3 or 5. In these configurations, five drives can be used, but only one drive is needed to mirror and protect the other four. Magic? I think so. We don't need to know how it works, we just need to know it works and the world is a safer place for data. So, with this type of setup, you get more actual storage space for your money. You can also set up three drives, where one protects the other two (though this is less efficient as you get ½3 storage space per drives purchased).

Digital photography is exciting, but it also requires us to manage thousands of image files on our computers.

Another solution we like and use is called the Drobo (www.drobo.com). This is a four-bay hard drive box that essentially works like RAID 5, but it's not technically called that. It's actually more flexible because you can start with only two drives, where one mirrors the other, and grow from there. When the main drive is full, simply insert another matching drive and the storage automatically grows! Now you have the storage of two drives, backed up by the third. When you fill those drives, just insert a fourth. Now it automatically grows, and you have the storage of three drives, backed up by the fourth. At the four-drive level, it makes the most efficient use of the drive space. This is a great system that I highly recommend.

It's a good idea to plan for nightly backups of your main computer and system software. This way, if something goes wrong, or you catch a virus, you can revert to the system from the day before. At most, you lose one day's work. All that's needed is a single external drive that is the same capacity, or larger, than your computer's internal drive. Simple automatic backup software can be used to copy the contents of one drive to the backup drive at timed intervals so the user doesn't have to think too much. We set ours to run automatically at midnight every night.

This setup should serve most small studios and singleperson operations well. If you find yourself often pulling old hard drives from the cabinet to fill orders, then it may

STORAGE COSTS

Digital storage is cheap. Up-front costs on new hard drives and storage systems may seem high, but when amortized over the number of jobs they will hold, the cost per megabyte goes down considerably. Look at buying hard drives as an ongoing sales expense, just like film, processing, and proofing. When considered this way, purchasing hard drives is less stressful. The following breakdown should help ease the pain:

- An average wedding, captured in RAW format (1500 images taken) requires 18.7 GB of storage space. This also includes proof copies of edited images and the PSD format tweaks. With current average prices for a 750 GB hard drive running \$150, and archival gold DVD media at \$1.79, it costs us \$10.90 to permanently store the job on hard drive and DVD.
- Of course, we want backups of everything, so we have duplicate hard drives and duplicate DVDs. The total price to store on two hard drives and two sets of DVDs: \$21.80.
- The same job, if shot on film, would require forty rolls of film, processing, and proofing. With an average cost of \$20.00 per roll, that adds up to \$800.00. Ouch. And we haven't even included the cost of purchasing dedicated boxes for storing the film.

In the above scenario, we have considered that our studio loves to create files and hates to throw anything away. For a studio that shoots less at a wedding and doesn't create all the extra files for enhanced images and slide shows, the storage requirements could go down considerably.

Let's look at an example for a typical portrait job. Again, we shoot many images for portrait sessions as well—on the average, one hundred and fifty images.

be worth investing in a second RAID type case to keep two active RAID drive sets mounted at all times. Usually, by the time the second drive set is nearly full, old jobs on the first drive set aren't needed on a regular basis and can be stored. The second set of drives then moves to the first drive set's previous position, and new drives are inserted.

Multiple Employees. When a second person is added to the studio mix and needs access to the images, a file-sharing setup is in order. Whether you use a Mac or a PC,

- Our average portrait job consumes 2.3 GB of storage space (with all files in RAW format). Assuming the same expenses as above with the wedding scenario, it would cost \$2.25 to store the files on a hard drive and DVD.
- Doubling this for a backup hard drive and DVD comes to \$4.50.
- The same job shot on film would cost \$60, assuming only three rolls

So, is it cost effective to factor in \$21.80 for storage of each wedding and \$4.50 for each portrait job? Absolutely. Even if you raised your wedding and portrait package prices by a paltry \$22.00, you'd be covering the cost of double hard drives and DVD media. What are you waiting for?

The benefit of the above system, which entails keeping all jobs permanently on removable hard drives and DVD, plus a backup copy of both, is obvious. Access to images is nearly instant because you simply open the files from the connected hard drive, eliminating the need to retrieve the DVD from storage every time an order comes in.

When a hard drive becomes full, simply remove it from the hot-swap case (see sidebar on page 27) and store it away. Buy a new hard drive and insert it in the case. If images are needed from an old storage drive, the drive is pulled from the cabinet and inserted into the case, a process that takes about thirty seconds. The DVDs are simply kept as long-term backup—they should never need to be accessed, unless both your hard drives fail. It is not uncommon for a hard drive to fail eventually, usually after extended use, so keeping a backup is very important. If a hard drive ever fails, simply replace or repair it and copy the entire contents of your backup drive to the new one. You're back in business.

it is easy to set up your system for file sharing. Once it's done, other computers can connect to them—via an Ethernet or wireless network—and use the files residing on that computer or on any connected hard drive. This allows one main computer to be the "server," and other computers can connect to it and access files on its hard drives. The server can still be used for regular work since the file access happens in the background. Frequent access to the files from other computers will start to slow down

the server slightly, so regular, frequent use of two or more computers may warrant an upgrade.

The Next Stage. When your studio volume increases and you have at least one helper working on images with you, everyone will need fast access to the images, and nobody will want their computer to slow down. It's an ego thing, of course. This is where a true server system comes in. It is essentially the same principle as discussed above, except that a dedicated computer handles the file serving. File-server system software can be installed on the computer to most efficiently handle multiple users. With this, every workstation runs at full speed, and access to the server files is simultaneous and quick.

There is certainly more expense involved in the true server setup: a computer must be dedicated to serving (or an older computer could be used). The server-system software will cost anywhere from \$150.00 to \$500.00, depending on the number of users and the computer platform. The time-saving and efficiency benefits can make it worth it, however, in a busy studio.

If you feel you need a server system, it's best to hire a computer/networking consultant to help you set it up properly. It will be money well spent as there are numerous settings and configurations to consider. Once it's set, however, it should be fairly easy to maintain and will significantly speed up your studio workflow.

■ CATALOGS VS. VIEWERS

Catalogs. A catalog is a standalone file that permanently stores information about your images. Catalogs also display image thumbnails and previews instantly, once the

HOT-SWAP HARD DRIVE SYSTEMS

Hot-swap hard drive systems consist of a power supply case and removable sleeves. The bare hard drive is permanently installed into the inexpensive sleeve, and the resulting unit can be mounted or unmounted in seconds without shutting down the computer. Bare hard drives are much cheaper to purchase than individual external drives. We purchase two matching drives at a time—one main drive and one backup. Go to www.cooldrives.com or www.drobo.com to check out some great hot-swap hard-drive systems.

catalog has been initially built, which is much faster than most types of viewers. It stores the EXIF information (the data about the camera, lens, and exposure settings) as well as any categories, labels, and sets the images have been assigned to in the catalog. Since the catalog only contains thumbnails and low-resolution previews (the original full-sized images remain in their original location on the hard drive or disc), catalogs are relatively small in file size. This catalog file can be saved and stored anywhere, separate from the images if necessary. You can keep catalogs on your computer, and have your original images stored of-fline on CDs, removable hard drives, or other media.

In addition to storing information about and helping you organize your images, some programs, like Adobe Lightroom, have basic image-editing features, allowing for a majority of your image adjustments to be done completely within the program.

Viewers. A viewer only shows a temporary view of images on your hard drive or mounted discs. They also provide information about the images, but when the images are removed from the computer, the viewer is pointed to another folder, or it is closed, the info is gone.

■ ADOBE LIGHTROOM

Pound for pound, many studios, ours included, feel that Adobe Lightroom is the best workflow tool currently available. Lightroom is a great cataloging tool, but it is also designed to be a RAW image processor (it works with JPEG and other file types too). It affords a full range of intuitive image adjustments to allow photographers an all-in-one solution for editing, organizing, adjusting, and final processing of images. In fact, you may not need to open Photoshop very often (okay, I lied—we still love and need Photoshop for our image enhancement and retouching). Lightroom just makes the workflow process much more streamlined and efficient. Photoshop is no longer really necessary for basic color, tone, and sizing operations; it can be saved for artistic enhancements and more complicated retouching.

Features. Lightroom has a plethora of great tools. Here are some of the main features, although we won't be covering all of them in detail. We'll primarily focus on the essential workflow features and image adjustments. It's important to know what's possible, however, if you want to study it further.

Cataloging. Lightroom can build a quick catalog of various image types, and the catalog can be stored on any local or removable hard drive for quick access and storage.

Organizing. Labels and star ratings can be used to organize and edit images quickly. Virtual sets can be created to group images in any number of ways.

Adjusting. Using metadata, Lightroom can adjust images without modifying the original file. All adjustments are stored within Lightroom or in separate XMP files that can also be carried over to Bridge and Photoshop. This is the most efficient and flexible way to adjust images. Lightroom has powerful and intuitive image adjusting tools.

Enhancing. By using presets for adjustments, users can create "looks" that give images a distinctive color palette, contrast range, monochrome conversion, etc. The presets can be applied to any number of other images or exported to other computers.

LIGHTROOM KEYBOARD SHORTCUTS

Here are some essential shortcuts. There are many more, but these are "must knows" for now.

G-Switches to grid view in Library.

D—Switches to Develop mode.

Opt/Alt double-clicking a thumbnail in grid view opens that image in Develop mode. Opt/Alt double-clicking again returns it to grid view.

Tab-Hides side panels. Hit Tab again to restore.

Shift Tab—Hides all panels. Hit Shift-tab again to restore.

Arrow keys-Previous/next image in both modes.

F-Cycles through Window modes.

~—Toggles the flag rating on or off. (Note that this shortcut operates differently in Lightroom version 2 than it did in version 1.)

Space bar—In Library mode, it will cycle fit image, then your favorite zoom level; e.g.1:1 (100 percent). (We'll set these levels later.)

Return—Cycles between grid view, fit image view, and zoom view in sequence.

Z—Zoom to 1:1 in Library or Develop mode. Using the Navigator, position the box where you'd like to view.

Cmd/Ctrl-D-Deselects all images.

Cmd/Ctrl-Shift-D—Deselects all except the current active image (in Library mode only).

Batch Renumbering and Capture-Time Error Correction. Images can easily be renumbered chronologically by the capture time, even when they are located in several different folders. If capture times are inaccurate, Lightroom can quickly adjust an entire series of images at once.

Batch Conversion. RAW images can be converted to standard formats like JPEG, TIFF, or PSD. Batches are quick and work in the background, freeing the user to tend to other tasks.

Web Site Creation. Image galleries for online display can easily be created. Users can modify the layouts and save their own variations.

Slide Shows. Users can show instant, beautiful quality slide shows directly from Lightroom. Layouts can be modified and saved, and shows can also be exported to PDF format.

Printing. Contact sheets can quickly and easily be created for direct printing from Lightroom. Single images can also be printed quickly with intuitive control over various print options.

Branding. Users can customize the look of the Lightroom interface by adding logos or images. This provides a more professional look when the program is used to view and order images with a client.

Know How Lightroom Thinks. When an image is viewed in Lightroom, you are actually looking at a low resolution copy that Lightroom created from the full-sized file. All adjustments are done on this low-resolution copy as well (until the export), so they happen quickly. The fullsized RAW (or other type) file remains in its original location. Lightroom's database, also known as the catalog, maintains a link from the low-resolution version it creates and stores to the original file. It also keeps track of all the image adjustments that are performed in its catalog and/or external files, called XMP files. This is what makes the system so efficient: all adjustments are just instruction sets and can be changed and tweaked at any time. The adjustment instructions are not actually applied to the original image, keeping its integrity intact. Only when an export process is performed, converting the RAW files to something more common, like JPEG, are the adjustments actually applied to the resulting file.

This feature also makes Lightroom effective for offline editing, which means the full-sized images can be on an external hard drive, for example, and the low-resolution catalog can be on a laptop. The catalog can be used to browse the images, organize, edit, and label, even when not connected to the drive with the full-size images. This is handy for those who travel and want to edit while on the road without bringing the large original files along. When the drive with the full-size files is reconnected, the catalog is re-linked to the originals, and all the editing information is synchronized.

Workflow Overview. The following is an overview of the workflow. Details for each step appear later in the chapter. (1) Images will be downloaded directly from the memory card to the client/originals folder on the hard drive. If image numbers overlap, keep them in separate subfolders temporarily. The image numbers will be changed later with Lightroom. (2) Images are imported into a new Lightroom catalog. We recommend that each job has its own separate catalog. You can put all jobs in one giant catalog, but when a catalog becomes very large, it starts to slow down. (3) The images are sorted by capture date and time, renamed in chronological order, and backed up to archival DVD (4). Now the fun part! Edit, edit, edit. Nix the losers, label the winners, apply quick adjustments via presets, and fine-tune exposure and color with Lightroom's tools. (5) After editing, the top images from the session are given the full artistic enhancement

All image adjustment instructions are stored in the XMP file.

Lightroom stores its catalog files in the folder of your choosing.

treatment in Photoshop. These "tweaked" images represent the photographer's creative vision and should illustrate to the client what final image selections will look like when ordered. Tweaking is highly recommended. The ex-

A "tweaked" image before (left) and after (right).

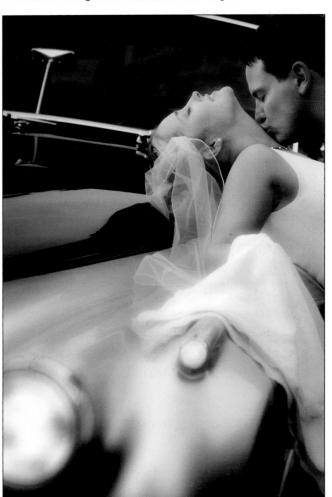

ception may be high-volume school photography, news photography, or other jobs where enhancing images is not practical or desired. On the previous page, you'll find a sample of an image before tweaking and after. Notice the impact of the tweaked image. Often it's not apparent how significantly an image can be improved until it is seen side by side with the original. Techniques for tweaking your images are covered in chapter 9.

Is tweaking worth the effort? Absolutely. When we started tweaking images, we noticed our clients would start to buy many, most, or all of the images we tweaked. By tweaking, you show clients your full artistic vision, which shouldn't end with pressing the shutter button. They appreciate your extra work and suggestions, and the images really sing. Many other photographers have also reported to us the more they tweak, the more they sell.

Setting Up Folders. At our workshops, we witness far too many people wasting valuable time simply trying to remember where they put images on their computers, instead of actually working on them! Set up a well-organized folder system from the start, and use it consistently. You'll thank yourself later.

One time-saving tip that also promotes consistency is to create folder templates in your main image directory or folder that contains all the typical organizational folders you would use for a job. By creating this folder, filled with empty subfolders, and saving it as a template, you can simply duplicate the master folder template and rename it with your client's name and job number when you start a new job. The graphic below shows an example of the folder template structure to use.

Common folders can be set up using an empty folder template that can be copied for each new job.

Use a database program to track all your jobs, search for old jobs by name, add job descriptions, etc. We've created our own software for our customer database and job tracking, and guess what? You can use it too, for free! It's called the KIT E-Studio, and you can download it from

our forum at www.kubotaimagetools.com. For basic file tracking, try CDFinder (CDWinder on the PC), which is a great little program that simply catalogs every file and disc you drop onto the program. It will keep info on the file/disc even if you remove it from your system. See www.cdfinder.de for more info. We use both in our studio as they each have unique and helpful features.

Using the job database is simple: when you return from a job, open the job file and create a new record. It will automatically assign a sequential job number and prefix it with a letter corresponding to the job type, e.g., *W* for weddings, *C* for commercial, etc. Enter the rest of the pertinent job information, especially the notes field, as this information can be searched easily. So, for example, we add the name of the vendors we worked with, the location, the time of year, etc. This way it's quick and easy to find sample images for any marketing or promotional needs of referring vendors.

Workflow Details. Lightroom offers several ways to organize and view your images. You can organize images within a library (catalog) using Collections, Quick Collections, Keywords, Filters, and Metadata. Also, the Folders tab in Lightroom lets you view the images as they are organized in their original folders on the hard drive.

Collections. These are virtual folders that live within Lightroom only. When an image is added to a collection, it is not moved from its original location. Images in a collection are just references to the originals. The same image can be added to any number of different collections, and it is not duplicated each time. Collections can be nested within other collections too, so you could have a parent collection called, "Formals," and subcollections for "Bride and Groom," "Wedding Party," "Family," etc. Think of it as an internal organizational tool while in Lightroom only.

Quick Collection. The same concept as a collection, except this is only one group, without subgroups, and it cannot be renamed. Use it to quickly and temporarily gather a group of images for an export or comparison.

Keywords. These are universal bits of metadata information. Metadata is text that is stored inside the image itself and can be read by many programs that work with digital images, including Photoshop and Bridge. The Keyword Tags are used in a similar way to Collections, but keep in mind that they are actually attached to the images. They are useful for permanently categorizing your images,

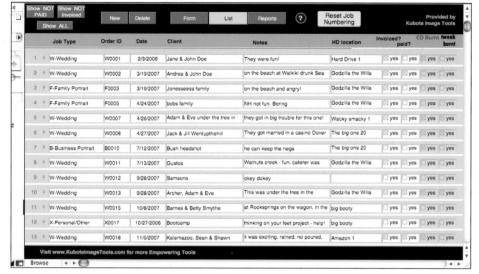

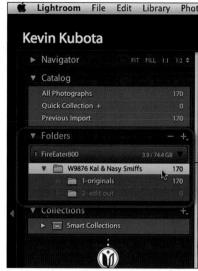

LEFT—This is a sample screen from the KIT E-Studio showing the main list of jobs. RIGHT—The Lightroom folders panel shows the same hierarchy as the original folders on the hard drive.

especially for stock photography. Keywords could be: Nature, People, Travel, Fine Art, Micro Marsupials, etc. Multiple keywords can be assigned to a single image.

Filters. These do not add any information to an image but allow you to selectively hide and show only images meeting a certain filter criteria. Examples would be: all images labeled red, images rated three stars or higher, images with the X flag on them, etc. You can also combine different filters to further narrow the search. When images are hidden using a filter, they are not deleted, only temporarily hidden from view.

Metadata. This is another way to "filter" based on information embedded by the digital camera. For example, I can use the metadata filter to show only images from the Nikon D3 camera, or only images captured at ISO 800 and above. I can, of course, combine these, and any of the other above filter methods, to narrow my search.

Folders. Using this feature, you can view only images that reside within the selected folder, or folders, on the hard drive. Working with folders does affect the original images, however, so if you drag an image from one folder to another in Lightroom, the actual image file will be moved accordingly on the hard drive. All of the other methods mentioned above do not move the original files.

Lightroom has five main views: Library, Develop, Slideshow, Print, and Web. We'll use Library mode and Develop mode for most of the workflow process. Library mode (shortcut: G) is used for browsing the thumbnails, quickly organizing, rating, labeling, and basic image ad-

justments. It is also used for finding images and comparing multiple images side by side. Develop mode (short-cut: D) allows for more control over adjustments, retouching, seeing before/after versions of an image, cropping, viewing the history of adjustments, and multiple versions of the same image. It is also used to visually apply presets.

■ SETTING PREFERENCES IN LIGHTROOM

Before getting started on an actual job, it's necessary to set some preferences and create presets to help automate as much of our work as possible.

To begin, open Lightroom and create a new catalog. If this is the first time you've used Lightroom and you are staring at a full-screen Lightroom window with no images in it, you are looking at a new empty catalog. Whenever you see the navigation bar at top right listing Library, Develop, Slide Show, Print, Web, you are inside a catalog.

If you see the dialog box below, you have the option to open an existing catalog or create a new one. Click on

Create a new catalog for each job.

Name the catalog with a job number prefix and store it in the client's folder.

Create New Catalog and save it with a name like "W0123 Archer catalog." This job number prefix comes from our KIT E-Studio. Save it inside the folder for the client you are working on.

There are two types of preferences: those that are general for all of Lightroom's catalogs, and those that are specific to each individual catalog.

General Preferences. On a Mac, go to Lightroom> Preferences>General. On a PC, go to Edit>Preferences> General. We'll click on each of the tabs in the dialog box and select the preferred settings. If a preference is not covered here, then leave it at the default. We'll only cover those that are important to change or be familiar with.

General

Click on the General tab and set the default catalog field to Load Most Recent Catalog. You can access your catalog-specific preferences from here as well.

Presets

- Turn off Apply Auto Tone Adjustments or Lightroom will modify all your files on import, including finished JPEG, TIFF, or PSD files. We will want to use Auto Tone on our newly imported RAW files, but we'll apply this in a different way later.
- **2.** Keep Apply Auto Grayscale Mix When Converting to Grayscale checked.
- **3.** Uncheck Store Presets with Catalog to avoid confusion. This will keep all presets universal, rather than job specific.

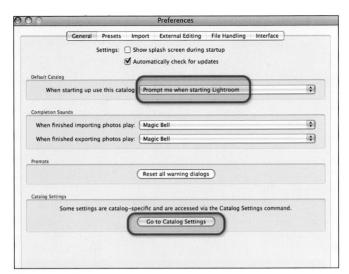

General preferences.

Presets preferences.

Import

We prefer to download images by simple Copy>Paste in the finder or explorer. This is more reliable than using other software to download images. Turn Show Import Dialog off (see facing page, top left image).

External Editing

Under File Format, select TIFF. This produces smaller files than PSD (sometimes over 50 percent) when compression is used. The compression is lossless, meaning it won't degrade the image quality. (Be sure to include LZW compression.) The downside is that the files can take longer to save. You can use PSD format for faster saves. (Note that when you modify a file in Photoshop, and create layers, you need to save the PSD file with Maximize Compatibility turned on to see it in Lightroom. This

Import preferences.

Choose the file format for Lightroom to copy and open an image in Photoshop.

makes the file much larger. By using layered TIFF files, you can preserve all the Photoshop layers but take advantage of LZW compression in your TIFF files, which dramatically reduces the file sizes and still works perfectly in Lightroom.) The choice is yours: do you want to save storage space or time?

We add the letter *T* to the end of the file names for images we've tweaked. This helps us identify them quicker, and is especially important when we receive orders over the Internet. We only see a file name, and if it's a *T* image, we know that it's been retouched and enhanced, and we can simply pull it from the folder of images, convert it to JPEG, and send it to the lab. Here's how it's done:

1. In the Template pull-down menu, select Edit.

- **2.** In the text box of the new dialog box, insert Filename then type the letter *T*.
- **3.** Under the Preset pull-down menu, choose Save Current Settings as New Preset.
- 4. Click Done.

Your new template should now be available in the External Editing preferences.

File Handling

Skip this one. No changes need to be made.

Interface

In the Filmstrip section, it's convenient to show all items in the filmstrip as indicated.

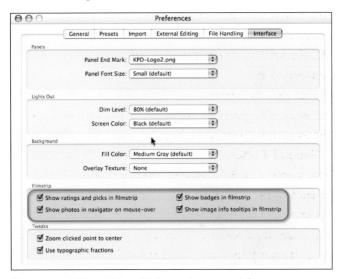

Show the additional bits of information around filmstrip images.

Catalog-Specific Preferences. To access catalog-specific preferences, go to Preferences>General. At the bottom of the dialog box that appears, click the Go To Catalog Settings button. (Note: These are saved with each individual catalog and should be checked each time you create a new catalog.) Select the options outlined below under the following tabs:

File Handling

Lightroom can store three types of image previews: thumbnails, standard previews, and 1:1 full-sized previews. Thumbnails are viewed in the Library mode and in the filmstrip along the bottom of the window. When an image needs to be enlarged to fill the screen, the standard preview is used. If the standard preview is not pre-built, or is

built too small, then it is generated on the fly when an image needs to be enlarged. When the user zooms in to see the image at 1:1, then the full-sized preview is used, or built on the fly. Since few images need to be viewed at 1:1 during the editing process, it makes sense to let Lightroom build these as needed, in order to save loads of storage space.

1. Set your standard preview size. Choose a size appropriate for the size monitor you will be working on. For example, if your monitor displays 1440x900 pixels, then use the larger number for your previews: 1440. If you set your preview size to smaller than what you will typically fill the monitor with, then Lightroom will have to create a new, larger preview

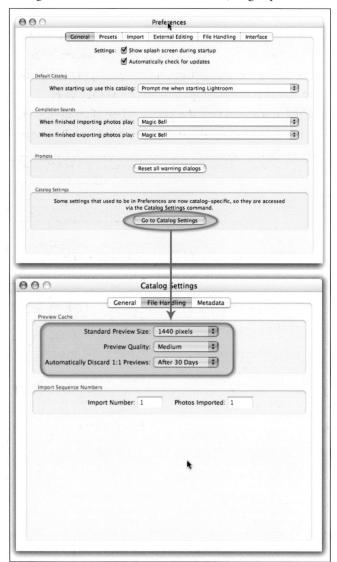

Set the preview sizes for each individual catalog. Match the preview to the size of the monitor you'll work on.

- on the fly when you enlarge an image to fit the screen. This can cause slight delays while editing. You may want to experiment to find the best size for your monitor. You normally shouldn't have to wait more than a few seconds for an image to fit the screen. Note this is different from 1:1 (or 100 percent) view, which always takes a bit longer.
- **2.** Set the preview quality to Medium. This is adequate quality and affords considerable file-size savings.
- **3.** Automatically discard 1:1 previews after thirty days. There's no sense in wasting storage space by keeping these obese previews in the catalog. Let Lightroom get rid of them when you are done working on the job. They can always be rebuilt on the fly if needed.

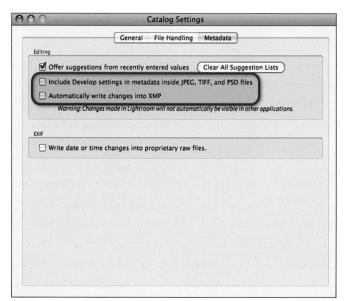

Uncheck Automatically Write Changes to speed up Lightroom's performance.

Metadata

Turn off Automatically Write Changes Into XMP. Keeping it on will slow Lightroom down a bit as you edit. The XMP files are needed to ensure your images look the same on another computer or in Bridge/Photoshop, but we'll generate them manually when editing is complete in Light- room. This will be covered later.

That's all for Preferences. Close the dialog box, please.

■ CREATING REUSABLE ADJUSTMENT PRESETS (AND OTHER TIPS)

You'll need an image in Lightroom to create presets. Import any file for now.

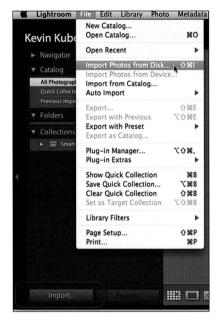

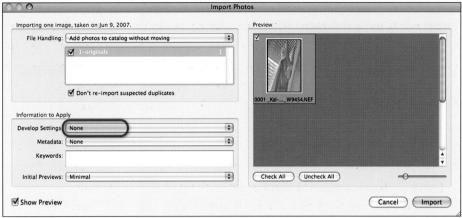

LEFT—Import photos from the menu or the button in Library mode. ABOVE—Import only one photo for the purpose of creating general presets.

- 1. Go to File>Import Photos or click Import while in Library mode. In the Import dialog box, import the photo from the original location, and don't apply any presets.
- **2.** Click Import. Select your image and switch to Develop mode.

Develop-Mode Presets. Presets are combinations of adjustments that can be instantly applied to an image or group of images. It's a tremendous time saver to create presets for common adjustments (e.g., B&W, lighten midtones, vignette, Color Boost, etc.). When you find a combination of settings that you like, name and save them as a preset.

- 1. Working in Develop mode, adjust your image to taste with any of the tools.
- **2.** Right-click on the Presets header and make a new folder. Give it a name.

Create a new folder for your own presets, if desired.

Click "+" to save a preset in your newly named folder. Name the preset.

- **4.** Check off only the settings that were used to create your "look." These checked items will override any existing settings in future images you apply the preset to. Unchecked settings will be left as they were.
- **5.** Click Create to save the preset. (Tip: If you place an asterisk [*] before the file name, that file will appear

	New Develo	p Preset
Preset Name: Folder:	My Groovy B&W	
Auto Settings		
Auto To	ne	Auto Grayscale Mix
Settings		and which is the second second
Fill L Black Brigh Cont	ne Isure Ilight Recovery ight c Clipping Inness rast	▼ Treatment (Grayscale) ▼ Grayscale Mix ▼ Split Toning □ Vignettes □ Lens Correction □ Post-Crop
☐ Tone Cu ☐ Clarity ☐ Sharpeni ☐ Noise Re ☐ Lumi ☐ Colo	ing duction inance	☐ Graduated Filters ☐ Calibration
☐ Chromat	tic Aberration	

Check off only the settings that contribute to the look that you've created.

Via the Preset panel.

at the top of the alphabetized list. All presets will then be accessible from the Presets menu in Develop mode, the Quick Develop panel in Library mode, or through the contextual menu [right-click on a thumbnail] in either mode.)

Custom-Look Presets. It's really cool to be able to create presets for your favorite "looks." We have looks for weddings, commercial shoots, portraits, etc. These presets are applied automatically when a batch of images are imported, saving time and helping to create world peace.

An important setting is Auto Tone. This feature will allow Lightroom to analyze each image individually and apply its ideal tonal adjustment to achieve a full dynamic range. Most of the time, it does an excellent job and gives us a great starting point. You can always override the adjustment for images that it doesn't get just right.

Here's an example of some settings used for a "wedding look" preset we use:

Basic Panel Settings:

Auto Tone: on; Clarity: 14; Vibrance: +23; Saturation: +4

Vignettes Panel Settings:

Post-Crop Vignetting: -57, 61, 0, 57 (The Post-Crop Vignette will recalculate the vignette even after you

Via the Quick Develop panel.

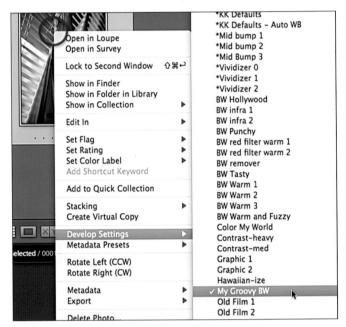

Via the Preset Contextual menu.

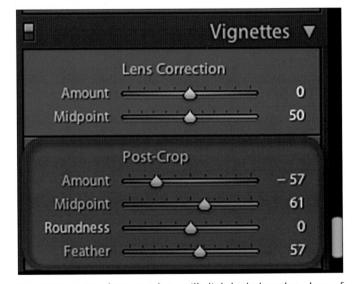

Vignetting using these numbers will slightly darken the edges of the photo. We love this look, and we apply it to every image.

crop an image, whereas the Lens Correction Vignette will not readjust itself. You also have a few more control options with the Post-Crop.)

Note that in the New Develop Preset dialog box, we've selected every option. This is probably the only preset where all options are checked. We do this because this preset can be used to restore all settings to the way they were on import, after experimenting unsuccessfully with other adjustments. By checking on every option, all settings will be restored, giving a clean slate. Just make sure that when you save the preset, all these settings are actually set the way you want them to be for all images.

	New Develop Preset				
Preset Name:	Kevin Wedding Look				
Folder:	Kevin's presets				
Auto Settings					
✓ Auto To	ne				
Settings					
☑ White Balance		▼ Treatment (Color)			
✓ Basic Tone ✓ Exposure ✓ Highlight Recovery ✓ Fill Light ✓ Black Clipping ✓ Brightness ✓ Contrast ✓ Tone Curve		✓ Color ✓ Saturation ✓ Vibrance ✓ Color Adjustments ✓ Split Toning ✓ Vignettes ✓ Lens Correction			
☑ Clarity		✓ Post-Crop✓ Graduated Filters			
 ✓ Sharpening ✓ Noise Reduction ✓ Luminance ✓ Color 		☑ Calibration			
☑ Chroma	tic Aberration				
Check All	Check None	Cancel Create			

Check to ensure that the preset overrides any existing settings.

Here's a preset for a nice black & white conversion. In the HSL/Color/Grayscale panel, select Grayscale. (Because you set your presets preference to Apply Auto Grayscale Mix When Converting to Grayscale, that's what Lightroom will do now.) In the Split Toning panel, adjust the Split Toning to warm up the shadows a bit. Leave the highlights set to 0.

Check to ensure that the preset overrides any existing settings.

New De	evelop Preset	
Preset Name: Groovy Warm	J&W	
Folder: Kevin's prese	ts	
Auto Settings		
☐ Auto Tone	☑ Auto Grayscale Mix	
Settings		
☐ White Balance	✓ Treatment (Grayscale)	
☐ Basic Tone	☑ Grayscale Mix	
☐ Exposure ☐ Highlight Recovery	✓ Split Toning	
Fill Light		
☐ Black Clipping ☐ Brightness	☐ Vignettes ☐ Lens Correction	
Contrast	☐ Post-Crop	
☐ Tone Curve	Graduated Filters	
☐ Clarity	☐ Calibration	
Sharpening		
☐ Noise Reduction		
☐ Luminance ☐ Color		

Save the black & white preset.

Delete the Test Image. You'll want to start with a clean catalog. The image you brought in was just there to enable you to create presets. Remove an image from a catalog by

selecting it and hitting Delete. Click Remove to take it out of the catalog; the original image will not be touched.

Remove the image from the catalog without touching the original file.

■ IMPORTING, RENAMING,

AND BACKING UP IMAGES IN LIGHTROOM

Download and Import. Download your images from your camera's memory card to the Originals folder directly in the Finder or Windows Explorer. It's best to simply Copy>Paste images from card to folder without using any software.

If you have images with overlapping names, download them into separate subfolders within the Originals folder for now. Call the folders "camera 1," "camera 2," etc.

Open Lightroom, and enter the Library mode.

- 1. Click the Import button at the bottom-left corner of the screen.
- 2. Point to your job folder (e.g., "W0123 Smith") and hit Choose. All subfolders that contain images will be included by default.

RENDERING PREVIEWS

When the Initial Previews size is set to standard in the Import dialog box, Lightroom builds nice, color-managed thumbnails right away. It takes slightly longer to see all your images, but they will be color correct and ready for zooming and editing when the import is done.

Without Standard Initial Previews selected, the camera's default thumbnail is used (which normally won't look as good or accurate), and the larger image preview isn't built until you select an image. However, they will import faster, so this may be used to quickly see all images.

You can do the rendering at any time later by selecting the image or images you want to render and choosing Library>Previews>Render Standard-Sized Previews.

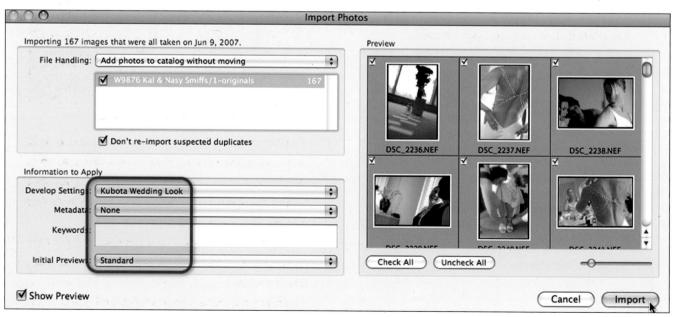

Check the Show Preview button if you don't see the thumbnails in the Import dialog box.

- **3.** Under Develop Settings, select the desired option (e.g., auto tone or wedding look).
- **4.** Add keywords that will help you organize and find images later, if desired. Separate with a comma.
- 5. Under Initial Previews select Standard.
- 6. Click Show Preview to see the thumbnails.
- 7. Hit Import.

Sort by Time. Sorting is important so that the images, even if the numbers are mixed and from different cameras, will still be chronological. Be sure you are viewing all images from the folders again (if subfolders were used). If you do have multiple subfolders, be sure to Shift-click each of the folders to select all the images within multiple fold-

Shift-click to select multiple subfolders for renaming.

Sorting the images by the camera embedded capture time.

ers. Select all images and choose View>Sort>Capture Time. The embedded capture time will be used to sort the images. Of course, if you forgot to synchronize the times on the cameras ahead of time, the images won't be in the correct sequence.

Don't forget to synchronize! Make a label that says, "Time Sync" and attach it to the back of each camera. If you still forgot to time sync, and you are in the middle of a job, take a moment to gather all your cameras around, point them at a strange object that you'll easily identify (like your foot), and fire one shot all at the same time. This gives you a frame to use from each camera to synchronize with later in Lightroom. See the sidebar below ("Time Out!") for how to do it.

TIME OUT!

Did you forget to synchronize the times on multiple cameras prior to the shoot? It's okay—Lightroom to the rescue. After importing, just look for common images (your foot, or maybe "the kiss" at a wedding) shot simultaneously from each camera. These are your reference images.

Make a note of which time, from one of the reference images, is correct. This camera is your master camera. The time the image was taken on this camera is your master reference time. Then, use the Metadata Browser (in Library mode) to select all images from one of the time-incorrect cameras.

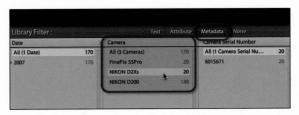

Viewing all images from a specific camera.

Make sure the reference image is still active. With all images from the time-incorrect camera selected, go to Metadata>Edit Capture Time. Use Adjust to a Specified Date and Time and put in the noted master reference time from the master camera.

All other selected images from this time-incorrect camera will be offset by the same amount, not to the exact same time. Cool!

Repeat for any other cameras that are off, if applicable.

Start the Batch Rename Process. You can create reusable templates for different naming schemes. We use the following format:

0001_ClientName_W0123.NEF 0002_ClientName_W0123.NEF 0003_ClientName_W0123.NEF

... and so on. This keeps files organized. Notice that the image sequence number comes first, followed by a name, the common job number, then the file type extension. Here's how to set up the job numbering pattern:

- 1. While still in Library mode, select the images you wish to rename, then go to Library>Rename Photos.
- **2.** Under File Naming, select Edit from the pull-down menu.
- **3.** In the Sequence and Date field, select the sequence # with the appropriate number of digits (e.g., if you have hundreds of images, use #001).
- **4.** Type an underscore or space after the placeholder that appears in the white text box.
- **5.** In the Custom Text section, click the Insert button. A placeholder for modifiable text is added.
- **6.** In the Preset section, choose Save Current Setting as New Preset.
- 7. Name the preset and click Create. Click Done on the template editor.

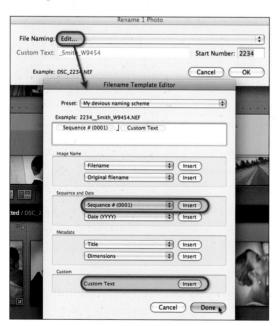

The filename template editor saves your favorite naming schemes.

- **8.** Go to Edit>Rename Photos>File Naming and select the template you just created. Enter your client's name and job number, then a starting number (usually 1).
- 9. Click OK to start the renaming process.

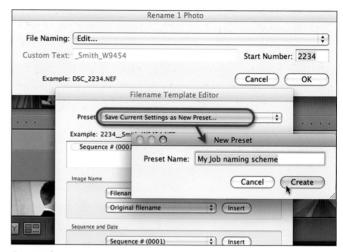

Create the preset.

Consolidate All Images to the Originals Folder. If you had images downloaded to two or more separate folders (because of overlapping names), then it's a good idea to consolidate them all into one main folder.

- **1.** Shift-click to view all the images in subfolders. (*Note:* Folders with numbers next to them contain images).
- **2.** Select all the images (Cmd/Ctrl-A).
- 3. Drag the icons to the Originals folder.

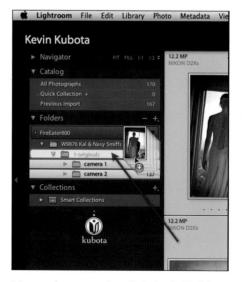

Drag the images out of the subfolders and into the Originals folder.

Next, clean up the Originals Folder. Make sure the old subfolders show "0" indicating that all images were moved out. Select both empty folders (if not still selected from previous step) by Shift-clicking on each. Click the "—" button to delete the folders. Click on the Originals folder to see all your images.

Remove the empty subfolders.

Now would be an excellent time to make sure your images are all backed up to an archival CD or DVD. It is recommended that silver or gold archival discs be used for long-term image storage in excess of one hundred years. That should give you sufficient time to retire and move to the Bahamas. Burn the client's entire master folder to disc.

Here's a shortcut: right-click (Ctrl-click on a Mac without a right-clicker) on the main client folder and select Show in Finder (PC: Show in Explorer). This reveals the folder where you can burn it to CD/DVD with your preferred software.

All sorts of useful tricks live just a right-click away. In this case, right-clicking will locate the client folder on your computer.

■ EDITING AND ORGANIZING IMAGES IN LIGHTROOM

Tag the Rejects. Now that the images are safely backed up, we can edit our collection. The most intuitive way, for many people, is to mark images that should be rejected. By using the technique that follows, images can quickly be marked with an X flag (the pirate flag for those who prefer imaginative analogies, like me). As they are marked, they "walk the plank" or disappear temporarily from view, helping to narrow the selection.

CONTINGUOUS NUMBERS? YOU DECIDE.

In our workflow, we rename and back up our images before beginning to edit out the losers. We do this to ensure we have a thorough backup before messing with the images. The result is that our clients will see gaps in the final numbering. This is not a problem for most people. If you prefer to show images with no gaps in the numbering, then you'll need to edit out the losers prior to renaming.

The downside to this is that, for safety's sake, you should make a backup DVD before even starting to edit. This means you'll have the wrong numbers backed up and will need to burn a new backup when you have edited and given the final numbers. Then, you should toss the old backup as the numbers are all wrong. This requires extra time and DVDs, but it's your choice. We prefer the quick and easy way.

Contiguous numbering of images.

1-originals		0001 _Kal-Nasy-Smith_W9454.NE
2- edit out	-	📕 0002 _Kal-Nasy-Smith_W9454.NE
3-jpg proofs	-	M 0004 _Kal-Nasy-Smith_W9454.NE
4-slide show	-	M 0005 _Kal-Nasy-Smith_W9454.NE
5-print		0008 _Kal-Nasy-Smith_W9454.NE
6-album	-	M 0009 _Kal-Nasy-Smith_W9454.NE
W9876 Kaliffs catalog		0011_Kal-Nasy-Smith_W9454.NE
		0012 _Kal-Nasy-Smith_W9454.NE
		0014_Kal-Nasy-Smith_W9454.RA
		0015 _Kal-Nasy-Smith_W9454.NE
		M 0016 _Kal-Nasy-Smith_W9454.NE
		0017 _Kal-Nasy-Smith_W9454.RA
		0018_Kal-Nasy-Smith_W9454.NE
		0019_Kal-Nasy-Smith_W9454.RA
		0023 _Kal-Nasy-Smith_W9454.NE
		S 0024 Kal-Nasy-Smith_W9454.NE

Non-contiguous numbering of images.

1. Working in Library mode, select an image and type *X* on your keyboard. The pirate flag (a flag with an *X* on it) appears.

2. To hide the rejects as you flag them, go to View> Show Filter Bar and make sure the Attribute bar is

Reject images are tagged for rejection with an X flag.

When the Flagged and Unflagged filters are turned on, the images labeled as rejects will be hidden.

Using the Filter function to show only flagged images.

showing. Turn on the filters for flagged and unflagged by clicking on the white and gray flags. This will show only those images and temporarily hide the rejects.

If you prefer to mark keepers instead of rejects, click on the images you want to pick and type *P*. They will be flagged accordingly with the white flag. When you're done editing, simply turn on the Flagged filter (in the Filter bar). All other images will be hidden from view. This method doesn't allow for narrowing down the selection by hiding the losers as you go, but some people prefer picking favorites over marking losers. Let your inner pirate be your guide.

Review the Outtakes. When the editing process is done, double-check the edit-out images to make sure they really deserve to go. You can review the pirate flagged images by inverting the filters; turn off the white and gray flags, and turn on the black flag. This will now show only the images marked for rejection. If you have cold feet and want to restore a rejected image to the survivor pile, simply type the letter U on your keyboard, which is short for "unflagged." This is the same as marking it neutral, or no flag. It disappears from the current view of rejected images and returns to the keepers. When the final decisions are made, reverse the filter again—deselect the X flag filter and enable the flagged and unflagged filter. Now you

Activate only the X flag to show the images marked for rejection.

have a clean view of all the lucky images that will stay and enjoy the plunder.

Set Up and **Apply Labels.** Colored labels are another of Lightroom's organizational tools. We'll use a yellow label to mark the black & white conversion candidates and a red label to mark the tweaks. We'll add these names to the existing colors.

Change the names as needed. If you use both Light-room and Bridge, use identical names for labels in both programs, otherwise the color will disappear when the image is transferred to the other program.

Assign label names to the colors. Be sure to use the exact same names for the labels in Adobe Bridge if the labels are to be used in both programs.

As you browse through your images, type the number 6 to apply a red label (for tweaks) and 7 to apply a yellow label (images you will quick convert to black & white in Lightroom). Each image can have only one label. A label can be cleared by typing the same number again.

■ ADJUSTING AND ENHANCING IMAGES IN LIGHTROOM

Now that the images are edited and labeled, the next step is to adjust, or color correct, as needed. Not all images will need work, obviously, but you'll find that spending a few seconds on an image can make a marked improvement.

In Lightroom, there are three ways to approach adjusting images. The first is to use the presets you've created, the second is through the quick adjust panel in Library mode, and the third is through the full-control adjustments available in Develop mode. For a typical job, our

Images labeled red and yellow, for tweaking and black & white conversion, respectively.

The shortcut keys show in the Color Label menu.

adjustment workflow goes something like this:

- 1. Import images with the default "look" preset applied. (This uses Auto Tone adjustments.)
- **2.** In Library mode, apply presets for black & white conversion to yellow-labeled images.
- **3.** In Library mode, apply other presets where possible to quickly enhance images.

- **4.** Switch to Develop mode and fine-tune images that need more attention.
- **5.** In Develop mode, apply any cropping or retouching as needed.

At this point, your import has already been done using your favorite "look" preset, which, if you've followed our example, will have Auto Tone already applied to every

Add a preset from the Quick Develop menu.

Right-click a thumbnail to bring up the contextual menu. Delve in to Develop Settings to see a plethora of your handy presets.

image. This is a great starting point, and often there is not much else that needs to be done to the images, other than black & white conversion and/or slight tonal or color balance fine tuning. The next step is to apply adjustment presets as needed.

Applying Presets. Presets can be applied in a few different ways:

- 1. If working in Library mode, simply select one or more thumbnail images, then select the preset from the menu in the Quick Develop panel.
- 2. Presets can also be applied by right-clicking on an image or group of selected images (bringing up the contextual menu), and selecting the preset from under the Develop Settings submenu.
- **3.** Apply presets in Develop mode from the Presets panel. This is where the fun happens! Applying presets here is more visual; you can simply hover your mouse over a preset name to see the effect in the Navigator window. Cool! Click a preset to apply it to the image.

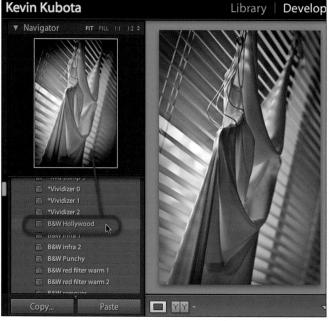

Applying presets in Develop mode is very intuitive because you have a live preview of the effect before you apply it.

Tip: Normally, when you work in Develop mode, you only affect one image at a time, even if multiple thumbnails are selected. To apply the same preset or adjustment to all selected images simultaneously, use the top secret Auto Sync mode. Here's how to activate it. While in Develop mode, select two or more images. Hold down the Cmd/Ctrl key

and the Sync button will change to Auto Sync. Click it once, and it will be locked in Auto Sync mode until you change it back (which can be done the same way you turned it on).

Batch Apply Your B&W Preset. Click on the yellow swatch in the Filters bar to view all the yellow-labeled images. (Use the backslash key [\] to show the Filter bar if it's not visible.) Select All, and apply your favorite black & white preset.

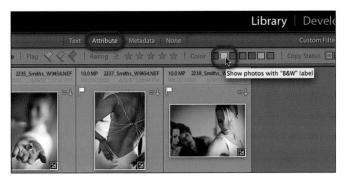

Click the yellow box in the filter bar to show only yellow-labeled images (those marked for black & white conversion).

Apply Presets to Thumbnails. In Library mode, uncheck any colored label filters to see all the images. Your reject images should still be hidden.

You can apply other presets to images to quickly adjust brightness, color saturation, contrast, etc. Get creative when building your presets as they are the quickest way to fine-tune an image or group of images all at once. We've created presets for corrections *and* enhancements. To apply the same preset to multiple images, select the thumbnails first, then apply the preset. Every selected image receives the same adjustment preset.

Quick Correct Images. For images that need basic adjustments that go beyond presets, you can use the Quick Develop panel in Library mode. It seems the adjustments in Quick Develop are just a little too simplified, making them less than intuitive to use. We prefer making such changes in Develop mode.

MORE SHORTCUTS

In Lightroom, and in almost every other application, there are useful shortcuts available via a contextual menu. Simply right-click (or Ctrl-click on a Mac without a right-clicker) on an image, or text buttons, to see what's hiding. You may be surprised at what you discover!

The Quick Develop panel gives simplified adjustment control. Is it too simple?

■ MORE ON DEVELOP MODE

When you want total control over the look of the image, Develop mode comes to the rescue. It offers extensive control over just about every aspect of the image, and the controls are intuitive and easy to use. They are also generally organized in the order that you should approach adjusting your image—starting from the top and working down. Here are the key adjustments, in the order in which they should be approached:

Find a Good White Balance. Often, our camera's white balance setting is just fine, and no further adjustments are necessary, but more often than not there are a handful of images that need some work. Setting the white balance first is important because it can affect other adjustments down the line. We have five choices for setting a white balance: (1) Use the camera's embedded setting; (2) Let Lightroom figure it out with Auto WB (shortcut: Cmd-Shift-U); (3) Use one of the preset temperature options, like daylight, tungsten, etc.; (4) Pick a spot that should be neutral and do a custom white balance. Simply type "W," then click a spot in the image that should be neutral and the white balance is set according to the spot

you used. As with presets, the Navigator shows a preview of what the image will look like when you move the eyedropper over the image; or (5) Manually adjust the color temperature and tint.

All of these tools are accessible in the Library mode, but their use isn't very intuitive. Switch to Develop mode for better control.

Set Exposure and Tonal Range. Though photographers may expect the exposure slider to offer control over the lightness or darkness of an image, like it does in camera, it is best used to control your highlight point. Move

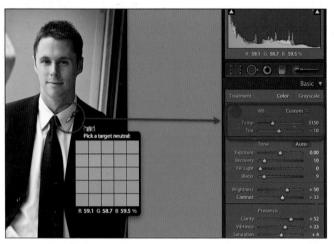

The eyedropper tool allows you to simply click on an area that should be neutral to set the custom white balance.

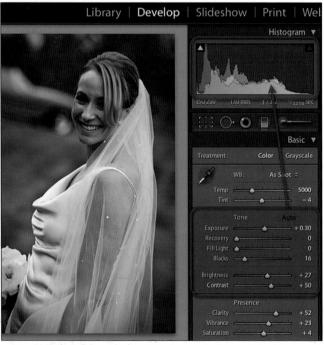

When Auto Tone is used, the exposure, recovery, fill light, blacks, brightness, and contrast are adjusted based on the needs of each image.

the exposure slider so that the right side of the mountain in the histogram just tapers off at the right edge, providing minimal highlight clipping. If the image feels "dark," don't worry, we'll handle that next with brightness slider.

Adjust the brightness to open up, or bring down, the midtones. This affects the overall light or dark feeling of the image. Use the recovery slider to reduce highlight burnout if needed. Finally, use the fill light slider to open up, or brighten, the shadows. The blacks slider will set the black point, to ensure your blacks are black. Auto Tone usually handles this just fine, so it shouldn't have to be adjusted often.

Add Clarity and/or Color Saturation. Finally, you can add some optional enhancement. The Clarity adjustment provides a little localized edge contrast, which is helpful when images have a slightly "hazy" feel to them. We usually move it up to the 16 to 20 range. Vibrance is a great tool that allows for saturation of colors that are already low in saturation. It tends to affect skin tones to a lesser degree, minimizing the overly orange look that can occur in skin when normal saturation is too high. We find a setting in the 20 to 25 range works nicely for most images. It is part of our default "look."

The regular saturation adjustment can also be used to boost the saturation of all colors in the image. Use this judiciously.

Other Adjustments. There are various other adjustments that can be made, and most are self-explanatory. One worthy exception is the Vignette tool. This was designed to fix problem lenses that vignette the edges, but we find it useful as an artistic tool. Dark edge vignetting is a classic photographic technique that draws the viewer's eye to the middle of the photograph. It adds a feeling of depth, through lighting. We apply dark edge vignetting to all our images by default, as part of our custom "look" preset. Use the post-crop vignette if you want the vignette to readjust itself should you crop the image.

Noise reduction, though somewhat subtle in its approach, is useful to minimize noise in higher ISO images. For more powerful control over noise, we prefer dedicated Photoshop plug-ins, like Noise Ninja.

There are also controls for image sharpening, which generally can be left at the default setting. You can use them to do a little presharpening on images destined for Photoshop enhancing, where a final sharpening will be applied before printing. If images are to be printed directly from Lightroom, or exported and printed directly without further work in Photoshop, then a higher sharpening amount may be desired. We suggest making a few test prints from a typical, well-focused image. Print the same image with various sharpness settings to see what you prefer. Image sharpening can be a subjective adjustment as some people prefer their portraits to be less sharp and other types of images to be more sharp. Oversharpening any type of image can make a photo look too "digital," so apply it gingerly.

Intuitive Target Adjusting. For more advanced control over color and tone, Lightroom offers target adjusters. This is one of the most intuitive tools we've seen in any image editing program! Target adjusters are available for five types of adjustments: Tone Curve, Hue, Saturation, Luminance, and Grayscale Mix. The target adjusters allow you to click on an area in the image that represents the color or tone you want to adjust, then click-hold-drag the mouse up or down to raise or lower that value. Easy! Shortcut keys can be used to quickly jump to the target adjuster you want to use. Examples follow.

Tone Target Adjuster (shortcut: Cmd-Opt/Alt-Shift-T). These will turn on the Tone Curve spot adjuster. Simply click in the image where you want to adjust and drag up

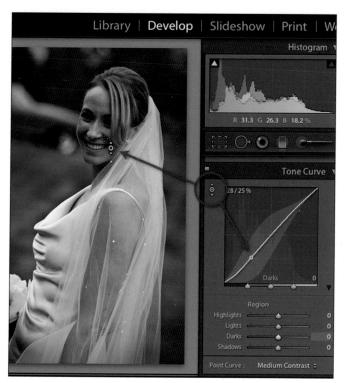

The target adjuster icon.

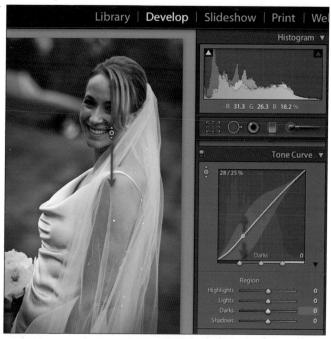

Click-hold and drag mouse up or down. The tone values in the image from the area you clicked will be adjusted.

to lighten/down to darken! All similar tonal values in the image to the spot clicked will be adjusted accordingly.

Luminance Target Adjuster (shortcut: Cmd-Opt/Alt-Shift-L). This will adjust the brightness, or luminance, of the color you clicked on. Great for pseudo fill-flash on skin tones!

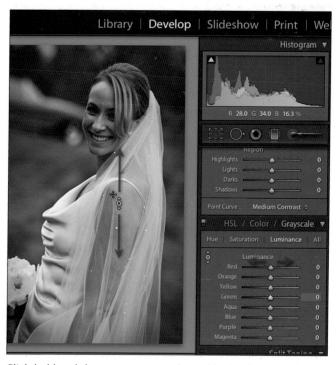

Click-hold and drag mouse up or down. The luminance values in the image from the area you clicked will be adjusted.

Hue Target Adjuster (shortcut: Cmd-Opt/Alt-Shift-H). This will adjust the hue of the color you clicked on. Useful if, for example, you want to warm up skin tones without affecting other colors in the image, or if your subject's wearing a red sweater that you want to be more pink.

Saturation Target Adjuster (shortcut: Cmd-Opt/Alt-Shift-S). Useful to raise or lower the saturation of a specific color. We use this occasionally to make a blue sky more intense or foliage colors more rich.

Grayscale Mix Target Adjuster (shortcut: Cmd-Opt/Alt-Shift-G). This will convert a color image to grayscale while allowing control over the color filtering prior to the conversion. Click on a color in the image and drag up or down. This color in the image will be lightened or darkened in the grayscale conversion! Fun and easy!

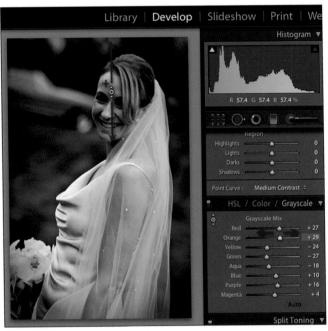

Click-hold and drag the mouse up or down to create the perfect grayscale mix.

Cropping. Cropping in Lightroom is nondestructive; you can change or remove it at any time. Image previews will be updated to reflect the current crop status. Cropping can be applied to one image or many images at one time. In Develop mode, type *R* to jump to crop mode, then drag a freestyle crop around the image or use one of the preset proportions (you can also create and save your own favorite proportions). Keep in mind that these numbers are proportions or ratios only and do not represent actual print sizes. The print size is determined in the Print mode or when the image is exported. You can also crop

Create your own crop ratios.

Start your mouse movement outside the crop area to view the rotate tool. Drag in the direction you wish to rotate.

and straighten in one movement by dragging out your crop box, then moving the mouse outside the crop box and dragging to rotate the image.

■ TWEAK YOUR FAVORITES IN PHOTOSHOP

When your images have been labeled, adjusted, enhanced, and cropped as needed, then it's time for some good ol' fashioned tweaking in Photoshop. Tweaking, if you recall, is the process of applying Photoshop enhancements to your favorite images. This is an important process as it shows the viewer your full artistic vision and helps them imagine what, ideally, the prints they order will look like. Lightroom will allow you to open images directly in Pho-

When you use Edit In Adobe Photoshop CS3, a copy of the image is made and added to Lightroom.

toshop, all the while tracking these images and automatically importing them back into Lightroom when done so they can be paired ("stacked") with the original, nontweaked file. To begin the tweaking process:

- 1. Filter to see all images labeled red (marked to be tweaked).
- 2. Select a group (four to six) of these images and go to Photo>Edit in Adobe Photoshop CS3 (Cmd/Ctrl-E). Work with no more than four to six images at a time to avoid bogging down Photoshop.

Lightroom will make copies of your RAW files in PSD or TIFF format and open them into Photoshop for editing. They will all open at once, where they can be enhanced (hopefully using our award-winning Kubota Photoshop Artistic Actions!). When done enhancing, simply close the image. A dialog box will ask if you want to save the image; just click Yes. It is not necessary to use Save As and specify a location, as Lightroom automatically created a copy of the original file and placed it in the same folder as the original images. The tweaked version will have a .psd or .tif file extension, depending on your preference, clearly separating it from the RAW original.

The tweaked images will also be assigned a special "T" suffix, which we set up earlier in our preferences, so they are further identified as the chosen ones.

Images are "stacked" with the original RAW file, which is a virtual link within Lightroom. Stacks of images can be expanded (so that all the variations are visible) or collapsed (so that only one version is "on top" and visible). This is how we'll ultimately keep our collection, with the tweaked Photoshop version on top of the stack. When an image collection is exported or printed, what you see is what you get, so we only want to see the tweaked version.

When all four to six images have been tweaked and saved, return to Lightroom and collapse the stacks. To quickly collapse the stacks of images, showing only the tweaked version, type the letter *S*, which is short for Stack Images. The original versions will be hidden behind the enhanced images. Now select the next group of four to six images and repeat the process until all of the red-labeled images have been tweaked.

Stacked Images are labeled as 1 of 2, 2 of 2, etc.

Tweak the image in Photoshop using Actions for time savings.

The tweaked version is now stacked with the original.

Clean Up the Originals Folder. When all tweaking is done, it's a good idea to move the outtakes, or losers, into a separate folder on the hard drive. This keeps the originals folder full of only the good stuff. You may eventually want to delete the images in the Edit Out folder to save a significant amount of disk space.

Lightroom can move images across folders on your hard drive, but first the folders must be visible in the folder list in Library mode. By default, the folder list only shows existing folders that had images in them on import. Empty folders like the Edit Out folder that was in the client folder template have to be added manually. To do so:

Simply close the image when done. A dialog box will ask if you want to save it. Click Save.

Typing S will collapse the stacks, as indicated by the icon.

The menu for collapsing stacks.

- 1. View the Folders panel in Library mode.
- 2. Click the "+" button and choose Add Folder.
- 3. Navigate to the client's Edit Out folder and choose it.
- **4.** The empty folder is added to the list in Folders view.

Now that the folder is available, select *only* the images that are marked for rejection by using the X flag filter, turning

off the unflagged and flagged filters so those images remain hidden. Select all the X flag images and drag them to the Edit Out folder. After moving the images, uncheck the X flag filter to return to viewing all the remaining keeper images.

■ FINISHING TOUCHES BEFORE EXPORT

Lightroom has kept track of all the adjustments (cropping, color correction, B&W conversion, etc.) in its internal database. The original images have not been touched (except for the file name change). If the original images were opened in Adobe Bridge or Photoshop, for example, none of the adjustments would be visible and it would look as

Manually add the Edit Out folder to the list of folders in Lightroom.

Filter to show only X flag images, then drag them to the Edit Out folder.

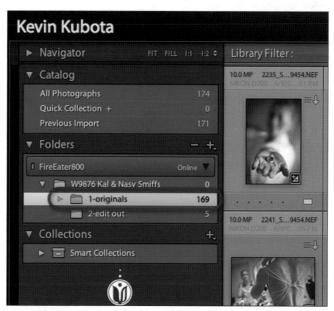

After moving the X flag images, deselect the X flag filter to see all remaining images.

if nothing had been done to them—unless you saved the changes you made in XMP ("sidecar") files. These data files have names matching the original image name and are stored alongside them in the Originals folder. Adobe Bridge and Photoshop can read the XMP information and interpret the image the exact same way that it displayed in Lightroom. To do this, follow these simple steps:

- 1. Select all the images.
- 2. Go to Metadata>Save Metadata to Files.

It's a good idea to use this save process after you've completed any additional adjustments to images as well.

■ BATCH PROCESS OR EXPORT YOUR IMAGES

The final part of the process is to create low-resolution JPEG copies of the images so they can be used in a DVD, web site, proof book, proof prints, etc. Though Lightroom can create a basic slide show with the RAW files, we want the flexibility that some of the other programs provide for creating a dynamic presentation. We also want to create a DVD of images for our clients; this requires images in JPEG format. In addition, Lightroom can print very efficiently directly from the RAW files, but to send images to a lab for printing, we need to export JPEG files.

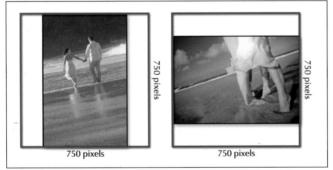

Using a 750x750-pixel bounding area keeps horizontals and verticals the same size.

We are going to export low resolution copies of the images, as higher resolution versions will not be needed until an image order is placed. We want just enough resolution to suit our proofing needs. An ideal target size for screen presentations, web upload, or making a DVD is 750x750 pixels. This means the image will *fit within* an imaginary 750x750 pixel box, not that it will be made square.

Select Images to Batch Process. Turn off all label filters or star filters, then select all your images, and you're

The Export dialog box for proofing.

ready to begin the batch process! Go to File>Export. Choose the settings as shown above. Be sure to use Choose and select the JPEG Proofs folder as the Export Location. (*Note:* You created this folder during the folder template creation.)

Save Your Export Preset. You can save all your settings so you can quickly reuse them the next time you run a batch process. Click on the Add button at the bottom-left corner of the dialog box to create a preset. Just remember to change the export folder location with each new job.

Click the X to abort.

Monitor Your Batch Process. Once you begin the export, a progress bar in the top left of the Lightroom window shows you the status. Click the *X* to abort a batch in progress. You can continue to work on other things while the batch runs in the background. You can even start a second batch at the same time if you really want to.

Additional Export Options. You may choose to have your lab print proofs at the typical 4x6-inch size, in which case it's necessary to export a higher resolution version of the files (though it's still not necessary to use the full resolution images). To create print-ready proof image files, follow the same export process as before, but change the output. To create print-ready files for 4x6 prints, use the settings shown below.

Exporting proof print images.

Alternately, when you need to supply full-resolution images so the lab can output large prints, simply export without any resizing.

Exporting full-sized images for larger prints at the lab.

Preparing Cropped, Up-Sized Images. Many pro labs now will use a web interface order system to allow you to choose your print size and cropping when you upload the files. This is the easiest way to work, as the photographer doesn't need to pre-size or crop images. Multiple sizes, quantities, and cropping can be ordered from the same original file.

Should you need to crop and up-size an image prior to sending it to the lab, however, follow these tips:

- 1. In the Develop mode, select the image and crop if needed (shortcut: R) to the desired proportions. In the following example, we'll use 16x20.
- 2. Choose File>Export.
- 3. Use JPG, Quality 90-100
- **4.** Color Space/Resolution: whatever your lab requests.
- **5.** Resize to the exact size you want the final image to be, whether smaller *or* larger than the original. Be sure to use the same proportions as you set in the crop of step 1. Make sure the Don't Enlarge option is not checked.
- **6.** Export.

Set the crop aspect ratio. Remember, this can be changed at any time.

■ PRESENTATION

Congratulations! You've completed the essential workflow steps and are well on your way to becoming a workflow-a-holic . . . no, wait—that doesn't sound right. You are well on your way to becoming a master of efficiency and have now created hours of freetime for yourself! Now you're ready to make slide shows, proof booklets, web galleries, etc.

Resize the image to the same dimensions as your crop ratio. Make sure Don't Enlarge is not checked.

To create dynamic slide shows, timed perfectly to music, we use our favorite tool, TalaPhoto (downloadable from www.talasoft.com). TalaPhoto can mix music to the images and export beautiful QuickTime format movie (.mov) files. It's fun and easy, and we'll cover the steps required in a later chapter.

To really get your point across in the presentation, a projection system in your studio or a large computer monitor is highly recommended. If your space and budget allow, step up to a projection system, which can quickly and easily pay for itself in added sales. A typical studio can often increase sales enough to pay for a projection system in two to three months. Showing images in a beautiful slide show, large and on the wall, is dramatic and impressive. It not only encourages clients to invest in larger images, it gives your entire presentation, and each image, more impact and importance.

It would be a good idea, after all this hard work, to back up your Lightroom catalog to DVD for safe keeping.

Phew! Did all of that seem confusing? Honestly, it is—at first. Once you've become familiar with the system, however, it can really speed up your workflow. Many photographers are intimidated by all the specific steps when they start out, but patience and practice will pay off. This system has been implemented by photographers all around

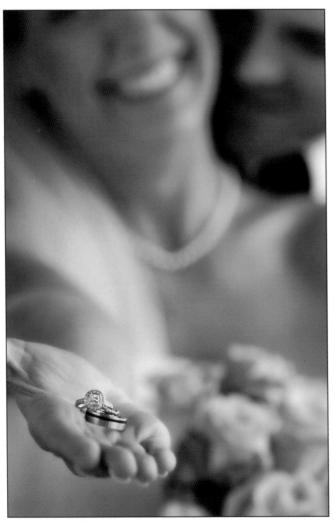

Showing images in a beautiful slide show encourages clients to invest in larger images.

CHEAT SHEET

Here's a step-by-step outline of the stages involved in the workflow system.

- Create a job folder and download images to the Originals folder.
- **2.** Import job folder containing the originals into a new Lightroom catalog. Sort images by capture date.
- **3.** Batch rename using a sequence number/client name/job number format.
- **4.** Back up the folder of originals, and the catalog, to CD/DVD.
- **5.** Mark keeper images with Pick flag or mark loser images with an X.
- **6.** Filter to show only images marked without the X (if you used the X in the previous step).
- 7. Label images that will be converted to black & white.
- **8.** Use presets to quickly adjust images individually and in groups.
- **9.** In Develop mode, fine-tune the images that need more attention.
- **10.** Gather the images to be enhanced and open Photoshop.
- 11. Enhance the selected images using Photoshop actions. Return the files to Lightroom.
- **12.** Gather all images and batch export to low-resolution JPEG files for online and slide show use.
- **13.** Clean up by moving all X images (the losers) to the Edit Out folder.

the world—with tremendous success. When you've gone through the whole process a few times, it starts to become second nature, and you may wonder how you ever lived without it! Nothing worthwhile ever comes easy, right?

6. COLOR MANAGEMENT

Artists can color the sky red because they know it's blue. Those of us who aren't artists must color things the way they really are or people might think we're stupid. —Jules Feiffer

■ COLOR IN THE DIGITAL WORLD

Sometimes dealing with color, at least as our computers see it, can make us feel stupid. But we're not dumb. Computers just deal with color in a different way. They need it to be clearly spelled out, by the numbers, like computers always do. So let's take a minute to look at color from a computer's point of view.

A digital camera cannot capture the entire world of color, which is far greater than our eyes can see. The world of color also cannot be displayed on our monitors nor printed on any paper. In fact, our computers can't even work with the colors we humans can actually see. Com-

puters really are dumber than we are. They have a more limited color palette, so to make them happy we set limits to the range of colors that we will work with. This is known as a color space.

The graphic on the next page shows a comparison between the wide world of color and a color space within it.

■ PIECES OF THE COLOR PUZZLE

In order for color management to be simple, all the pieces must be in place from capture to print. The user must also be consistent in following the steps. With these components in place, predictable color is quite simple—although

Though the image was enhanced slightly with my Landscape Radiance action, the existing color and light were phenomenal.

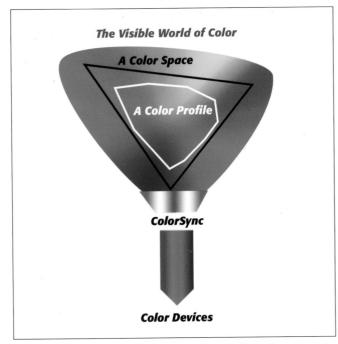

The large color blob represents the world of visible color. The black-lined area represents a standard color space, and the white polygon represents a device's color profile.

grasping the underlying logic may not be. That's okay, though, as it's the end result that photographers really need to focus on.

Here are the components of the color management puzzle:

- Understand your camera's color space.
- Calibrate and profile your display monitor.
- Decide on a Photoshop working color space.

• Obtain and use printer profiles (or, know what standard color space to convert images to for the lab).

It really can be simple, especially as color-management implementation gets more refined and universal. Apple Computer Inc. has made great efforts to simplify the mysteries of color management by integrating it into their system and many Apple applications. It works behind the scenes to make sure what you see is what you get. Even Apple's e-mail program and web browser (Safari) are color managed so that images you view in either program will appear correctly to the viewer (assuming the monitor is profiled and the images contain a color profile).

■ COLOR SPACES

There are really only two color spaces that photographers need to be familiar with: Adobe RGB and sRGB. You've probably heard discussions about both—heated discussions—as every digital professional seems to have an opinion about which is best. Let's take a quick look at each.

Adobe RGB. Adobe RGB is a standard color space that is designed to encompass the full range of colors that professionals will need to work with. It covers the color needs of the CMYK printing press nicely, as well as high-quality photographic printed output. Most professional digital cameras allow the option to capture in Adobe RGB color mode. It is a good choice when the widest gamut of color and saturation is desired or when images will be reproduced in CMYK print.

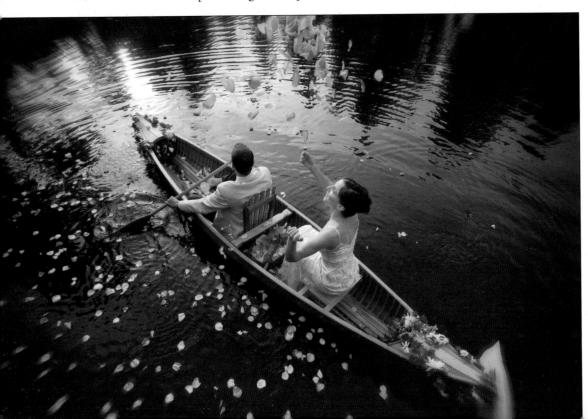

With all of the color management components in place, achieving predictable color is quite simple.

sRGB. sRGB is a color space designed to closely mimic the color capabilities of a typical computer monitor. It is a smaller color space than Adobe RGB and does not quite cover the colors in the CMYK print range. Think of it as the "least common denominator" color space. All consumer digital cameras, and most pro cameras, default to using this color space for capture. The richer, more saturated colors of the Adobe RGB space are not covered in the sRGB color space. In fact, printers like the Fuji Frontier, which are very common in digital labs, are actually capable of more color than the sRGB color space will provide. This is also true of better inkjet printers. Therefore, using an sRGB color space is adequate but may not suit the capabilities of your camera or printers.

Many photographers like to use the sRGB color space, however, because of its universal implementation and "safe" color palette. This is primarily true with portrait photographers, whose subject matter mainly consists of people (skin tones). If portrait images will be passed through Photoshop with little or no corrections involved and printed solely to an sRGB-type printer, then a pure sRGB workflow may be perfectly adequate. It is certainly a little simpler to employ for the beginning digital photographer. The two workflows are outlined below.

sRGB Color Workflow

- 1. Set your camera to sRGB capture mode.
- **2.** Set Photoshop to use sRGB as the working color space.
- **3.** Send images to labs/printers with an sRGB profile attached.

Adobe RGB Color Workflow

- 1. Set your camera to Adobe RGB capture mode.
- **2.** Set Photoshop to use Adobe RGB as the working color space.
- **3.** Send images to labs/printers with Adobe RGB or convert them to sRGB as needed.

Some studios, ours included, advocate a workflow that is based on Adobe RGB. One of the primary reasons we do so is to avoid limiting images to an sRGB space when a multitude of output needs may be filled by the same image. Any given image may be used for magazine printing, high-quality photographic output, medium-quality

photo output, inkjet printing, web use, etc. By using the "highest common denominator," each output receives the best color translation possible from the original image. Here's an example:

In our studio we shoot everything RAW, then convert the printable files to Adobe RGB. Our wedding and portrait images will often be used in magazine ads, brochures, or books—which require CMYK conversion. Adobe RGB provides the best color base here. The same images will also be ordered as loose prints, which we send to a lab that accepts images in the Adobe RGB color space. We can easily "downgrade" the images to the sRGB space, if needed, and send them to a lab that requires sRGB profiles, and they look fine. When we make inkjet prints on our printer, the profile for the inkjet is more closely covered by the Adobe RGB space as well, so we get the most from our images and printer here, too.

The first step is to decide which color space you wish to use and set your camera accordingly.

It is a simple matter to convert images from a larger color space (like Adobe RGB) to a smaller one (like sRGB). No loss of quality occurs (as compared to shooting it in sRGB to begin with). However, converting an sRGB image to Adobe RGB offers no benefits. Moreover, the extended potential color range of the original, if shot in Adobe RGB, will not be realized.

Set Your Camera. The first step is to decide which color space you wish to use and set your camera accordingly. This is only important if you capture in JPEG format. If you capture RAW, the color space can be assigned later in the workflow process upon export of the RAW file to a standard format. Check your camera manual for instructions on how to change the custom settings and choose your color capture space. Some cameras even offer different "flavors" of a color space (e.g., sRGB I, sRGB II, etc.). Consult your manual for the specific uses of each. If the camera has an option for Adobe RGB, it's worth a try (again, assuming you are not capturing RAW). Run some comparison tests on typical subject matter and compare the results. Keep in mind, too, that the lab you use

today may not be your lab of choice tomorrow. Do you want to limit yourself to the least common denominator?

Imagine this: you have all the money you need and you've given more than your share to charity. You live in a city where everyone drives a Honda to scuttle about town. The Hondas are great, efficient, and reliable. You could get a Honda too—or, you could get a Mercedes, which would scuttle about town just as well as the Hondas during the week. The weekend comes, however, and it's time to open it up and go for a long, beautiful drive down empty country roads where there are no speed limits. The Mercedes will really shine here, and you'll be glad you bought it. You have the best of both worlds. Back in our real world of digital capture, it doesn't cost any more to capture in Adobe RGB, but you still have the best of both worlds.

Monitor calibration and profiling is best done with a hardware device, affectionately known as a "spider."

Calibrate and Profile Your Monitor. This is probably one of the most important things you can do to simplify your life, end frustration, and facilitate world peace. Why doesn't everyone profile their monitor? Many people think a monitor is a monitor—which it is. However, every display device, just like every camera and every printer, has a unique way of showing color, and it needs to be profiled in order to show an accurate representation of an image on-screen. Our good buddy color management does all the work behind the scenes, using the image's color profile and your monitor profile to show you accurate color.

Using an unprofiled monitor to judge color in a digital image is like holding a transparency up to Christmas tree lights to evaluate the color quality—you just don't know what you're going to get.

Monitor calibration and profiling is best done with a hardware device, affectionately known as a "spider." ColorVision started the trend with their device, called the Spyder, but several other companies make comparable products. Most will work fine with both CRT (tube type) and LCD monitors—laptops included. Keep in mind that not all laptop screens can be accurately calibrated. Many

have a very narrow viewing angle, meaning the colors and brightness appear to shift when you move your head off center of the screen. Some just don't have the inherent quality to display accurate color—even with calibration and profiling. We have found that most Mac laptops have high-quality screens that respond well to profiling.

Two major companies, X-rite (www.i1color.com) and ColorVision (www.colorvision.com) make popular and affordable hardware devices. Most run between \$200 and \$300, including the necessary software. Using the device and software is easy and takes only about ten minutes. You should plan on recalibrating your monitor monthly, as the color tends to drift and change somewhat over time. The above manufacturers also allow you to use the device and software on all the computers in your studio, so you can create harmony in your little world.

Speaking of LCD monitors, they are highly recommended for professionals for the following reasons:

- 1. High-quality units are stable and color accurate. Colors and brightness drift less over time compared to CRT-type monitors.
- 2. LCD technology is much easier on your eyes for extended use. These monitors do not have a high-frequency flicker like the CRT-type do, and they are sharper, reducing eye strain and possible headaches. How much are your eyes worth?
- **3.** The have no electromagnetic radiation, reducing possible health concerns.
- **4.** They last twice as long and use one-third the energy of a typical CRT monitor, saving money and reducing environmental waste.

Keep in mind that a good-quality LCD monitor is necessary for accurate color work, though inexpensive models can be used for second monitors that will not be used for color correction. An efficient setup is to have one main monitor for viewing images and a second monitor, attached to the same computer as an extended desktop, to put all the palettes or other program windows on. Most current Macs have this ability built in, and PC computers need only to have a second video card installed.

Instead of spending money on a giant monitor, purchase a high-quality, medium-sized monitor and an inexpensive small- to medium-sized monitor for the palettes.

A good-quality LCD monitor is necessary for accurate color work.

This combination yields more screen space than the largest of monitors, yet costs less. It's a very efficient way to work, and you'll easily find yourself spoiled by the breathing room. The dual-monitor setup is also a great way to work if you only have a laptop computer as your main workstation. You can attach a larger display to the computer for the images and use the built-in screen for palettes. Again, Mac PowerBooks have this capability built in, and some PC laptops do as well. Be sure to check your computer's specifications before buying the second monitor.

Here are some resources for high-quality LCD monitors that can be used for photo editing work (all of them can be used with Mac or PC computers):

www.eizo.com—Very high-quality LCD monitors. We use these in our studio. They represent some of the best in the industry.

www.mac.com—Apple monitors are arguably some of the most beautifully designed on the planet. They also work with PCs. We also use these in our studio. **www.lacie.com**—Known for their high-quality graphics products.

These manufacturers often sell a companion hardware calibration device that is tuned to work best with their displays. If you don't already own a monitor calibrator, this would be a good time to get one.

Decide on a Photoshop Working Color Space. Similar to choosing your camera working space, you'll need to decide what color settings to use in Photoshop. By doing this, you set up predefined limits to the colors you'll be working with. Chapter 6 details setting up the Photoshop working color space.

Printing from Photoshop. A calibrated monitor does not, in itself, guarantee every print will match your original image on screen. Calibration does, however, allow Photoshop to display colors accurately so you can see a true representation of your photo in Photoshop. By using the Soft Proofing feature, described in the following section, Photoshop can provide a simulation of what your

Each printer has different capabilities and characteristics. Not all will be able to print the exact same color range.

particular printer will create from that image. In other words, sometimes your printer simply cannot match the colors of your original image exactly, but with a calibrated monitor and the Soft Proofing feature, you can at least see what you will get before printing.

Each printer has different capabilities and characteristics. Not all will be able to print the exact same color range. Therefore, certain printers may be preferred for different projects and color ranges. "Soft proofing" means that you can see on screen, with a profiled monitor and printer, what a particular printer can do. So, though we cannot make every printer do our bidding, we can at least know what they will do.

The first ingredient you need is a color profile for your printer. You can use the factory-installed profiles or have

a custom one made. The actual profile is a small file with an extension of either .icc or .icm. They must be installed in the correct place in your system before they are available to Photoshop. Here's where to install them on your computer:

Mac OS X—System Drive>Library>ColorSync>Profiles
Windows XP—right-click on the profile and select Install Profile

With the profiles properly installed, you are ready to soft proof in Photoshop. Follow these steps:

- With an image open, go to View>Proof Setup> Custom.
- 2. In the dialog box, open the Profile list and find the profile for the printer/paper combination you want to use. Set the other options as shown.

The Intent describes how colors are translated from one color space to another (e.g., from your working space to the printer profile). The two Intent options that are most suitable to photographic images are Perceptual and Relative Colorimetric. Perceptual is better suited to photographs and will generally give only a slight visual shift in colors—if any. We usually use Perceptual, but it is okay to try both to see which is more pleasing to you. You'll see the differences, if any, on screen immediately if you have the Preview option checked.

When you print your file, or send it to a lab, make sure to use the same Intent in the print dialog box or the Convert to Profile dialog box. Both of these are discussed later.

- 3. With the Preview option selected, you should now see an on-screen simulation of your printed output. How does it look? It's a good idea to save proof setups for your common printer/paper combinations so you can access them quickly from the bottom of the Proof Setup list. Click OK.
- **4.** Your window is now in active Preview mode. (You can always check this by going to View and verifying that Proof Colors is checked.)
- **5.** If you don't like the way your image looks, you can alter it using any of your adjustment layers.

Keep in mind that the Proof Colors option will only be active for the current window. If you open another image and want to proof it, you'll need to turn it on again.

Now it's time to print this image. Use Photoshop's Print with Preview option from the File menu. In the dialog box, select your printer profile again in the Print Space: Profile section. Make sure that Perceptual (or the intent you soft-proofed the image with) and Black Point Compensation are also selected. Click Print.

In the Print dialog box you have options for the quality, paper choice, etc. When using a color profile, it's necessary to use the same settings that were used to make the profile originally. If this is a custom profile for your printer, then the service that made the profile will supply specific settings to use. If using factory inkjet printer profiles, choose the matching paper and be sure to turn off any additional print-driver adjustments, as shown below:

If your monitor is profiled and you have used goodquality printer profiles, then your on-screen proof should match your printout quite nicely. If it is significantly different, then go through this checklist to see if you've missed anything:

- 1. Monitor profiled.
- **2.** Accurate printer profile installed in system.
- **3.** Printer/paper profile selected in Photoshop's Print with Preview dialog box.
- **4.** Matching paper for profile selected in Print Driver dialog box.
- **5.** All auto corrections turned off in Print Driver dialog box.
- **6.** Print is being compared to proof view, not normal image on screen.
- 7. Print wasn't made on the backside of the paper. (Don't laugh, I've done this.)
- 8. Computer and printer both turned on. (ha, ha)

If all the steps seem to have been followed, but still the print doesn't closely match the screen proof view, then it's likely the printer profile in use is not very good. It may be time to invest in a custom-made profile. Unless you need to make many profiles for different printer/paper combinations, you'd be better off paying for good profiles one at a time. It's possible to buy the hardware packages to make your own custom-color profiles, but they are ex-

pensive and time consuming to use. Save your sanity and let the profiling services do it for you. The process is simple with most companies: you download a target file from their web site, print it according to their instructions, then send the printout to them via mail for scanning and profiling. Within a day or two they will e-mail you the custom profile with instructions for use.

Here are a couple resources for custom printer profiles:

www.Drycreekphoto.com—\$50 per profile. Moneyback guarantee.

www.Chromix.com—\$100 per profile. Money-back guarantee. Great resource for monitors and display calibrators.

Most printers come with factory profiles in the box. However, their quality can vary. They are usually acceptable, and better than no profile, but a custom profile will squeeze every bit of color-matching accuracy out of your printer as possible. Printing doesn't have to be complicated or time consuming. Be consistent and follow the steps, and you should never again have to scream, "All I want to do is print a picture!"

7. PHOTOSHOP ESSENTIALS

The negative is comparable to the composer's score and the print to its performance. Each performance differs in subtle ways. —*Ansel Adams*

he darkroom, as many of us knew it, has forever changed. The smell of developer has been replaced by the smell of leather office chairs and aromatherapy candles. Hallucinating under extended periods of red-light cave dwelling has been replaced with an electronic hum and an iTunes visualizer screen. Instead of backaches from standing, we get backaches from sitting. Yes, everything is really the same, but it's also completely different. Having worked on images both in the dark and via LCD illumination for many years, I have to say I like the new digital darkroom a lot better. I still disappear into my cave, but at least now I don't have to freak out when my kids open the door unexpectedly.

Photoshop is as much an artist's tool as is the camera. Just as film photographers would seek out the best dark-room artists to reproduce their work, digital photogra-

phers can apply artistic enhancements to their own work. I like the epigraph from Ansel Adams because it bridges traditional thinking and artistic thinking. Most people think of Ansel Adams as one of the finest and most influential "traditional" photographers of our time. Yet traditionalists often frown upon any sort of "manipulation" to photographic images.

What many photographers may not realize is that Ansel Adams and most other famous photographic artists spent hours in the darkroom manipulating their photographs! Every time a photographer puts a filter in front of her lens or changes film stock, she is essentially manipulating a scene or photograph. Anything done prior to capture or in the darkroom to achieve the artistic vision was fair game, yet Photoshop manipulation is considered "cheating." Why? Maybe because it is easy. It takes the creative power

Good images must be made in capture and enhanced in Photoshop.

away from the "elite" who invested the time, space, and money into a darkroom setup—who studied, and often learned via trial and error, the "dark art" of printing their own images.

Let's face it: Photoshop is really fun. And it's not that hard to learn. In fact, in a single day it's possible to learn some essential imaging techniques that would take weeks or months to master in the old darkroom. Moreover, the pressure is now upon photographers to produce better work to begin with. Fancy Photoshop tricks don't impress much anymore. Good images must be made in capture and enhanced in Photoshop. Everyone is expected to be able to produce good clean work, at the very least.

In this chapter, we'll take an extensive look at some essential Photoshop techniques. If you want simply to finetune an image for best output, you'll find the required techniques here. When it's necessary to correct problems in images, retouch, reshape, or remove—then the Photoshop Corrective chapter is the place to go. When it's time to add an artistic touch to an image, to really customize it, then the Photoshop Enhancing chapter will give you some great ideas and techniques.

■ THE BASICS

Though this chapter is not a "Photoshop 101" type of instructional (it assumes some knowledge of Photoshop CS or newer), it is broken down into simple-to-follow steps. Don't be deceived by the simplicity of these techniques. They are critical building blocks to outputting the perfect image. Many books have been written on the use of Photoshop, but not many get straight to the point: "this is what you need to do every day, in a busy photography studio, to make your images look great."

Before diving into the well of knowledge with Photoshop, please copy down the following points and pin the paper up above your computer:

- The temptation to wander is great. I will focus on day-to-day necessities—efficiency and production yet allow the right brain equal satisfaction.
- I am a digital photographer; therefore, I have more options available than any film photographer. I will exercise them.
- I will not be a slacker and let the open door to creative opportunities slam on my foot.

Setting Up for Success. Photoshop has preferences that should be tweaked a little. Here are some settings that should be changed from their defaults, and an explanation of each. It is not a complete run-down of every option—just the settings that will make the most difference for the workflow and techniques used on a daily basis. If a preference is not discussed, then it can be assumed that it is left at the default. The techniques throughout this book are illustrated with Photoshop CS3, but they will be very similar, and equally applicable, with future versions of Photoshop as well.

Go to Edit>Color Settings and change the Settings menu to North American Prepress 2. Click on More Options if you don't see all these options. Though this preset is designed for prepress, it works perfectly for photographic print output too. The main feature we want to see here is our working color space changed to Adobe RGB.

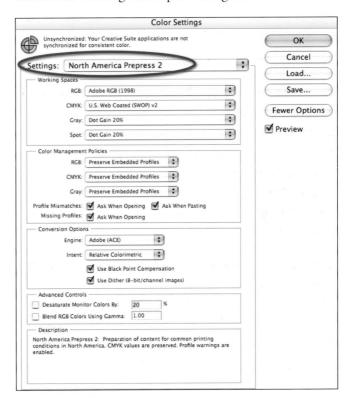

Change the default color settings.

Open Photoshop>Preferences>General.

- 1. Turn on the History Log.
- 2. Save to Metadata.
- 3. Edit Log Items: Detailed.

The History Log is a useful feature that will make a note of everything you do to an image in a simple text file in the

image's metadata. This can be very useful, for instance, if you pull up an image at a later point and can't remember what you did to achieve that look. The History Log will tell you every step, what actions were used, what adjustment settings were used, when it was saved, etc. Pretty much everything. Big brother is watching you now!

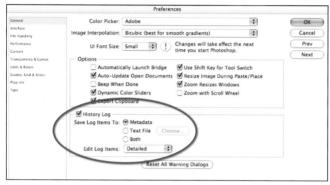

Turn on the History Log and all your work is remembered.

To view the actual history information in the image later on, go to File>File Info, then look under the History section.

More information and fun than should be humanly possible!

Set the brush and cursor styles.

Go to Photoshop>Preferences>Cursors.

- 1. Painting Cursors: Normal Brush Tip. Show Crosshair.
- **2.** Other Cursors: Precise. This will give an exact-point crosshair instead of a picture of the tool, which is rather useless for precise work.
- 3. Click OK.

In the tool bar, there are a couple of settings that should be changed as well:

- 1. Double-click on the circle to open the Quick Mask options. Change the opacity to 100 percent and the Color Indicates option to Selected Area. This is helpful when you use a Quick Mask (a.k.a. the Red Blob) mode to see an actual feathered selection area. This will be covered in
 - more detail later. Be sure to return the icon to Normal Mode (not red) after closing the dialog box.
- 2. Click on the Eyedropper and change the Sample Size to 31x31 Average instead of Point Sample. This gives a more realistic

The Quick Mask icon.

Set the Eyedropper sample size so that it averages similar pixels.

representation of an area of color as it is seen by the eye.

■ WORKING EFFICIENTLY IN PHOTOSHOP

Once you start getting a grasp on all the amazing things you can do with Photoshop, you may actually enjoy working on the computer. However, it's still a good idea to make your time spent as efficient as possible. After all, time is money. Here are a few ways to work faster:

Learn and Use Keyboard Shortcuts. By taking the time to remember a few key combinations, you can greatly reduce time and energy spent mousing around and digging through layers of menus. Here are the most essential keyboard shortcuts from Photoshop's built-in set. Try to memorize these, at the very least, and your productivity will go up by 68.23 percent!

Space bar—produces the Hand tool, which allows you to move the zoomed-in image around in the window for close inspection of various image areas

Cmd/Ctrl+space bar—Zoom In tool (click with mouse to zoom)

Cmd/Ctrl+Opt/Alt+space bar—Zoom Out tool
Cmd/Ctrl+O—fit entire image on your screen
Cmd/Ctrl+Opt/Alt+O—see actual pixels or 100 percent
view

D—reset default colors (black foreground, white background)

X—switch foreground and background colors Opt/Alt+Del—fill with foreground color Cmd/Ctrl+Del—fill with background color

[or]—each press reduces or enlarges the current brush size (up to four steps total)

Shift+[or]—each press softens or hardens the brush edge (up to four steps total)

Cmd/Ctrl+Z—undo your last step

Cmd/Ctrl+Opt/Alt+Z—move back through your History states one step at a time. Multiple undo.

If some of your commonly used menu items don't have keyboard shortcuts, go to Edit>Keyboard Shortcuts and you'll see a list of every available menu item. Assign your favorite menu item a unique key combination. You can then print out a summary of all your shortcuts with the Summarize button. Almost anything can be given a shortcut! Choose your own key combinations to use with: make new Levels adjustment layer; make new Curves adjustment layer; Unsharp Mask; Gaussian Blur; and New Layer Mask

Assigning keyboard shortcuts can streamline your workflow.

Add Function Keys to Your Favorite Actions. Double-click just to the right of the action name to bring up

the options box. Add a Function key combo here. Then, on the keyboard, tape a hint tab with the name of the action to help you remember.

Use a Programmable Mouse or Wacom Tablet. You can customize them to play your shortcuts or actions by clicking certain buttons on the tool.

Use a Larger Monitor. Although not a free option, using a larger monitor, or ideally adding a second monitor, can really boost your efficiency as well. Much time is saved when it's not necessary to scroll around in a large image.

■ THE PHOTOSHOP WORKFLOW

As in life, Photoshop has what's known as the Path of Least Resistance. This is the sequence of steps that should generally be followed when working on an image. Following this sequence will help preserve image quality and minimize corrections—and stress.

- 1. Tonal correction.
- 2. Color correction.
- 3. Retouch.
- 4. Enhance.
- **5.** Save a master file.
- **6.** Size/crop for intended output.
- 7. Sharpen.
- **8.** Resave a copy for output.

Often the first two steps can be combined into one. For example, a Levels adjustment layer may be used to inspect and adjust the histogram to create the perfect tonal range. In the same dialog box, the white balance can be done using our "Single-Sample Neutralizer" technique shown later in the chapter. If both will be done together, it is easier to do the white balance first, then adjust the tonal range in the same dialog box. It is possible to use either a Levels or Curves adjustment layer for this purpose. Both will be discussed later. Also, if you are using a program like Lightroom for your workflow, the tone and color correction will already have been done, and all that's left for Photoshop is the interesting stuff—starting with retouching.

Once a photo is looking good as a "straight" image, meaning that it is "correct" and technically ready for print, it's time to start looking at ways to improve it. This is where the retouching and enhancing come in. It's best to have a clean image before adding the spice.

Retouching could simply mean blemish removal, stray hair trimming, removing distracting objects (like the mother-in-law), or more complex things like cloning and head swapping. These techniques will be covered in chapter 8.

Enhancing is where creativity takes over. The image can be made black & white or handcolored, digital fill-flash can be applied, the image can be softened, etc.

After all the main image work is done, a master file should be saved in the PSD format with all adjustment layers intact. This will give you a starting point for any sized image that needs to be made in the future. Notice that cropping, sizing, and sharpening the image have not been done yet.

When a file is needed for printing—either at an outside lab or on an in-house inkjet—the master PSD file can be opened and sized appropriately. Sharpening should then be applied. The resulting file can be printed directly or saved in the lab's preferred format.

This is a brief and simplified view of the process, and each part will be covered in more detail later. Let's start with some essential Photoshop concepts and image basics.

■ 8 BITS VS. 16 BITS

In Photoshop, the user has the option to work in 8-bit or 16-bit mode. As of Photoshop version CS, users can also

maintain layers and still work in 16-bit mode, a feat that was not possible in versions 7 and earlier. This feature is a key component to a simple imaging technique we developed that can be integrated into your daily routine. The technique is called "8-16-8." Before delving into this, it's important to have a basic understanding of what bit depth means.

In 8-bit mode, Photoshop has 16.7 million colors at its disposal. This may seem like more than enough, but really it is just barely enough. Occasionally, when major color corrections or enhancements are done—including techniques like vignetting—an image can show signs of posterization. This monster rears its ugly head in the form of "stair steps" where smooth transitions of color should normally be. For example, imagine a rich blue or amber sky that is lighter at the horizon and graduates to a darker shade at the edges of the photo (see below).

The posterization happens here because in 8-bit mode, there really aren't enough shades of the particular color to allow for a seamless transition. This is especially obvious after an already graduated sky is enhanced with a vignette.

Now, take this same image in 16-bit mode (RAW camera images are captured in 12 bits or 14 bits, which translates into Photoshop's 16-bit mode): there is now more than enough color to fill in the gaps and eliminate posterization. Even if the final image must be converted down to

8 bits in order to send to your lab or printer, the best 8-bit color palette can be created from the 16-bit data.

What if you shot the original image as an 8-bit JPEG file? Is all hope lost? No. Actually, we can reap some of the benefits of a 16-bit workflow even if starting with an 8-bit original. In the case of an original 8-bit file, we can apply our corrections while in 16-bit mode, and Photoshop will have the extra colors available to fill in any potential gaps in the color gamut with the best-possible 8-bit palette. Here are the simple steps to take advantage of the "8-16-8" concept:

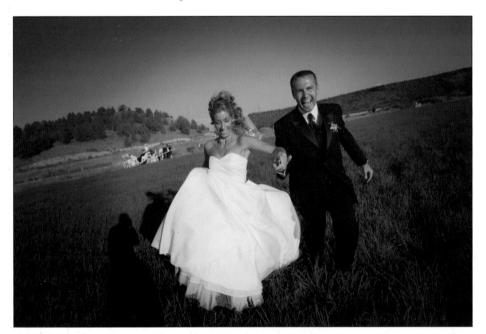

The full 8-bit JPEG image. (*Note:* Posterization is more apparent in high-quality photographic prints than in offset press production [like the images in this book], which tends to camouflage it somewhat.)

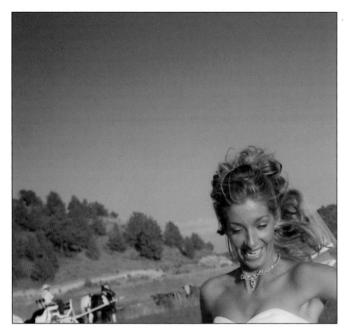

Normal 8-bit image.

- 1. Work on your image as normal in 8-bit mode by using adjustment layers for tone and color corrections as well as any enhancements.
- 2. Save the master image as normal.
- 3. When it's time to print or send a copy of the file to your lab, convert the image to 16-bit (Image>Mode>16 bit).
- 4. Flatten the image.
- **5.** Convert the image back to 8-bit mode (Image>Mode>8 bit).
- 6. The resulting 8-bit file should now show improved gradations and a full histogram, sans gaps.

The image crops above show the difference between the traditional 8-bit workflow and the improved "8-16-8" workflow. The left image was done purely in 8 bits, while the right image used "8-16-8." Both started as an 8-bit JPEG file. Look particularly at the graduated area of the sky where posterization is obvious in the 8-bit version.

The following are the final histograms for each image. Notice that the gaps in the histogram, indicating missing information, are gone in the "8-16-8" version.

Using adjustment layers is key to this technique. With them, the image can be worked as normal in 8-bit mode and doesn't actually need to be converted to 16 bits until print time. Why? Because an adjustment layer simply shows a simulation of what will happen to the image when

Image using the 8-16-8 technique.

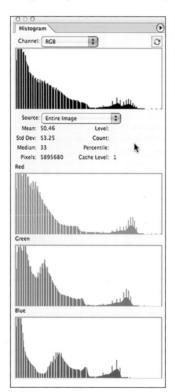

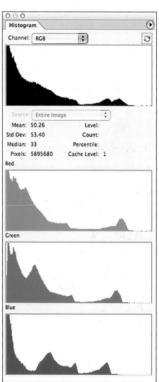

The 8-bit histogram vs. the "8-16-8" method histogram.

it is flattened or saved in a flat format. When you move the image into 16-bit mode and flatten it, this is when the adjustments are applied to the image data—for good.

The "8-16-8" technique can easily be made an action, which can then be assigned to a function key. From then on, it's a simple matter of pushing the appropriate key and waiting five seconds or so for it to complete the steps. It

can easily be the last step before sending off any image for print.

■ EVALUATING OVERALL IMAGE OUALITY

You open an image in Photoshop—then what? The first step is to go to Image>Adjustments>Levels and peek at the histogram. The image may be a little low in contrast (especially if you shoot in low-contrast mode as recommended). You may also notice right away that the color is off a bit—perhaps too warm or too blue, indicative of an improper white-balance setting in camera. Both problems can be addressed using Levels or Curves, if you prefer.

The Histogram. Photoshop CS (and newer editions) has a helpful feature known as the Histogram floating palette. To access it, go to Window>Histogram. As with the other floating and dock-able palettes, it can be visible all the time and will update whenever an adjustment is made to an image. This can come in handy when working

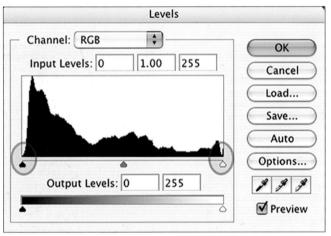

A picture perfect histogram with image information completely within the range of black to white.

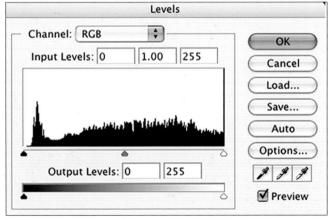

An overexposed image has mountains of information running off the right side of the scale.

with adjustment features like Curves, which do not show a live histogram.

The histogram is basically a type of graph indicating where the tones in your image lie in relation to the pure black and pure white points. The left side of the histogram represents pure black, the right side pure white. The higher the black hump in the middle (a.k.a. the mountain), the more pixels in the image that are in that tonal range. For example, a low-key image with a lot of shadow information will have a large hump on the left side of the scale. In contrast, a high-key image with very few dark tones will have a hump toward the right end of the scale.

A "good" image will have all its mountainous regions within the confines of the left and right edges, with data that starts and ends right at the corners of the scale.

The key thing to look for, which may indicate problems with the image exposure, is a mountain that runs off the left or the right edge. Mountains running off the left edge indicate underexposure, and those that run off the right edge indicate overexposure. Keep in mind, however, that some images have highlights that simply must be overexposed to maintain important detail in other areas of the image. An example of this would be a photo of a person backlit by a bright-white sky. Without fill lighting, the exposure must favor the subject, and the sky will naturally blow out. In this case, the histogram will have mountains running off the right edge of the scale, but this is really unavoidable.

Generally it's best to see most, if not all, of the mountains within the histogram. When shooting with a low-contrast camera setting, it is not uncommon to see a histogram where the mountains are within the range but don't quite reach to the corners—and it's really just fine. It is a simple matter to extend that tonal range and increase the contrast to a pleasing level. The opposite is not true, however. If the mountains extend past the edges, indicating detail has been lost, there is no way to recover that detail information, other than re-shooting the image.

Set the Tonal Range. Now that you have an idea of what a good histogram should look like, it's time to tune the low-contrast image to give it the snap it needs. This is known as "matching the mountains" and simply involves pulling your black- and white-point sliders in to the scale and matching them to where the mountain starts and ends. Of course, it makes sense to use your judgment and

visual preference as well. You may like the image's low contrast, and you're the boss. Here's how to "match the mountains."

1. Open a Levels adjustment layer.

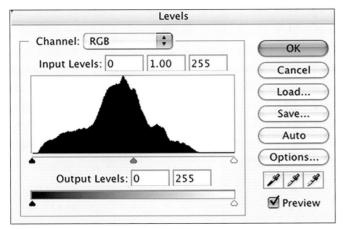

A low-contrast image histogram with mountains that need to be matched.

The low-contrast histogram with mountains matched. Black and white points are pulled in to the bases of the mountain.

Holding the Opt/Alt key down while sliding the white point slider will show image areas that are affected by clipping.

- 2. Drag the white-point slider to the right edge of the mountain. When you place the slider, any image information to the right of it will be pushed to pure white with no detail. If there is an area that looks like a flat line extending toward the right from the base of the mountain, this represents specular highlights. These are normal, and it's okay for some data to fall in the pure-white range.
- 3. Drag the black-point slider to the left edge of the mountain. Generally, it's best not to have information on the left side of the black triangle, as this indicates a pure black with no detail. Featureless black areas in an image are generally more objectionable than specular highlights, which are often expected and acceptable.

Here's a trick to help see how far to pull those triangles in. With the Levels dialog box open, hold down the Opt/Alt key and drag the white triangle in toward the left. The image area will go black, and as you near the mountainous region it will reveal a bright color. This is the color chan-

Original image.

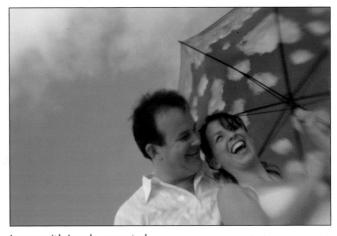

Image with Levels corrected.

nel information that will get "clipped," or pushed off the scale, if the slider is released there. Back off a bit so that just a hint of color shows. These areas will be your brightest spots in the image. If large areas of color appear, then releasing the slider there will wash out the highlight detail. The same works on the black end of the scale, except that the screen will turn white, and dark areas will appear to indicate the clipped areas.

If the image feels a little dark in the midtones but the contrast range looks correct, then sliding the midtone (gray) slider to the left will open up the midtones and give an overall brightening effect to the image, without washing out the dark and light areas. With this accomplished, click OK and rest assured you have a nice tonal range.

Set the White Balance. If everyone remembered to make a custom white-balance setting in their camera prior to shooting, this step would not be necessary. However, the truth is that everyone forgets—or should we say the camera forgets? In fact, many images that initially look quite good may look even better when a white balance is done. The following technique simply and accurately neutralizes any color cast brought about by an inaccurate white-balance setting. It is called the "Single-Sample Neutralizer."

Keep in mind that this works great for images that are slightly off and works fairly well for many images that are grossly off (like an outdoor shot done with a tungsten white-balance setting). However, it is not a replacement for proper white balance in camera! Images corrected with this or any other technique will never look as bright, clean, and color accurate as those captured with a proper white balance. Photos needing significant adjustment with this technique may also benefit from some Color Balance adjustments. This will be described in the next section.

If an image will need both a color balance and tonal adjustment, it's easiest to do this technique first. Then apply tonal corrections with matching mountains.

The first step is to identify an area or object in your image that should be neutral. Areas like a bride's white dress, a gray card, a concrete sidewalk, a white shirt, etc., can be used.

1. Make sure your eyedropper is set to 31x31 Average. Also, go to Preferences>Display & Cursors and make sure you've selected Precise under Other Cursors.

- 2. Open a Levels adjustment layer.
- **3.** Press Shift and click on the image to set a neutral sample point. Be sure that the sample point has image detail (no blown-out white spots). The RGB values in your Info palette should all be between 50 and 200 for this point.
- **4.** Double-click the white eyedropper in the Levels dialog box to open the Color Picker.
- **5.** Position your cursor just over the sample point on the image so that it disappears, indicating perfect alignment with the sample. Click once.

Sampling the off color from the image into the color picker for neutralizing.

- **6.** In the Color Picker, the top swatch will indicate the color of the area you've clicked on. The color cast may be more obvious now. Set your "a" and "b" channel values to 0 (in the Lab boxes).
- 7. Click OK to close the Color Picker dialog box.
- **8.** Click again on the same sample point in the image. The color cast should disappear.
- **9.** Match the mountains on the histogram, if needed, then click OK.

What's happening here? Essentially we are telling Photoshop, "This is an area that should be neutral. Keep the brightness of this point the same, but shift the colors to make it neutral." When this happens, all the other colors in the image should fall into their natural places.

It can be helpful when shooting to simply capture a gray card, or neutral object, whenever the lighting conditions change. These shots can be used as reference images for all other images captured under the same lighting conditions. Of course, it's still ideal to create a custom white balance using a gray card at the time of exposure.

Fine-Tune the White Balance with Color Balance. Sometimes a perfect white balance is not desired; perhaps a certain color bias would enhance the mood of the image. It's generally best to start with a clean, neutralized image and adjust from there. The Color Balance adjustment layer is a great tool here. It is also helpful after using the "Single-Sample Neutralizer" technique on an image with a severe color cast, as occasionally it will still need help.

Color Balance is also helpful when there really is nothing in the image that can be used for a neutral reference point. In this case, it will need to be balanced by eye, and this tool makes it most intuitive for photographers.

- 1. Go to Image>Adjustments>Color Balance.
- 2. Start in the midtones (the default). Images that are too blue (this is common when shooting under overcast skies) generally need warming with a touch of red and yellow. Move the top slider toward Red and the bottom one toward Yellow.
- Click on the Highlights button to adjust them separately from the midtones. Add the same type of red and yellow adjustment.
- **4.** The Shadows generally need less or no adjustment. Experiment to see what's needed.
- 5. Click OK.

Images that are too warm will generally require moving the sliders toward Cyan and Blue. Images with a green cast, like those shot under fluorescent lighting, can usually benefit from moving the middle slider toward Magenta. As before, working in the midtones and Highlights will usually give the most obvious correction. The Shadows will probably need a smaller adjustment.

The three techniques that are described in steps 1–3 will probably handle 95 percent of your basic image needs. A good, clean image can be readied for print in very little time. Occasionally, though, corrective techniques (covered in the next chapter) will need to be applied, or an image will be converted to black & white.

■ CONVERT TO BLACK & WHITE FROM A COLOR IMAGE

Capturing every image in color, and applying a black & white conversion in Photoshop, gives the most flexibility in terms of the tonal quality of the black & white image. It also allows for simulated handcoloring techniques to be easily applied. There are myriad methods for converting color images to black & white, and it seems every experienced Photoshop user has their own "best" way. Really, though, the best way is the way that gives you the look you like. You're the boss, remember?

Grandient Map Technique. After trying most methods commonly used—grayscale mode, desaturation, channel mixer, channel mixer with pre-filters, Lab-mode conversion, etc.—we've developed a method that consistently gives us the look we like best. This technique uses a Gradient Map adjustment layer as its key. One of the nice things about the Gradient Map technique is that it bases the conversion of an image to black & white on tones rather than colors in the image. It also allows for an intuitive way to adjust the tonality of the new black & white image interactively. Lastly, it allows for warming or colorizing to be quickly applied. A slightly warm black & white, reminiscent of selenium-toned darkroom prints, has a much richer feel than a completely neutral black & white

Add a Gradient Map adjustment layer.

image. These warm black & white images also print beautifully on inkjet printers, offsetting the common green cast that can occur when attempting a neutral black & white. Here are the steps:

- **1.** Reset your Color Swatches to black over white (press D on your keyboard).
- **2.** Add a Gradient Map adjustment layer to a color image.
- **3.** Click in the gradient area to bring up the Gradient Editor palette.

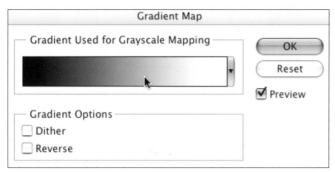

Gradient Map selector.

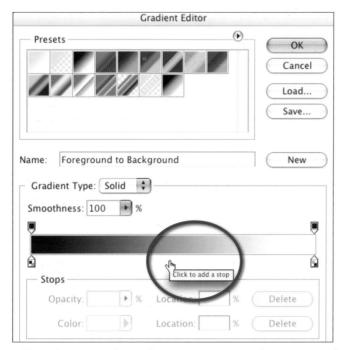

Add a color stop to the gradient to create a control point.

- **4.** Put your cursor just under the center of the gradient. Photoshop will give you the finger when you have it in the right place.
- 5. Click to set a color stop.
- **6.** Double-click on this color stop to open the Color Picker.

7. In the Lab section, enter 54, 1, 6, respectively. This gives a warm-tone black & white. For slightly less warmth, use 54, 1, 4. For a completely neutral black & white, use 54, 0, 0.

Choose a warm shadow tone.

- 8. Click OK.
- 9. In the Gradient Editor you can adjust the overall tonality by grabbing your new color stop and dragging it to the left. Notice how the midtones and highlights open up without losing detail. The image has a nice "pop" to it, and the shadows stay deep. Try setting the Location amount to 42 percent for starters.

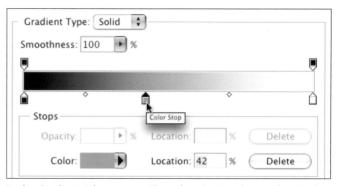

In the Gradient Editor, move the color stop to change the shadow compression and open up the highlights.

10. Fine-tune the overall contrast by adjusting the Smoothness slider. Values less than 100 percent effectively lower the contrast.

The Gradient Map is cool; I mean, it's warm. Anyway, the reason it works so well is that it allows the tonality to be shifted so that the midtones and highlights get a longer ramp—effectively "brightening" the image and giving it

A warm, tasty black & white conversion using our Gradient Map technique.

more snap. The warm gray color is mixed with neutral gray as it moves from black to the middle of your tonal stop, then fades back to neutral gray and white as it reaches the highlights. The overall effect is clean—pure blacks in the shadows, warmth in the midtones, and clean white highlights. Most photographers find the adjustments very intuitive once they've done the technique a few times.

Black & White Conversion via the Adjustment Layer. Starting with Photoshop CS3, we have a new tool

Create the Black & White adjustment layer.

for black & white conversions via an adjustment layer called, appropriately, Black & White. Though it doesn't offer all the tonal control of the Gradient Map technique, it is still very flexible and produces a high-quality monochromatic conversion, even allowing for color toning. This tool also behaves similarly to the black & white conversion in Lightroom, where you simply click and drag in the image to adjust the tonality of the black & white conversion based on color pre-filtering.

- 1. Create a black & white adjustment layer.
- 2. Adjust to taste.
- **3.** Click in the image and drag left or right to lighten or darken that color range in the monochromatic conversion.

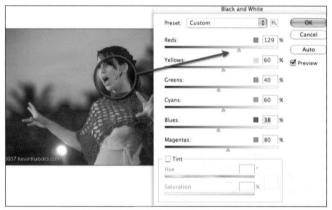

Adjust the tonality of the conversion by clicking and dragging in the image.

■ ADD COLOR TO A BLACK & WHITE IMAGE

Colorizing an image is simple once you have the Gradient Map in place. Sepia, blue tone, or even split-tone effects are easily achieved. Here's how:

- 1. Convert the image to black & white using the Gradient Map technique (pages 71–73).
- 2. Double click the Gradient Map adjustment layer.
- 3. Click in the gradient bar.
- **4.** Double-click on the midtone color-stop slider.
- **5.** In the Color Picker, click on the *S* (saturation) button.
- 6. Move the saturation slider upward to create a sepia tone. To create any other color toning, click on the H (hue) button, then move the slider up or down. If you only use the slider, instead of clicking in the color square, the brightness value will stay consistent.

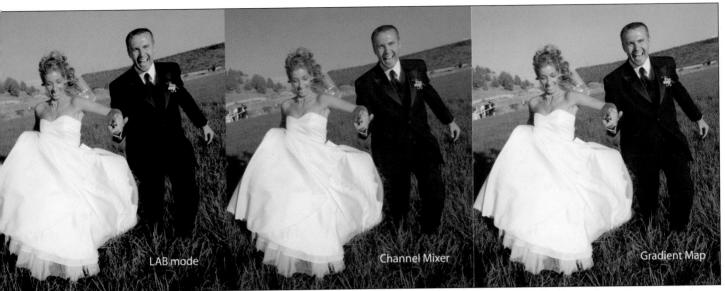

The three black & white methods compared. Notice the shadow detail in the tuxedo and the overall skin tone.

To create a toned image, click on the S button and adjust the saturation.

An added benefit of using the Gradient Map is that shadow noise is often minimized in the conversion, whereas it can be made more obvious using other methods. See the above examples of methods of converting an image to black & white. Notice the shadow smoothness and detail in the Gradient Map.

■ SAVE A MASTER FILE IN PSD FORMAT

Now that the handiwork has been completed, it would be wise to save a master file with your adjustment layers intact. The master file should be kept in PSD format to preserve all the layer information. It is not uncommon to want or need to revisit the image later and make changes to the tone or color—especially if repurposing the image file for different uses. Keeping the layers allows for infinite adjustability.

At this point, the image has not been cropped, sized, or sharpened. The same logic applies here as well: keep a master file and make a copy in the size, crop, and resolution you need for each type of output. This is also beneficial when working with certain labs that prefer you send an original, unsized, unsharpened file to them. They will use this master file for any size print. The lab may prefer to use their proprietary software to do the sizing and sharpening. This is great for photographers, as we need only keep one file and can send it for any image size.

When saving the master image, be sure to select the Layers and Embed Color Profile options.

Save the master image with layers intact and the color profile embedded.

■ PREPARE TO PRINT

With the master file safely preserved, proceed to making the print-ready file. Keep in mind that if you use a lab that wants you to send them unsized, unsharpened image files, you can simply save JPEG copies of the images and send them off. The following steps would then not need to be taken.

Cropping and Sizing. For most images (those needing less than 200 percent enlargement), the process of cropping to the right print dimensions and applying the correct resolution setting can be done with the Crop tool.

It is helpful to zoom out so that there is gray window area around the image before cropping. This way, the Crop tool can be placed outside the image area and pulled across it—and it will automatically snap to the edges of the image. You can change your window view by typing *F* on your keyboard. This will cycle through the Floating Window, a single image on gray, and single image on black—helpful for cleaning up your view and analyzing the image without distractions. Speaking of distractions, hit Tab and watch your palettes hide from view, leaving a lone image to inspect. Hitting Tab again will bring them back.

Select the Crop tool. In the options bar at the top of the screen, enter your desired width, height, and resolution. You can enter the dimensions in inches or pixels. Next, click outside the top-left corner of the image and pull down and across the image. The cropping border will snap to the edges of the image, and the proportions you set will be locked. When you have the crop you want, release the mouse and hit Enter. Your resulting image will be exactly the dimensions you asked for.

Tool presets go hand in hand with the Crop tool. A preset allows saving of favorite crop combinations—for example, 5x7 inches at 300dpi, or 8x10 inches at 240dpi. With the presets made, all you need to do is select one from the list, drag across the image, and press Enter. Presets are located at the far left of the menu options. To create a new preset, type in the desired number combinations and choose the Create New Tool Preset button. Give it a name, and it's done. Horizontal and vertical crops of the same dimensions will each need their own preset.

Sizing an Image to Over 200 Percent Larger or 50 Percent Smaller. When an image must be increased to over 200 percent or decreased to under 50 percent in size, Photoshop needs to do some serious resampling, known as interpolation. "Resampling" and "interpolation" are techy terms for making up new pixel information. When this happens in small increments, it is easier for Photoshop to figure out what the in-between pixels should look like. It's like taking baby steps instead of a giant leap. For Photo-

shop to "leap" to a 300 percent larger image requires quite a bit of guesswork because the program needs to fill in rather large gaps in the pixel information. A better solution is to let Photoshop take it "one step at a time," essentially moving up toward 300 percent in 10-percent increments. The first part of the technique is to decide what size the image needs to be, in total file size. This is easily done with the Image Size dialog box:

- 1. Go to Image>Image Size.
- **2.** In the dialog box, make sure Resample Image and Constrain Proportions are checked.
- **3.** Type in the desired dimensions and resolution in the size boxes.
- **4.** Make a note of your new file size, indicated at the top of the window after Pixel Dimensions. You should also see "(Was XXMB)," indicating that the image will be resampled. This new file size is your target size.

el

The Image Size dialog box.

- **5.** Now, change the top menu from Pixels to Percent and enter 110 percent.
- **6.** Click OK to close the box, and your image size will increase 10 percent.

Now, you just need to repeat the 110 percent enlarging process until the target size is met. The goal is to get just below your target size, without going over. Then, the last size adjustment should be to enter the exact final dimensions needed (e.g., 20x30 inches at 250 pixels/inch).

To check your progress as the image grows toward the target size, set your image window to Floating Window mode (using the F key, remember?) and set the status area

to Document Sizes (you'll find this to the right of the Percent field in the left-hand corner of the screen). Watch the number on the left of the slash as you increase your image size.

If this whole process seems tedious, it is. But only the first time. After that, you can make an action to automate the process. Simply start recording, change the image size by 110 percent, then stop recording. From then on, simply hit Play and your image will increase to the desired 110 percent. You might be thinking ahead now, "Hey, can I make an action to do that increase five times in a row? How about fourteen times?" Of course you can! (If you don't feel comfortable with actions, wait until you finish chapter 10.)

Since an increase in image size to over 200 percent will require at least eight steps at 110 percent, it makes sense to save actions that will increase one, five, eight, and ten steps. These can be used in combination to reach your target size. If using a five-step action makes the image too large, open the History palette and step back one history step at a time until you are just below your target size. Then, open the Image Size dialog box one last time and enter your exact finished dimensions.

Images resampled using this 110 percent method will retain fine details better than images that are resampled in one giant step. However, the difference is only really noticeable when enlarging beyond 200 percent.

Sharpening: The Final Step. Sharpening is merely a software trick, done either in the camera or in Photoshop. In Photoshop, we use the Unsharp Mask filter, which accomplishes its magic by increasing contrast along the edges to make them stand out more, effectively giving the sense of sharper edges. It does not magically find detail where there was none, but sometimes it appears to do miracles.

Sharpening should always be the last step in the postproduction process. When image resampling is done on an image that is already sharpened, like a magician doing his tricks in slow motion, the illusion becomes obvious and magnified. The artifacts from the sharpening process become resampled as well, and the resulting image can look "edgy" or oversharpened.

The amount of sharpening is also dependent on the final image size and resolution. Here are some guidelines and starting points for sharpening images that are about 6MP. These settings are applied in the Filter>Sharpen> Unsharp Mask dialog box. Begin with the following settings—Amount: 225, Radius: .7 or .8 pixels, and Threshold: 8.

The Unsharp Mask dialog box with basic settings.

The Amount setting used may vary with the image resolution and content; higher amounts may be needed for images without distinct edges. The Radius setting will generally vary with the image resolution. Low-resolution images, like web images, will need settings in the .3 to .5-pixel range. High-resolution images, like 300dpi, may require .8 to 1 pixel.

The Threshold setting is the only one that should generally stay in the 6 to 8 range, no matter what the size and resolution. Threshold is the amount of contrast necessary before Photoshop considers pixels a line that should be sharpened. You'll find that any threshold less than 6 or 8 will start to show sharpening artifacts, or graininess, in areas of smooth tone, like skin. This is generally not appealing. If a low threshold is used, digital noise is enhanced and made more obvious. Try this experiment:

Too low a Threshold setting reveals noise in areas that should be smooth.

- 1. Open a digital image in which the subject's face is visible.
- 2. Open the Unsharp Mask dialog box and zoom to 200 percent, keeping the face in your preview window. Set your image area to 100 percent for an overall view.
- 3. Set the Amount to 500.
- **4.** Set the Radius to 2 pixels so you can clearly see the effect.
- **5.** Set your Threshold to 0 and notice how "noisy" the skin becomes.
- **6.** Move the Threshold slider slowly up until the skin smooths out but the line detail is still enhanced. Usually this will be at about 8 or more.
- 7. Zoom back to 100 percent view for an accurate assessment.
- **8.** Now go back to the Amount and Radius and lower them to appropriate numbers.

For web images, try these settings for starters: 225, .3, and 8. To find the best setting for any image, try moving the

A higher Threshold setting smooths skin while still enhancing edge detail.

Amount up as high as is pleasing, then start moving the Radius. If the Radius is too large, dark lines appear to border detail, obscuring it.

Beginning with Photoshop CS3, there is a new sharpening filter called Smart Sharpen. Smart Sharpen is great at defining edges without overemphasizing the contrast;

The Smart Sharpen filter will do a nice job on edges but can't distinguish them from areas that should remain smooth, like skin.

however, it doesn't offer threshold control like Unsharp Mask does. So, the tradeoff for nice edges is that the noise or texture in smooth areas, like skin, tend to get emphasized as well. This is not always pleasing on larger prints where this texture can become obvious.

To make the Smart Sharpen filter smarter, we created an action to isolate only the edges of the image before the filter is run, to reduce its effect on smooth skin areas. You

can check out this action as part of our Kubota Artistic Tools Vol. 2, available on our web site.

When done, save this image copy in a format appropriate for your lab. Be sure to check Embed Color Profile. If it will be in a TIFF format, do not include layers. JPEG files should be saved with the highest-quality setting.

Now that the basic image is complete, we're ready to move on to bigger and more exciting things.

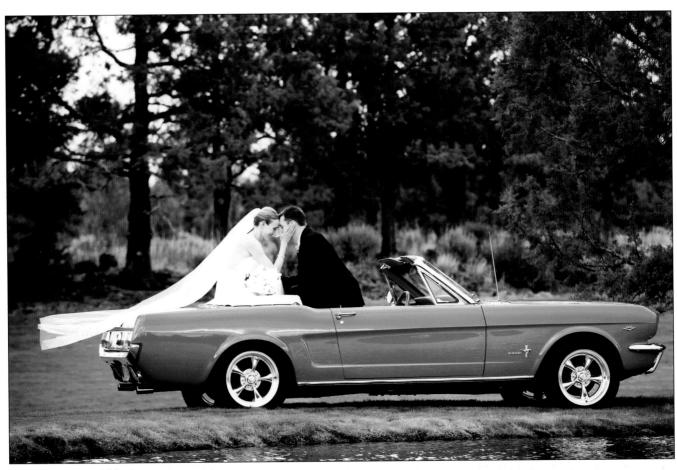

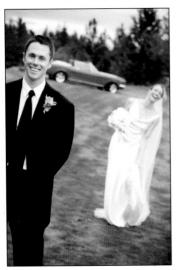

Good images must be made in capture. Then they can be enhanced in Photoshop.

78 DIGITAL PHOTOGRAPHY BOOT CAMP

8. PHOTOSHOP CORRECTIVE TECHNIQUES

The aim of art is to represent not the outward appearance of things, but their inward significance. —Aristotle

ot every image is perfect right out of the camera, or even after completing the basic adjustments outlined in chapter 7. Some images just need a little more help. Some of the techniques in this chapter are designed to address exposure and camera-specific problems, and some will simply make a scene or person look a little better. One thing is for sure; in portrait photography, everyone wants to look good. Your judgment will be the guide as to how far you want to go.

In portrait studios, there are many schools of thought as to the best approach for handling retouching. Should it be done before the client sees the image? Should we wait for them to ask, then charge a retouching fee? Should we point out problem areas and then offer to fix them—for a fee? At our studio, we take care of corrective retouching before showing the image to a client. We don't want them to feel uncomfortable asking, and we feel that first impressions are very important. We also price our prints so that we can do basic retouching without having to tack on an extra charge. However, complex retouching done at the client's request will usually incur an additional fee.

■ UNDEREXPOSURE FIX

The best remedy for underexposed images is retrospective, meaning that if the image was captured RAW, there is a lot more that can be done to improve upon it using the RAW processing software. If the image is a JPEG file, then the following technique can be helpful. Fortunately, even extreme underexposure problems can be corrected with decent results. Images will never look as good as when captured properly—but then again, it's not always possible to capture the full dynamic range desired in one photo-

graph. It is better to capture the highlight detail and adjust the underexposed areas than to have no highlight detail due to overexposure.

The Under-X Fix works well for a variety of images. It also works well when used in batch processes to fix multiple images at once. Start with an image that looks too dark in the midtones and shadows, typical of underexposure.

- 1. Open the underexposed image, and be sure the Layers palette is visible (Window>Layers).
- 2. Type Cmd/Ctrl+Opt/Alt+~.
- **3.** Inverse the selection by typing Cmd/Ctrl+I.
- **4.** Add a new Levels adjustment layer (Layer>New Adjustment Layer>Levels).
- **5.** Click OK to close the dialog box without making any adjustments.
- 6. Change the layer's blend mode to Screen.

Add a blank levels adjustment layer and change the blend mode to Screen.

Notice that the image will lighten about the equivalent of $\frac{2}{3}$ of an f-stop. The nice thing about using this method is you get nice lightening, similar to an exposure change, without hurting contrast or making the image look washed out. It opens up the shadows and midtones and shifts the highlights gingerly toward white, but keeps the blackest blacks, well, black. It also preserves color intensity, whereas other methods—like a Curves or Levels adjustment—will wash out the color and often some highlight detail.

The following images illustrate the difference between using Curves and Under-X Fix.

Curves was used to lighten this underexposed image. Notice the washed-out highlight detail. Key areas are circled.

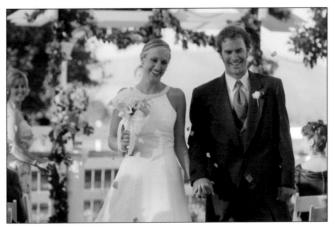

Using the Screen method, we preserved highlight detail while lightening shadows and midtones to an acceptable level. Notice the subtle blue of the sky was preserved. Two layers of Under-X Fix were applied, the second one at 59 percent opacity.

As you may have noticed, this trick is quite slick. The first part of the technique created a selection (Cmd/Ctrl+Opt/Alt+~) based on the highlights. Then we inverted the selection (Cmd/Ctrl+I) to target the shadow areas.

The original image was underexposed . . . or was it?

After one application of Under-X Fix, the foreground detail starts to reveal, but the dramatic sky started to wash out.

This helped to isolate our lightening to the darker parts of the image, preserving highlight detail in the process.

Loading the highlights or shadows as a selection, before creating an adjustment layer, automatically uses that selection as a mask for the new adjustment layer. It's perfect whenever you want an adjustment to affect primarily highlights or shadows separately.

However, there may be instances where you want to keep parts of an image dark—totally unaffected by an adjustment—and open the shadows in the rest of the image. To do this, we'll work some additional layer masking into the technique.

Layer masks allow for selective blocking and revealing of parts of the active layer. By painting on the Layer Mask on the Under-X Fix layer, parts of it can be blocked (using black paint on the Layer Mask), essentially showing the original image beneath it through this "hole." See the Layer Mask sidebar (facing page) for details.

This is very cool when, for example, an image was shot against a bright sky—a typical backlit-type scene. The sky

THE LAYER MASK REVEALED

The Layer Mask is one of the secrets to Photoshop guru status. Once understood and integrated, it seems that anything is possible, including world peace—but that's another story.

Here's the skinny on Layer Masks: think of a Layer Mask as a transparent piece of plastic attached to your layer. It always stays with the layer, and when the mask is white (the default), it is essentially invisible.

If we take black paint and apply it to the transparent sheet, it will block the area on the layer, allowing the layer or layers below to show through. It's like an eraser, but not permanent.

To restore the mask, or reveal what was blocked by the black paint, paint with white. By using the default colors (hit

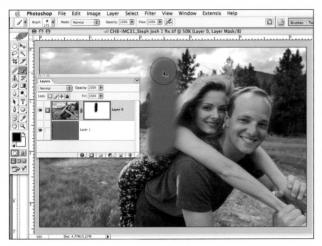

Painting with black, with the layer mask active, blocks whatever is on that corresponding layer. Notice how the green from the background is showing through.

may look beautiful, but the foreground subject is very dark. Using the Under-X Fix, the foreground can be opened up and detail revealed; however, the sky will also lighten somewhat and lose its drama—as you can see in the pair of images that appears in the right-hand column on the facing page.

Let's bring back the dramatic sky with a simple Layer Mask adjustment.

- 1. Create your Under-X Fix layer as above.
- 2. Choose a fairly large soft-edge brush.
- 3. Paint with black on the Layer Mask to block the lightening effect in certain areas (like a sky). The Layer Mask is automatically created when you add an adjust-

the D key) and the key for swapping foreground/background colors (X), it's easy to switch between black and white while "painting" on a Layer Mask. If you accidentally erase part of the image with black, type X to swap to white, and paint it back.

To make an area partially blocked, paint with a shade of gray. The darker the shade, the more it blocks. A Layer Mask can be affected with any shade from white to black.

Tip: To see just your virtual Layer Mask, press Opt/Alt and click on the Layer Mask icon. To return to normal view, press Opt/Alt and click again. This is helpful for cleaning up a mask and inspecting your handiwork.

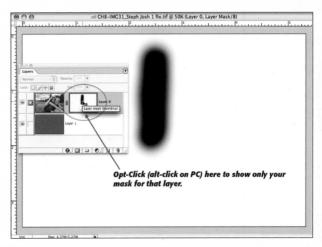

Viewing the mask alone helps you to see where you've painted.

- ment layer, so all you need to do is start painting on the image area.
- **4.** Use a smaller brush as you get closer to the edges of the area you don't want to block. By using soft brushes and selecting smaller brush sizes as you near the edges, no tedious selecting is necessary. The edge will blend smoothly and require very little time to complete.

Let's take this trick one step farther. Suppose you want to lighten the image even more than one application of Under-X Fix does. Simply select the Under-X Fix layer and duplicate it. Adjust the opacity of the layer if it's too strong, or duplicate it again to lighten it further. You can

Shift-click to select multiple layers.

Gather the selected adjustment layers into a set.

Add a Layer Mask to the entire group, so the mask will affect all layers in the group.

The image after application of the Under-X Fix. Curves was used to fix the contrast, and masking was utilized to bring back the sky. Had I overexposed the image to begin with based on the subjects' faces, I never could have recovered the dramatic sky.

also add a Curves layer to fine-tune the contrast at this point.

If multiple layers are used, then masking them all separately would be tedious. Instead, here's how the gurus do it:

- 1. To select all of the Under-X Fix layers together, select a layer, then shift-click to add the other Under-X Fix layers.
- 2. Go to Layer>New>Group from Layers.
- **3.** Add a Layer Mask to the set and paint away as usual.

Now the mask will affect all the layers in the group, saving you the trouble of having to mask each one separately and identically.

■ CLARIFY CUTS THE HAZE

Here's a neat little trick to help clear up some of the "haziness" inherent in some digital images. The Clarify technique adds subtle localized contrast that produces just the right amount of snap.

- 1. Open the image and choose Filter>Sharpen>Unsharp Mask.
- **2.** For the settings, use Amount: 20, Radius: 60, Threshold: 4.
- **3.** Notice the haze disappear and a nice edge contrast appear. (To increase or decrease the effect, adjust the Radius amount.)

82 DIGITAL PHOTOGRAPHY BOOT CAMP

The top image is the original. The results of the Clarify technique are shown in the lower image. Notice the subtle contrast and crispness.

This technique can be used in combination with a normal Unsharp Mask application—which is used to create overall sharpness in the image. It's generally a good idea to use the Clarify technique first, after overall tonal corrections have been done but before applying the normal Unsharp Mask (which should be done last, remember?).

■ HOT YELLOW FIX

No, this is not a drug. It's just good, clean fun. This works great on images that have what may be called "color staining," which often shows up in the highlight areas where the image is verging on overexposure—or has ventured unrecoverably into "blown out." It can also be used to colorize areas to match similar objects in the scene. For example, brown grass can be matched to living green grass, or sunburned skin can be given a more natural coloration. This technique works by sampling the color of a good area and applying it to the area that needs fixing—without changing the detail or tonality of the destination area.

- 1. Open the image to adjust and look for a color you can use that represents your "good" color.
- Create a new, blank layer above the main image and change the blend mode to Color.
- **3.** Select a medium-soft brush and then press Opt/Alt and click on the image where the good color is. This will load the color into your foreground swatch.
- **4.** Paint on your new layer over the area that needs the good color. To reload a new color sample, press Opt/Alt and click.
- **5.** Adjust the layer opacity, if necessary, to vary the intensity of the newly colored area.

Changing the blending mode to Color allows the brush to change an area's color without impacting detail.

Painting on a layer in color mode allows detail to show through. Sample the good color with the eyedropper, then paint where needed. The left side of the lawn has been re-greened. Digital Miracle Grow!

■ RETOUCHING BASICS

Photoshop has some great retouching tools, and I'd like to personally thank the genius who created the Healing Brush. What a great tool! Alas, it's not perfect, but we can adapt. This section will cover some basic retouching skills

and tips for using the tools more efficiently. While not an extensive course in retouching, which is a book in itself, the techniques should cover most of your day-to-day needs.

The Healing Brush. For general blemish removal, the Healing Brush really shines.

- 1. Zoom in to a 100 percent view of your image.
- Select the Healing Brush and choose a hard brush that is just barely larger than the blemish you want to remove.
- 3. Press Opt/Alt and click on an area of skin that has good, clean texture and would make a good patch for the blemish area. It does not have to be exact in tone or color, but being close helps.
- **4.** Click on the blemish, and it is blended away.

This works great if the area to be healed needs complete obliteration. But what if you want to soften an area, like lines or wrinkles? (It's generally a good idea to minimize wrinkles and lines rather than completely remove them.) The Healing Brush does not offer an opacity adjustment, allowing for partial replacement of an area. To do this, we need to add a retouching layer that can be faded independently of the main image.

In Photoshop CS2 or newer, there is a handy option that allows for applying the healing on a new blank layer, yet it samples from the original layer below. The advantage here is reduced file size and complete adjustability of the retouching.

- 1. Select the Healing Brush.
- **2.** In the Layers palette, add a new blank laye above the background layer. Name it Retouching.

Create a blank retouching layer that can be faded over the original image.

3. In the options bar, under Sample, select Current & Below.

Sample from all layers below the blank layer.

- **4.** If there are other layers in the image, besides the background layer, turn them off now, or the retouching results may be unpredictable. You can turn them back on when the retouching is done.
- 5. On the blank layer, use the technique above to remove lines or wrinkles. However, it may be helpful to pull short strokes along lines to erase them, or dab a little at a time. If you pull across them, notice that your sample point (where you pressed Opt/Alt and clicked) follows you as if tied to the area you are replacing. Be careful not to let this sample point run into a different textured area. Short strokes or dabs work best to keep it in the same sample area.
- **6.** You have now made your subject look like a Barbie doll. Unless you're doing before-and-after ads for a plastic surgeon, you probably want to simply minimize, not remove, these lines. Adjust the opacity of the top layer and watch as the lines fade in and out. Pick a realistic balance, and you're done.

Use a hard-edged brush when using the Healing Brush. The Healing Brush automatically blends the edges nicely, so a hard edge gives more accurate feedback as to where the actual border of the brush is. The Healing Brush is not a good choice for detailed areas, however (e.g., to clone a patch of grass to cover a distracting element). Enter the Clone Stamp.

The Clone Stamp. The Clone Stamp used to be the tool of choice for retouching, and it still has myriad uses. When using the Clone Stamp, select a soft brush. Press Opt/Alt and click to sample an area to use as your source, then start dabbing or dragging across the area to be replaced. Note that the source point will follow when you

The Clone Stamp with the Aligned option selected.

drag to replace an area, as if connected to the brush by an invisible string. If you want the source point to remain in the same spot, then deselect Aligned in the options bar. The source point will then still move with the brush when dragging, but it will always return to the same starting point.

■ SWAPPING BODY PARTS

Digital imaging has opened many doors for portrait photographers. It is now a simple matter to take the eyes from one image, the legs from another, and the head from a third and replace these parts on a fourth image to create the perfect composite. Is it cheating? Of course it is! So what! Clients love it, and we can give them exactly what they want. The trouble is, buyers of portrait photography are all too aware of what's possible now, and some ask for the stars and the moon.

With this is mind, our studio will often make a judgment call to decide whether an image could be significantly improved by an eye or head swap. If so, we'll do it before the client sees the image. This way, we don't have to make statements in the sales room like, "We could easily swap the head from number 6 onto number 4 if you like it better." When you start making suggestions like that, the customer begins thinking about changing things at the slightest whim. It's best to wait until they really seem to need a push, then you can offer to make the swap—especially if it will save the sale (or create one from nothing).

Fortunately, swapping body parts is quick and easy in most cases. The hardest part is making sure you don't get carried away and accidentally put Aunt Jane's head on Uncle Bob.

To make this trick work, it's best to have two (or more) images that were shot in the same lighting conditions and from the same angle and distance. We generally shoot a few more images when we take group photos, just to make sure we have a good expression from everyone. Then we can grab a head here or there if needed. Here are the steps involved for a closed-eye swap, but any other body part could be Frankensteined too:

- 1. Open both images, good eyes and bad eyes.
- **2.** Use the Lasso tool and draw a rough selection around the good eyes.

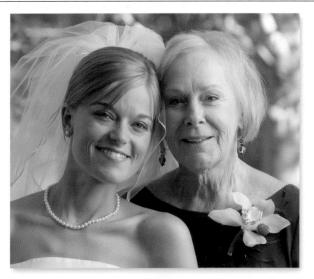

On the top is the original unretouched image. The middle image was made with the Healing Brush's default settings; can you say "plastique"? On the bottom is the more natural image with the healing layer faded about 50 percent.

3. Press Opt/Alt and drag the selected area to the image needing new eyes.

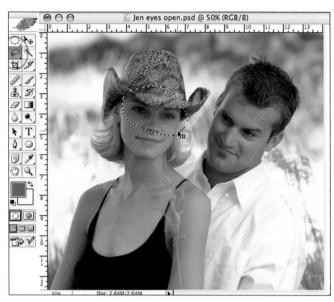

Use the Lasso tool to select the good eyes.

Drag the selected area into the second image.

Making the new eyes layer temporarily 50 percent opaque allows for easy alignment of the old and new. Kind of freaky too.

- **4.** Release the mouse when over the destination image, and the new eyes should be visible—although probably in the wrong place.
- **5.** Type 5 on the keyboard to make your new eyes layer 50 percent opaque.
- **6.** Select the Move tool and drag the good eyes precisely over the old ones. Use a common point for reference, like a nose or eyebrows.
- 7. When the new eyes are aligned, type 0 to return the new eyes to 100 percent opacity.
- 8. Add a new Layer Mask to the good eyes layer.
- **9.** Choose a soft black brush, a little larger than one eye socket, and paint away the edges of the new eyes that aren't needed!

Use a soft brush to paint away the edges of the new layer. The soft brush allows the new area to blend nicely with the underlying image with no effort at all. (The mustache shows the masking stroke, not my juvenile delinquency.)

Sometimes the source and destination parts are not exactly the same size, meaning they won't line up seamlessly. In this case, when the new part is brought over (step 6 above), use the Free Transform command (Cmd/Ctrl+T or Edit>Free Transform). With the transform active, corner handles will appear.

- 1. Grab a corner, hold down the Shift key (to maintain proportions), and size it as necessary.
- **2.** The part can also be moved to the right position with the Free Transform active by grabbing inside the boxed area (but not right on the center mark) and placing it where needed.
- 3. The part can be rotated by placing the mouse just outside the transform box. When the curved arrow appears, click, hold, and drag in the direction of rotation needed.

Original image.

4. When the new component is the right size and in position, hit Enter to set the transform.

■ DIGITAL LIPOSUCTION

What power we hold in our hands! This technique can be used for good or evil, so be careful. It is also one of the most fun—and profitable—tools available in Photoshop.

Reshaping is not something that should be done automatically; the client should request it or have expressed concern over a feature that they are sensitive about. Some clients are shy about asking to be slimmed or trimmed, yet they would be happy to see their picture presented that way. Sometimes you have to make an educated guess; you don't want to offend them by removing something they are proud of!

The Liquify tool (Filter>Liquify) can be used for slimming and trimming, shaping a weak chin, straightening crooked noses, love handle removal, large ear or nose reduction, or comic relief and alien creation.

The tool offers an extensive set of options in the control window. However, we only use a few of them for basic needs.

The Forward Warp Tool. The actual instrument that does the deed. Its size and properties are determined by the settings in the options bar.

The Freeze Mask Tool. This is used to protect areas from any accidental warping and reshaping.

The Thaw Mask Tool. Erases the Freeze Mask where it has been applied.

The final image. Now he's got something to smile about!

Here's a sample image and the workflow used to correct it. The beautiful bride was a little self-conscious about her neck and chin and how they photographed in profile. She felt the area could use a little more definition. The image captured a beautiful moment, and we didn't want her to be distracted by any concerns for the way her profile appeared. So, let's get busy:

- 1. Make sure you are on the main image layer, not an adjustment layer.
- 2. Go to Filter>Liquify.
- 3. Set the Brush Pressure to 100.
- 4. Set the Brush Size to the width of her arm.

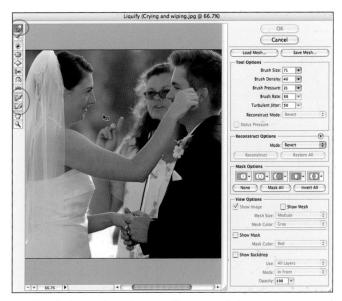

Liquify window with tools that will commonly be used.

5. Choose the Freeze Mask tool and paint over her arm to protect it from correction (protected areas will show as transparent red).

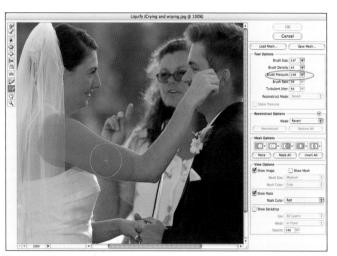

Use the Freeze tool to protect areas you don't want modified.

- **6.** Be sure to keep the red protected area just over her arm without going too far into the area we need to work on. (See example.)
- 7. Switch to the Forward Warp tool and change the Brush Pressure to 20.
- 8. Set the Brush Density to 50.
- **9.** Set the Brush Size interactively so that it is large enough to cover the area that needs correction. Too small a brush will create uneven, bumpy edges.
- 10. Position the brush so that a third of it is over the area to be corrected, then click, hold, and push to reshape. A few small movements may be needed to achieve the desired effect. Too many separate movements will start to blur edges and smear the texture or grain in the image. Keep them to a minimum.

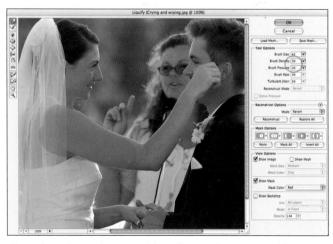

Gingerly reshape the area with as few strokes as possible.

If the texture seems compromised, it can be selectively restored using the Reconstruct tool. (Select a smaller brush with a Density of 100 and a Brush Pressure of 100.) Areas that cannot be retextured with the Reconstruct tool may be fixed with the Healing Brush or Clone Stamp once the image is returned to the normal Photoshop window. (*Tip:* To see the before-and-after effects in the Liquify window, check the Show Backdrop box at the bottom right of the Liquify window. Select these options—Use: All Layers, Mode: In Front, Opacity: 100 percent.)

We have recovered the cost of Photoshop many times over with profits made using the techniques in this chapter alone. With practice, everyday corrections should not take more than a minute or three per image. Consider factoring the cost of doing these corrections into every image (many of them probably won't need any corrections). If you can give your client a better product, without them having to ask for it, then the overall perception of your image quality in general will be improved.

Before-and-after examples of using digital liposuction. The effect is natural but significant.

9. PHOTOSHOP ENHANCEMENTS

Pictures must not be too picturesque. $-Ralph\ Waldo\ Emerson$

his is where the fun begins—not that digital liposuction wasn't more fun than a barrel of monkeys! Enhancing images is also affectionately known as "tweaking." In the minds of many photographic artists, an image is not ready for public display until it has been tweaked—whether simply and subtly, or given a full artistic work over. For many, myself included, half the creative fun of photography is creating the perfect print after it's captured. We can use the unlimited tools we have in Photoshop to extend our creativity and create what we truly envisioned when we took the photograph.

With Photoshop, we can blur the lines between photographic realism and painterly impressionism. In fact, I like

to use the term "photo impressionism" to refer to the images I create in camera together with Photoshop. The feeling of the image is more important than the exacting details. If an enhanced color palette or light-painting technique will convey the feeling more convincingly, then I will do it. If a soft, gentle glow gives the image more mood, I'm all over it. Now, this may not be appropriate for a pure photojournalist, but it can certainly apply to most other forms of photography where we are expected to take some artistic license—whether at the time of capture or in our digital art studio.

When shown both versions of an image, tweaked and normal, the client will inevitably prefer the tweaked ver-

A normal image speaks.
A tweaked image sings.

sion. The difference in quality and appeal is glaring and undeniable. Tweak more, sell more. Don't be a slacker, tweak it!

■ HANDCOLORED BLACK & WHITE IMAGES

Let's start with a best-selling technique that is fun and easy to do: black & white with handcoloring. The term "handcoloring" is used loosely here, as this is not traditional handcoloring where paints are used to apply color to a black & white photo. The look of this traditional technique is wholly possible in Photoshop as well, but it takes a great deal more time and some practice to make it look right. For day-to-day production work in a busy studio, the luxury of that kind of time is not always available, so here's the easy way. This may be more appropriately called "selective coloring," as that's essentially what we'll do.

This works best when you have an image that can stand on its own as a black & white photo but has an important

Selective coloring draws attention to special areas of the image.

element of color that would love to be revealed. It works great in advertising to focus on the product in a scene, in portraits of children with colorful outfits, and, of course, on flower girls with bouquets.

- 1. Start with a color image.
- **2.** Add an adjustment layer to make it black & white. (The Gradient Map technique works well.)
- **3.** When adjustment layers are created, they automatically have a Layer Mask attached to them in white, indicating the adjustment is entirely revealed. We are going to block part of this adjustment layer to let the color from the main image below show through.
- **4.** Choose a medium-soft brush and black paint. Paint on the image where the color should show. Voila!
- **5.** If you paint outside the lines and reveal color you don't want to, simply switch your color to white (*X* key) and paint it away again. As you get close to the finer details, reduce your brush size.

■ SOFTENING WITH KEVSOFT

The name may be a little corny, but the effect is nothing short of beautiful. This technique softens skin and adds a glow—as much or as little as you want—for a flattering look and a little mood. Unlike other types of softening,

"Painting" with black on the black & white layer's mask reveals the color below.

this minimizes blurring in the darker areas, where the edge detail lies, giving a soft glow with full edge clarity.

- 1. Start on your main image layer.
- 2. Go to the Channels palette.
- **3.** Hold the Cmd/Ctrl key down while clicking on the RGB icon. You should see a selection appear on the image, representing the highlights.

Cmd/Ctrl-click on the RGB thumbnail to load the highlights of the image as a new selection.

- 4. Switch back to the Layers palette.
- **5.** Copy the selection to a new layer by selecting Layer>New>Layer via Copy (shortcut: Cmd/Ctrl+J). This will copy the highlights onto a new layer.
- 6. Go to Filter>Blur>Gaussian Blur. Start with a radius of 3 to 6 pixels. Adjust to suit your taste. Click OK.

You should now have a nice image with glowing skin and highlights. But, we want to make sure there is full clarity in the eyes and around the lips and teeth. Therefore, we'll need to add a Layer Mask to this soft layer that we can paint on to block the softening from these areas.

- 1. Add a Layer Mask to the newly created softening layer.
- **2.** Choose a soft brush and black paint. Size the brush to one eyeball.

A Layer Mask is added to the soft layer so portions of it can be "painted away" with a soft, black brush. Paint over the eyes and eyelashes to restore sharpness.

- **3.** Paint over the eyes and eyelashes to restore full clarity. You are painting on the mask.
- **4.** Paint over the lips and teeth as well. Try using 50 percent opacity.

Before KevSoft. Skin is too "harsh" and hardly glamorous.

After KevSoft. The result is subtle but beautiful, and the eyes have full detail.

■ DIGITAL FILL FLASH AND DIGITAL DARK

One of our most-used techniques, this is a type of dodging and burning on steroids. It does wonders for bringing attention to the important elements in your image and works more naturally than the Dodge and Burn tools. We sometimes refer to it as a type of "light painting" too, as you really do paint with light, opening up shadows as needed and adding dimension to the image. It also allows

us to use natural light as much as possible, knowing that slightly dark areas can be opened up using this technique. It is then possible to reduce the dependency of fill-flash on camera, which can flatten an image and make it look a bit artificial. If you love natural light photography, you'll love this trick!

- 1. Open an image that needs a little fill.
- **2.** Create a new Curves adjustment layer. Name it Lighten. (You can name a layer by simply double-clicking on its default name in the Layers palette.)
- 3. Lift the curve so that you see the maximum lightening that you'll need anywhere in your image. Don't be afraid to go a little too bright, as this is the maximum lightening that will be available, not what the final image will look like. Click OK.

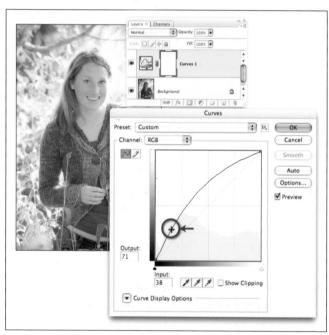

The midtones are lightened with a curve shaped like shown. It's okay to go a little brighter than you think you'll need. The effect will gradually be painted in.

- **4.** Immediately type Cmd/Ctrl+I to invert the Layer Mask (or go to Image>Adjustments>Invert) so that it is completely black, or blocked.
- 5. Select the softest white brush. Set the opacity to 20 percent. Size it to the area you'll be working on. The secret is to use as large a brush as possible (the feathered edge is softer on a larger brush) and reduce the brush size as you get closer to detail areas. When the brush is used right, tedious selections are unnecessary.

6. Paint over the areas that need lightening. Since the brush is set to 20 percent opacity, only partial lightening will occur. The more the area is painted over, the lighter it gets. Keep in mind that until the mouse button is released and pressed again, only the area covered will increase, not the lightening. To make an area lighter still, release the mouse button, press it again, and start painting.

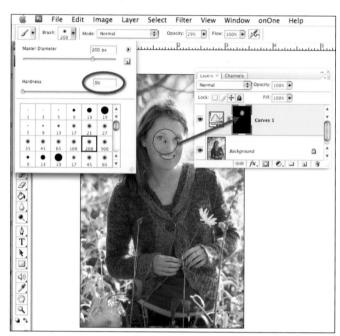

Paint with a soft, black brush and the area will begin to lighten progressively.

This technique is like painting with light. The more you paint over an area, the lighter it gets. Think about shaping your subject, gently bringing brightness and attention to areas that need it. If an area becomes too dark, you can undo your last brush stroke with Cmd/Ctrl+Z, or switch your color swatch to black (X) and paint over it again. Applying black paint will darken the image in 20 percent increments, toward the appearance of the original image.

Most images need a few dabs or strokes of light here or there to make a marked improvement in the depth and attention focus. If you really want to be a light-painting artist, you can add a darkening layer as well. It's simple:

- 1. Make another Curves adjustment layer. Name it Darken.
- **2.** This time, pull the curve in the opposite direction so it's more of a dip. Be sure to go darker than you think you'll need anywhere in the image. Click OK.

Before DigiFill the face does not jump out at you.

- **3.** Invert the Layer Mask as before (Cmd/Ctrl+I).
- **4.** Use the same soft, white brush at 20 percent. Painting now will darken areas.
- **5.** Switch layers depending on whether lightening or darkening is needed. Just click on the layer you want to work with. Be sure to click on the Layer Mask icon, instead of the first icon.

Using these two layers, an image can be shaped and lit exactly as you need it. Think about the basic rules in photographic lighting: lighter areas tend to advance, or be more obvious; darker areas recede. Think about how shadows can shape the human form, making it slimmer looking where needed. Flat lighting tends to make round shapes look wider.

Paint in shadows around a neckline or jawline to slim the face. Increase shadows on the dark side of arms or

After DigiFill and DigiDark, the image has more impact. Now she jumps out at you, like a lioness from the bush.

bodies to make them look slimmer. Add highlights to the bright side to give it more depth as well. Darken distracting objects to minimize their visual importance.

The best feedback is a before-and-after view. To do this, click the eyeball icons on the Layers palette off or on. Both the Lighten and Darken adjustment layers can be put into a layer set, then turned off or on together. Sets also help to clean up and organize your layer view.

■ CLEANING UP THE EYES AND TEETH

Now that we have the above steps down, let's use them for another classic retouching technique: enhancing eyes and teeth. Traditional portrait retouchers will lighten and whiten the eyes and teeth to increase their draw. Working digitally, we'll use a similar concept, while maintaining a natural look.

A simple dab of the brush in the whites of the eyes and across the teeth makes a subtle but noticeable difference.

- 1. Open a portrait image and zoom in to at least 100 percent so the eyes and teeth are large enough to see clearly.
- **2.** Create a new Curves adjustment layer and create a curve like you did in the digital fill flash technique. Click OK. Name the layer Lightening.
- **3.** Invert the Layer Mask (Cmd/Ctrl+I).
- **4.** Choose a small, soft, white brush. Set it to 20 percent opacity.

Dab gingerly in the whites of the eyes. Paint across the teeth as well. Build up the brightness as needed, being careful not to go too light so the enhancement doesn't look fake. Often, when the before-and-after view is toggled, the eyes and teeth may seem overdone. The easiest way to adjust the overall lightening is to change the layer opacity instead of the brush opacity. Switch to black and paint if you go over the wrong area or want to restore.

Now the lightening is complete—but wait, are those coffee stains and blood vessels from too much partying last night? Let's clean up a little.

Since we've already made a Layer Mask for the lightening, and essentially need to affect the same area again for stain removal, we'll reuse what we've already done.

- **5.** Duplicate the Lightening adjustment layer. Label it Bleach.
- Choose Layer>Change Layer Content>Hue/ Saturation.
- 7. In the Hue/Saturation dialog box, move the Saturation slider to 0. Click OK.
- 8. Yipee! You've now used your existing layer masking on a new saturation-reducing layer to get the stains out. If the effect is too gray, reduce the layer opacity. If more color removal is needed, paint over the eyes and/or teeth with the soft white brush to build up the "bleach."

■ SELECTIVE FOCUS

Selective focus allows us to see clearly only what we want to. We'll apply it here with the intention of simulating lens depth of field, where the area in front of and behind the subject is blurred. Our blur will also gradually fade in and out like depth of field.

- 1. Duplicate the background layer.
- 2. Apply the Lens Blur filter by selecting Filter>Blur>Lens Blur. Set the Radius to the maximum amount of blurring that you would like to see in the image. Click OK. (If you have Photoshop 7, use Gaussian Blur.)
- 3. Add a Layer Mask to this new blurred image by clicking the Layer Mask icon at the bottom of the Layers palette. Select the Gradient tool. In the options bar, choose a black-to-white gradient and select the icon for the linear gradient.
- **4.** With the Layer Mask still active, click on the image where the blur should start and drag a line to where the blur should be heaviest. A gradient will appear on your mask, blocking the blur where you started to drag and fully revealing the blur where you let go. This is the foreground blur.
- **5.** If you aren't satisfied with the blur fading, then click, drag, and let go again to redo the gradient. Each time you apply a new gradient, the previous attempt is replaced.
- 6. Duplicate the blurred layer.
- 7. On the duplicate layer, click on the Layer Mask icon to make sure it's active, then drag your Gradient tool again in the opposite direction. The old gradient will be erased. On this second layer, we are creating the background blur.

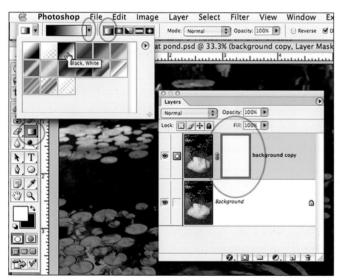

Select a black-to-white linear gradient from the options bar.

8. At this point the effect is fairly complete. On images that don't have a distinct foreground/background, it may take some experimentation to get the blur graduated just right. It's also nice to simply paint in blur at the edges of the image—without consciously simulat-

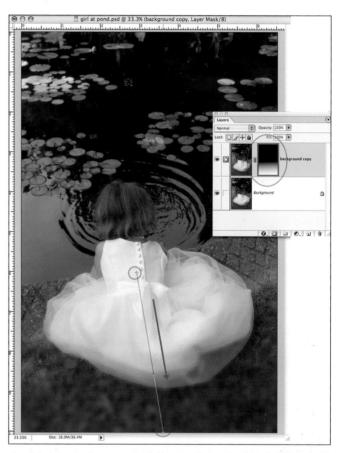

Applying a gradient to the layer mask on the blurred layer will gradually reveal the sharp layer below.

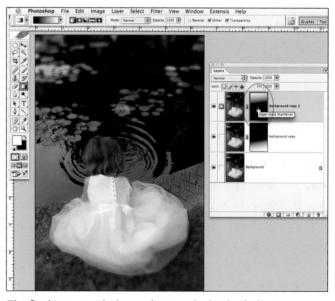

The final image with the gradient applied in both directions.

ing a depth-of-field effect. Use a soft, larger white brush at 20 percent opacity and paint any other areas that should be blurred. Since the opacity is at 20 percent, more painting will increase the blur—up to the total amount of the Lens Blur filter.

■ HIGH-SPEED BLACK & WHITE FILM

Here's another film-like favorite technique that has carried over into the digital domain. Grainy black & white films have always been popular for the raw, artistic feel in the images. High-speed black & white films have a couple of identifying characteristics: higher contrast and noticeable grain. Let's get some speed!

- 1. If the image is still in color, create a black & white version using the Gradient Map technique.
- **2.** Above the Gradient Map layer, add a new Curves adjustment layer, and call it Snap.
- **3.** In the Curves dialog box, create an S curve to increase contrast. Click on the line ½ from the bottom and pull down slightly, then click ⅓ from the top and push up slightly. Click OK.

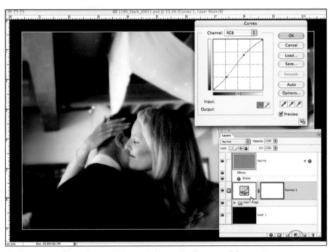

A Curves adjustment layer with an S shape adds contrast.

Now for the grain. This method creates an adjustable and more organic-looking grain than more standard methods. It also preserves shadow detail better than applying noise directly. Even if you don't quite understand what's happening when we create the following layers (it's a little wacky), don't worry—just follow along.

4. Start with your top layer active (simultaneously pressing Opt/Alt+Shift+] is a quick way to jump to the top

- of your layers). Press Opt/Alt and click on the New Layer icon. A dialog box will appear.
- **5.** In the dialog box, change the Mode to Overlay, then check the box next to Fill with Overlay—neutral color (50 percent gray). Click OK.
- 6. You'll now have a new gray layer that visibly does nothing—yet. Go to Filter>Noise>Add Noise. Set the Distribution to Uniform and check the Monochromatic box. Adjust the Amount to suit the image. 10–15 percent is a good starting point. View the image at 100 percent for best evaluation. Click OK.

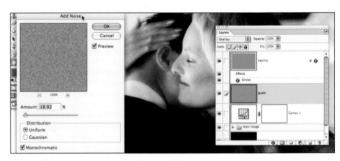

Noise filter with the initial "grain" settings.

- 7. You now have a nice grain pattern, but let's make it a little more organic. Duplicate the Noise layer.
- 8. Choose Edit>Transform>Rotate 180°.
- 9. Set the layer opacity to 50 percent.
- 10. Select Layer>Merge Down.
- 11. Yummy! Now that looks good. Adjust the opacity of this new grain layer to reduce the effect if needed.
- 12. Keep in mind that the amounts used in these examples are generally good starting points for high-resolution images around 6MP. If you are working on lower- or higher-resolution images, you may need to vary the amounts to get the results you like best.

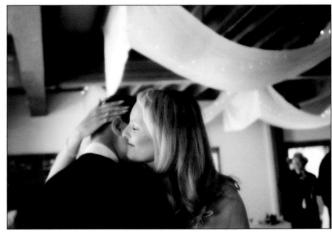

The final image with high-speed film effect.

■ VIGNETTE? YOU BET.

Here again, we've taken a traditional camera or darkroom effect and, instead of wielding it like a blunt battle ax, we'll control it like a svelte Samurai sword. Vignette was traditionally applied in-camera. A neutral-density filter with a circular shape cut out of the middle was placed over the lens. It was a little clumsy, and the dark edges were often obvious. The effect worked, however, because it really drew your eye to the subject and minimized distracting background areas.

Along with digital fill flash, this is one of those techniques that is hard to live without. It's simple to apply but makes a marked improvement to many images. It adds depth and directs attention where it should be. When applied subtly, it can be used on almost every image—especially portraits—and no one will be the wiser. They'll just look better. Generally, this technique should be applied at the end of your enhancing workflow. Make sure you have also set your tool preferences as described in chapter 7, as they will affect how this technique works.

- Select the top layer in your Layers palette (Opt/Alt+Shift+]).
- 2. Select the elliptical Marquee tool and drag a circular shape around the main subject. Release the mouse when the shape is just right. If you don't like the

- shape, simply start dragging a new one or go to Select>Transform Selection. Adjustment handles will appear around your selection. Pull them to reshape the selection, then hit Enter.
- **3.** Enter Quick Mask mode by simply typing a Q. Or, if you prefer to click things, it's the right-most circle under the color swatches in the tool bar.
- **4.** The elliptical selection area should now be a red blob that is 100 percent opaque. (If not, you may not have set your preferences as outlined in chapter 7.) This blob represents your selection.
- 5. To soften the selection border, we'll soften the red blob (Quick Mask) with the Gaussian Blur filter. Go to Filter>Blur>Gaussian Blur. In the Gaussian Blur dialog box, set the Radius as high as possible without allowing your main subject area to show through the red blob. The goal is to achieve a soft transition on the edges without seeing through to the main subject. Try 200–250 pixels. Click OK.
- **6.** Type Q again to leave Quick Mask mode and return to Selection mode. You'll now see the marching ants roughly representing your selection.
- 7. Inverse the selection (Cmd/Ctrl+Shift+I).
- **8.** Create a new Levels adjustment layer and move the middle gray slider to the right to darken the edges. Click OK.

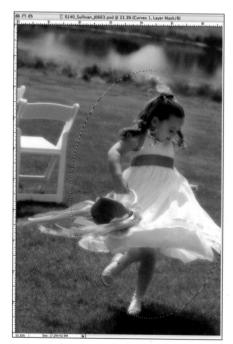

The elliptical Marquee tool should surround the subject but not come too close.

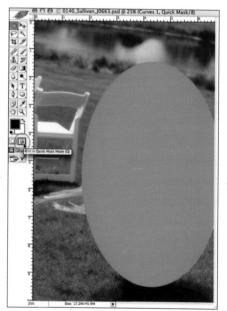

The Quick Mask icon, also known as the "red blob."

The red blob should be blurred enough to create a very smooth transition, but not so much as to reveal the main subject.

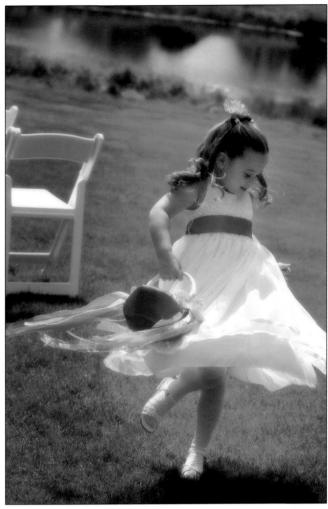

The image with a vignette has more depth, and the main subject is emphasized.

9. Wonderful! The result is a beautiful effect that is subtle yet very effective.

■ BORDERS AND EDGES

No photographer worth their weight in memory cards would present a fine image without a mat or frame of some sort. Why should online or screen images receive anything less than the royal treatment? Photos with built-in border and mat looks can also be printed that way. It is a good option when an image needs to be kept full-frame, yet printed within a standard size paper, like 8x10 inches, which would crop the full-frame image considerably.

Keyline. The first step is to create a larger canvas area around the image. We'll make an even border all around the image so there is room for a simple keyline border or film-like sloppy border. We'll start with a keyline.

- 1. Select the background layer. If the layer name Background appears in italics, double-click on the name, then click OK. This creates a floating layer.
- **2.** Go to Image>Canvas Size. In the New Size section of the dialog box, select Percent in the measurement pull-down menus.
- 3. If the image is vertical, enter Height: 108 percent and Width: 112 percent. Swap these numbers if the image is horizontal. This will give you an even border all the way around the image area. This is the pseudo "mat" area. Make sure Relative is not checked. Click OK.

Changing the canvas size by percent creates consistent borders.

4. Your image will now have a small mat with a checker-board pattern, which represents transparent areas. We need to fill the border with a mat color. On the Layers palette, create a new Color Fill adjustment layer.

Create a new Color Fill adjustment layer.

- **5.** Choose a color from the Color Picker for the mat. Your image is temporarily obscured, but don't worry. Click OK to close the Color Picker dialog box.
- **6.** Type Cmd/Ctrl+Shift+[to move the Color Fill layer to the bottom of your layer stack or just drag it down.
- 7. Nice. Now let's add the keyline. Select the image layer and add a Stroke layer style. In the dialog box,

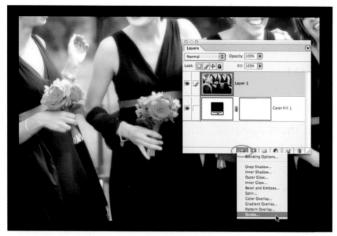

Adding a Stroke layer style to the image.

The final presentation is very polished, like a framed image.

choose Inside for the position, and use the Size slider to change the width.

8. Click on the Color box to change the color of the keyline. You can choose a color from the palette or click anywhere in your image to sample a color from it to use on the keyline. Slick.

Keep in mind that if your image has a black & white adjustment layer above this layer, it will be converting your keyline to black & white as well, so you won't see a color on the image, only shades of gray. Click OK.

The background mat and the keyline colors can easily be changed at any time by double-clicking on their respective layers and choosing a new color.

Adding a mat and keyline in this fashion gives a finished look. It also enhances the presentation—especially for images that will first be seen online or in a slide show.

Sloppy Border. Another popular effect is to use a filmtype "sloppy border" on digital images. There are standalone programs and plug-ins for Photoshop that are designed just for making borders. Many of them are overkill for the relatively few borders that most photographers like to use. You can make your own sloppy border template to use on any image.

The first step is to acquire a sloppy-border image. We like to use real sloppy-border edges, so we created blank frames in a darkroom, printed them, and scanned them. (If you don't have access to a darkroom, never fear: you can download a free sloppy border. See page 6.)

- 1. With the sloppy-border image open in Photoshop, make a selection around the inside of your border to eliminate the image area. Delete it.
- 2. Go to Image>Adjustments>Levels and pull the black triangle in toward the center until the inner black edge of your border is a true black. Verify this by moving your cursor over the image area and checking the values on your Info palette. The R, G, and B values should all be 0. (If your Info palette is not visible, go to Window>Info.)
- **3.** Double-click on the white eyedropper, and in the Color Picker that comes up, enter 255, 255, 255 for the R, G, and B values. Click OK to close the dialog box.
- **4.** Click in the image outside your black border and again inside the center area. Click on any area that should be white but may have a light-gray tone. This will push any dingy white area to pure white. Click OK.
- 5. Change the layer's blend mode to Multiply.

Changing the layer's blend mode to Multiply mode will make the white areas disappear when placed over another image.

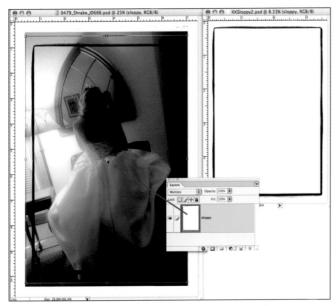

Drag the layer icon from your border-template file onto any image.

6. Save this file as your sloppy-border template. Keep it in PSD format. Now that this file is saved, it can be opened at any time and applied to any image. It will only need resizing and possible rotation.

To apply the border, open the desired image and use the following procedure.

- **1.** Increase the canvas size to 112 percent by 108 percent as described on page 98.
- **2.** With both the border template and your image file open, click on the border layer on the Layers palette.
- **3.** Hold the Shift key down and drag the layer icon from the border to your main image. Release the mouse, then release the Shift key.
- **4.** Choose Edit>Free Transform (Cmd/Ctrl+T) and grab each corner handle to size the border to the image. (If you can't see your border transform handles, zoom out so your image is small. Pull the handles in and size the border to the image.)
- **5.** When the image is sized just right, hit Enter to set the transform.

The final image with a classic film technique.

If you need to apply a sloppy border to an image that is oriented differently, you can rotate it before setting the transform. Put your cursor outside the border area and, when you see the curved double arrow, drag to rotate 90° . Holding Shift while you drag will snap the rotation to exactly 90° .

With these powerful tools, you may become a tweaking addict! Don't worry, you're not alone. We have a support hotline for those in need: (877) 330-4330. (Relationship counseling not included.)

10. PHOTOSHOP ACTIONS

No man ever said on his deathbed, "I wish I had spent more time at the office."

—Senator Paul Tsongas

ow that you've mastered all the steps to creating beautiful images, what if we told you they can be automated? Don't throw anything! Your brain is richer, and it's important to know what's happening when you create in Photoshop—after all, that's how new techniques are discovered. Once you are familiar with what can be done, however, it's time to start thinking about how you can automate repetitive steps using Photoshop actions.

Actions are recordings of processes you do, places you click, and menu items you choose. They can be saved and replayed on other images. They can also be used to process folders of images in one sitting—without further interaction from the user. Actions are tremendous time savers and help to ensure consistency in your images.

As we all know, computers aren't really very smart, they just do what they're told—most of the time. So, keep in mind that an action can't do things that require interactive thinking—like adjusting a color to your liking or looking for a neutral reference point on your image. It can, however, be told to stop and wait for you to make an adjustment before it continues on its merry way. Here are just a few examples of things that can be done with actions:

- Automatically convert a folder full of high-resolution images into lower-resolution JPEGs in black & white with a mat and keyline border and light sharpening.
- Save multiple versions of a completed image into different formats and sizes, each in different folders.
- Convert a color image to black & white using a favorite formula.
- Create a 13x19-inch page at 240dpi, then open twenty-one images, size them to 3 inches across,

- sharpen them, and place them all in a 3x7-image grid centered on the page. Add a text title in your favorite font. Save as a PSD and JPEG file for print.
- Take really bad photos and turn them into works of art. (Okay, I'm just kidding.)

How much time can you save with actions? If you can save merely an hour per day using actions, which is completely feasible, then based on 8760 hours in a year it would only take thirty-six-and-a-half years to save a whole year! Assuming you work with Photoshop from birth to age seventy-five, you would actually add over two years to your life. Now that's exciting.

But seriously, the time savings with actions is undeniable. Spend time creating new images and less time repeating mindless steps.

CAUTIONARY NOTE

There's a little "feature" in Photoshop CS and older that allows you to really mess up your actions if you're not careful—so take heed! If you click on the check box or dialog icon in the first two left-hand columns of the Actions palette, you could easily activate or deactivate every single step and/or dialog message in the Actions list. I can't think of any practical reason why someone would want to do this, other than to play a cruel practical joke by sabotaging another person's computer. Only click on these columns if you are very comfortable working with the Actions palette. This issue has been resolved starting in Photoshop CS2.

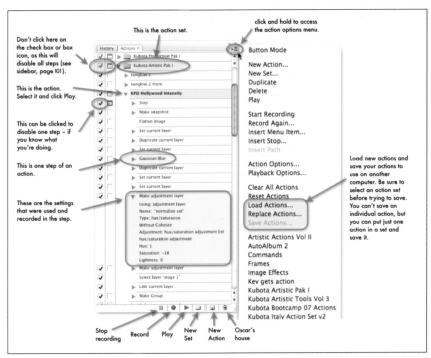

The anatomy of an Action palette.

■ THE ACTIONS PALETTE

Let's take a look at the Actions palette piece by piece. If it's not visible, go to Window>Actions.

The folder icon represents an action set, used to organize actions into logical groups. If you load a set of actions that you purchase (or the actions available to accompany this book; see page 6), they will appear within a folder in the list. Inside each folder are the actual actions. A folder can hold as many actions as needed.

Clicking on the triangle next to the action name will open the action, revealing the steps that were recorded. Clicking the triangle next to a step will reveal the settings used in that step. Juicy morsels of information are available here! Opening the actions, steps, and settings is a good way to learn more about techniques in Photoshop. If you get an action set from someone and like what it does, open it up and see what went into making it.

At the top-right corner of the Actions palette is the Action menu options button. Clicking on it will reveal a menu of handy possibilities. For a full description, consult your Photoshop documentation. We'll cover some of the immediately useful options below.

Record Again. When you have a certain action step selected, choosing Record Again will rerecord just that one step, not the entire action. This is great for fine-tuning an action after it's been created.

Insert Menu Item. Sometimes Photoshop may not accurately record picking an item from menus using the mouse. However, any selection from the menus can be added manually as an action step using this feature.

Insert Stop. Tells the action to stop running and display a dialog box. This can simply be a note to yourself about why you exist and what the action is for, or directions to complete a step manually before continuing.

Load Actions. This is where you can install an action set that you purchased or have previously saved.

Save Actions. It's a good idea to save your action sets periodically as separate files (also known as ATN files). These saved action files are very small and can

be easily stored or moved. Whenever you quit Photoshop, all the actions in the Actions palette are saved internally in Photoshop and will be there the next time you open the program. However, for portability and backup purposes, it's a good idea to save them separately on a regular basis.

■ THE BATCH DIALOG BOX

We'll cover how to make an action in just a bit, but first let's look at one more important dialog box. The Batch dialog box is accessible through File>Automate>Batch. In order to run actions on an entire folder of images, or selected images within the File Browser, certain options need to be set in this dialog box.

Play. Select the action to run from the list.

Source. Choose Folder if you have all the images you need to process inside one folder on your computer. The action will run on every image in the folder. If you want to select certain images within a folder, select them in the Browser first, then choose File Browser from this menu.

Suppress Color Profile Warnings. If your Photoshop Color Settings have been set to Preserve Color Profiles, then this will open all images without asking for your confirmation. It's necessary to have this box checked if you plan to run a batch unattended.

Destination. Choose Folder if you want to make copies of the images you process and put them into a new folder.

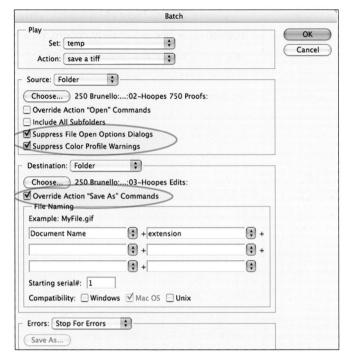

The Batch dialog box determines how an action will behave on multiple images.

Click the Choose button to specify where the folder is. You can also select Save and Close to run the action on an image and resave it, so that it replaces itself.

Override Action "Save As" Commands. This option is a bit tricky to comprehend, but it's very important to understand. If your action includes a Save step—specifying a place, file type, and compression settings—then this option will use the recorded file type and compression settings but override the save location with the one specified above. Note that if you don't have a Save step recorded and check this box, the batch won't work as expected. If you have a Save step recorded and don't check this box, the batch won't work as expected.

Whenever you plan to use an action in a batch process, it's a good idea to record a Save step with the action, specifying your file type and compression settings. The location for the saved images can be overridden each time the action is run.

Most problems that people run into with running actions in batches have something to do with the Override Action "Save As" Commands box not being checked or unchecked appropriately.

File Naming. This can usually be left at the default, which uses the original image's name plus the appropriate file-type extension.

■ CREATING A BASIC ACTION

We'll cover a couple of simple actions to help get you started on the road to action hero/heroine status. This action will convert your image to black & white, add a little contrast, then display a message.

- 1. Go to Window>Actions to access the Actions palette.
- **2.** At the bottom of the palette, click on the Create New Set icon. Name the set anything you want.

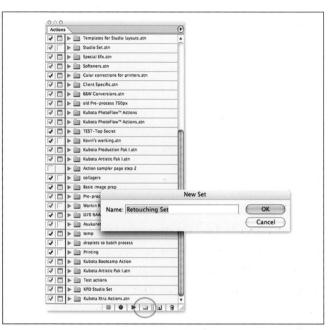

Create a new action set to organize your actions.

- **3.** Next, click on the New Action icon, name the action B&W with Snap, and click Record.
- 4. Photoshop is now recording your every move and everything you say, so hurry up and be nice! Okay, this isn't really the case—it just waits patiently for you to do something. The speed at which you create the action has nothing to do with how quickly it replays. Take your time.
- **5.** Switch to your Layers palette and create a black & white image using a Gradient Map adjustment layer.
- **6.** Now, create a new Curves adjustment layer and shape the curve into an S to add contrast.
- 7. Add a message window to write yourself a love note. From the Actions drop-down menu (accessed by clicking the arrow at the top-right corner of the Actions palette), select Insert Stop.
- **8.** In the Stop dialog box, write: "Adjust the curve layer for more or less contrast. Click the eyeball to turn it

- off completely. Think peace and have a groovy day." Leave the Allow Continue box unchecked.
- **9.** Click on the square Stop Recording button in the Actions palette to end the action.

Now all that's left is to reap the rewards of your efforts and play that action! Revert to the image's original color form or open another image. Click the Play triangle on the Actions palette and watch your image quickly transform. Read your note and do what it says. Can you think of a few hundred fun ways to use this?

A More Complex Action. Let's take this a step further and create an action that could be used in a batch process—for example, to transform a folder full of high-resolution images into low-resolution copies for proofing or on-screen presentations.

When using actions in batches, there are a few steps that should be included to ensure it will always run correctly, without stopping, on any type of image. Here are a few of the "safety" steps that should generally be included in actions intended for batch processes:

Flatten Image. Run this as a first step. This ensures the action will work predictably on previously layered files.

Convert to Profile. This ensures that images intended for on-screen display will look their best.

Flatten Image (Again). If your action creates layers and you want to save the result as a JPEG file, you'll need to flatten the image before saving it to avoid interruptions.

Save. This ensures that your file will be saved with the file type and compression settings you want.

Keep in mind that extra steps that have no effect on an image will be ignored, so it doesn't hurt to add them in as insurance.

Now let's build the action. This one will open a full-resolution file, run the Clarify effect, resize the image to 1200 maximum pixel dimension, sharpen the image, add a little color saturation, convert it to the sRGB color space, then save it as a high-quality JPEG file.

- 1. Open a full-sized image.
- **2.** Create a new action, call it Make Low-Resolution Proofs, then click Record.
- **3.** Choose Filter>Sharpen>Unsharp Mask. Use the settings: 20, 60, 4. Click OK. This is the Clarify effect.
- 4. Choose File>Automate>Fit Image. Enter 1200 in the

- Width and Height boxes. This will fit your image into an imaginary 1200-pixel box. It won't make it a square; horizontals will be 1200 pixels wide, and verticals will be 1200 pixels tall.
- **5.** Choose Filter>Sharpen>Unsharp Mask. This time, use settings of 225, 0.3, 8 (for sharpening a low-resolution image).
- **6.** Add a new Hue/Saturation adjustment layer. Increase the saturation by 10 points. Click OK.
- 7. Go to Layer>Flatten Image.
- **8.** Go to Image>Mode>Convert to Profile. Select sRGB as the destination (this is best for on-screen and web images). Click OK.
- **9.** Go to File>Save As. Put the image on your desktop for now (this is just a dummy copy of the image, which you can later throw away). Choose JPEG as the file type and select the highest-quality setting.
- 10. Press the square button to stop recording.

Note that we didn't need to create an adjustment layer for the Hue/Saturation since the image was going to be flattened anyway. We could have done it directly via Image> Adjustments>Hue/Saturation. However, we wanted to include a Flatten Image step, and this can't be recorded unless the image actually has a layer to flatten.

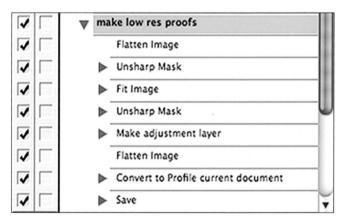

The completed action with all the steps in place.

Speaking of the Flatten Image step, we need to duplicate this step so that it happens twice in our action—once immediately when the image opens (in case we start with a layered file) and again near the end. It's easy to copy an existing step in your action and place it elsewhere.

1. Open your newly created action by clicking on the triangle next to its name.

- 2. Click once on the Flatten Image step.
- **3.** While holding down your Opt/Alt key, drag the step up just above the first Unsharp Mask step. This will copy your step so that it appears twice.

The action is now ready to use in a batch process. Keep in mind that if you run it on a single image without using the File>Automate>Batch dialog box, the image will be saved to your desktop, since that's where you told the action to save initially. When you use the Batch dialog box, the location can be overridden with the Override Action "Save As" Commands check box.

Finally, let's save the actions so that they can be transferred to other computers—and to keep a backup copy. Click on the name of your action set. Go to Actions>Save Actions and put the file in a memorable place. To use this action on another computer, choose Load Actions from the same menu. Here are some last-minute action tips.

- You can select multiple steps at a time in an action list to either copy or delete them. Press Cmd/Ctrl and click on all the action steps you want to include.
- Drag selected steps up or down to rearrange them.
 Dragging them into another set will automatically move them to that set.
- Before running a new or unfamiliar action, open it up and inspect the steps. Look for Flatten Image and Save steps that could mess up your image.
- Temporarily turn steps off (like the above-mentioned Flatten Image or Save) if you need to by unchecking the box next to that step in the left-most column. This is helpful to turn off Save steps when you run the action on a single image that is already open.
- If you want to play an action one step at a time instead of running it all the way through, click on the first step, then press Cmd/Ctrl and press the Play button. The program will walk through the steps one at a time. This is helpful for troubleshooting actions.
- Keep in mind that sometimes the main image layer needs to be selected before running an action, or unexpected results may occur. (E.g., if your action is playing a step to sharpen an image but you start running it with an adjustment layer selected, nothing will happen. The Sharpen step will run on the adjustment layer instead of the actual image.)

• Double-click to the right of the action name to bring up the Action Options window. You can assign a function key here so that your favorite actions can be run by pressing a single key. Bam! Now that's a time saver!

Double-click to the right of the action's name to bring up the Action Options box. You can assign a function key here.

• Actions can be recorded to play other actions. Using this, you could make a new action that plays a series of your other favorite actions, one after the other.

By now, you should be feeling like a superhero. With the power of actions, you can easily rule the world—or at least your little corner of it.

■ CREATING A DROPLET

Droplets are actions that are saved as mini programs. When an image is dropped onto the droplet icon (on your desktop or anywhere else you can save it), Photoshop will open, run the action, then save and close the file. This is great for applying your favorite actions, like a black & white conversion, from another program like Lightroom (covered in a moment). Here's how to create a droplet.

- 1. Create the action, if you don't already have one. Be sure to include a Flatten Image and Save step to specify the file type that will be saved. These should be the last two steps of the action, respectively.
- 2. Go to File>Automate>Create Droplet.
- **3.** Choose a location to save your droplet. Apply the other settings as shown on the next page and save your droplet to a convenient location.

Now, all you need to do is drop images on the droplet, and they will be converted using the action. Keep in mind that the image you drop will actually be converted, so

The droplet settings.

Quickly find your Export Actions folder from within the Lightroom Export dialog box.

make sure you have a backup copy if it's an original file. Usually you'll use droplets on proof files that you'll want converted anyway.

Using Droplets with Lightroom. Wouldn't it be great if you could edit your images in Lightroom, apply your presets and adjustments, then export the whole lot of them to make low-resolution copies for proofing and apply your favorite Photoshop sharpening action all at the same time? Yes, it's a loaded question, and yes you can.

If you plan to use droplets, it's a terrific idea to create a folder in your Actions palette and call it Droplets for Lightroom. Then copy (or create new) actions into this folder. Again, make sure they all have Flatten Image and Save steps as the last two items.

Droplets are accessible by Lightroom when they are saved into the Export Actions folder. The folder is located here:

- (Windows XP) Navigate to \Documents And Settings\[username]\Application Data\Adobe\Lightroom\Export Actions\.
- (Windows Vista) Navigate to \Users\[username]\App Data\Roaming\Adobe\Lightroom\Export Actions\.
- (Mac OS) Navigate to /[user home]/Library/Application Support/Adobe/Lightroom/Export Actions/.

You can also jump to the folder quickly through Lightroom by choosing Export, then under Post Processing, and After Export, choose: Go to Export Actions Folder Now.

Now that you know where the folder is, simply save your droplet from Photoshop to it. Be sure to give the droplet a useful name, and when you reopen this After Export menu, it will appear in the list. Keep in mind that Lightroom will do any resizing and color profile conversion to your image (if you specified it in the previous options) first, then it will pass the images to Photoshop one at a time for droplet processing.

Save the droplet, with a useful name, to the Export Actions folder so that it's useable from within Lightroom during export.

11. PRINTING AND PRESENTATION

To me art in order to be truly great must, like the beauty of Nature, be universal in its appeal. It must be simple in its presentation and direct in its expression, like the language of Nature.

-Mohandas Gandhi

ronically, learning to print and present your images effectively will keep you completely out of "chapter 11," if you know what I mean. By printing and presenting your images more effectively you'll see increased sales and repeat business—the goal of any studio.

Shooting digitally means that you are only a few steps away from one of the best ways to present your images—up on a big screen or wall in your sales room (which may very well be your living room too, and that's okay). Digital projectors are becoming commonplace in photo studios and are an effective tool for making the best first impression possible—and making the best first impression possible is key.

Even if you use other proofing and presentation tools, like proof prints, booklets, web proofing, or CD-ROMs, these should all be supplementary to a nice in-studio presentation. Many photographers, our studio included, initially got lazy and thought that web proofing meant we would never have to sit down with and sell to a client again. We thought we could upload the images and the orders would just pour in from around the world while we slept or lounged by the pool with our kids. Not!

Web proofing, as we'll discuss in more detail later, is a great supplementary sales tool. But its real benefit, in our opinion, is as a marketing vehicle for exposure and acquiring new clients.

Nothing beats face-to-face soft-selling with images larger than life and quality controlled. Emotional impact and the mood of the sales room is vital to a successful order. Equally important is the clients' enjoyment of their images and impression of you as a photographer and businessperson. Focus on the first impression and main presentation first—the rest is gravy.

Bill Sorenson, a very successful photographer and educator from Portland, Oregon, once told me, "When they cry, they buy." How true. When you've created the perfect mood in your studio and can passionately present beautiful images, the sales will happen. You don't have to be pushy or apply used-car salesman's techniques. Of course, pricing structures and packaging are all part of the equation too—which is part of Bill's area of expertise.

■ CREATING THE PERFECT MOOD

Imagine you're the client. You walk up to the studio door, and grab a solid, high-quality crafted handle. You come in and a pleasant scent of candles breezes over you—not too sweet, not too strong. The lights are low except for perfectly placed spots highlighting beautiful images—a baby's face, a cheerful bride, a family in a loving embrace. Some-

By printing and presenting your images more effectively you'll see increased sales and repeat business.

one immediately and cheerfully walks over to grab your hand and welcome you. A large, cozy leather chair looks ever so inviting, and you're offered it straight away. Now you start to sense the aroma of really good coffee brewing, and before your mouth has a chance to start watering, the offer comes, "I've got fresh coffee ready, decaf as well, can I interest you?" You spy a little plate of cookies on the end table and imagine it wouldn't be too hard to acquire one.

How do you feel now? Maybe a little hesitant, anticipating a typical sales pitch for a stack of photos you really

don't need. After all, you really just had the session done for one nice photo of your kids. You feel pretty comfortable, overall, though, and start to relax a little.

Let's continue with our fantasy: the background music is subtle and sophisticated—how did they know you love jazz? The photographer, or studio manager, shares a brief bit of casual conversation about their day or a recent event, then asks you some light and easy questions about your day, and maybe pays a sincere compliment about your new shoes or leopard-skin bikini (scratch that one). The photographer then tells you how excited they are about the images they have to share and how much they enjoyed meeting your children and family. You believe it because it is sincere and enthusiastic. This makes you feel good. You like your family too.

You should see an immediate increase in sales volume and larger print size orders when projection is used properly.

"Shall we look at the images? I can't wait to show you." Hmm . . . the photographer didn't say "photos" or "pictures," your subconscious notices. You relax back in your big comfy chair as the lights dim slightly. A movie screen appears from the ceiling on the wall in front of you and slowly lowers into place. A black page appears with a title in elegant white type, "The family is one of nature's masterpieces.—George Santayana." Beautiful images of your children begin to fade in and out, one after the other. Their faces are large, glowing, and almost touchable—big, joyous smiles and all the subtle little expressions that you cherish every day. You instantly realize this is going to be an expensive day, but some of the best money ever spent.

Does this sound good? It's certainly an idealized scenario but is not unrealistic or uncommon by any means. It doesn't take much to make people comfortable and set them at ease. Once they have relaxed, you can appeal to their emotions. And—whether you are presenting children's images, families, or their wedding day—the purchasing decisions are primarily emotional in nature. Nobody really needs more than one little photo of their kids or family, do they?

■ PRESENTATION INGREDIENTS

So, let's take a look at what's involved in creating that first, all important, impression—from a technical standpoint.

Digital Projectors. If it fits in your budget and space, a digital projector can quickly pay for itself. You should see an immediate increase in sales volume and larger print size orders when projection is used properly.

For studio use where the room can be darkened somewhat, a projector with 1200 lumens (the brightness measurement) should be sufficient. XGA resolution is important (1024x768) for sharp images at full screen size. Look for a model with good, natural color that is fully adjustable. We've had good experiences with Mitsubishi and NEC (made by the same company) projectors, which offer great quality and color matching to the sRGB color space.

Slide Shows. Slide shows can be presented directly from Lightroom. Later in this chapter, we'll explain how to quickly make portable slide shows with perfect music synchronization.

You'll also want to play music to accompany your slide show. If you are going to use music in a business environment, you'll probably need to get some sort of licensing rights. Common resources for this would be ASCAP, BMI, and SESAC. The Professional Photographers of America (PPA) web site has some helpful information on music licensing. The loopholes and contingencies for how and where popular music can be used can be a little confusing, so it's best to read the information pages carefully.

A great solution for music that you'd like to include on DVDs or CD-ROM slide shows that you give your client is to contact local musicians who write original music. Offer to photograph their band or CD covers in exchange for rights to use some of their original songs on your slide shows. If you offer to include a credit line at the end of all your shows, giving them increased exposure, they'll probably be more than happy to oblige. If you have decent musicians in your town, this is not too difficult.

If your town is musically challenged, look for royalty-free music on sites like Triple Scoop Music (www.triple scoopmusic.com). This is one of the best music sites around (most sound like elevator music), and you only pay a moderate fee for unlimited usage in your slide shows. They have music by Grammy Award—winning artists and have modeled their business for photographers, an industry first. If you visit their web site, they even have a special

"Kevin Kubota" collection of music that I selected to cover wedding event slide shows. Check it out!

Hopefully, we're all in agreement that slide shows are the way to go. Ultimately, the slide shows created for the initial presentation can also be turned into a DVD that clients can purchase and play in their standard DVD players. Many of our clients tell us that this is their favorite way to enjoy the images we've created for them. They pop that DVD in and watch it over and over again. Traditionalists may take issue with the idea of selling slide shows, feeling that it detracts from print sales. This may be true, but how can we argue with the fact that clients love the slide shows? It may take some adjustment to traditional thinking, shifting the product line a little, and of course pricing the slide show products so that they are profitable as well. The times they are a changin', and digital photographers need to go with the flow.

Because of the popularity of digital slide shows, there are numerous programs on the market for creating them. Your choice will depend on the computer platform you use and the degree of creative control you want to take. With CD-ROM slide shows, the format of the actual show file is important to consider as well. On the PC, there are several options for making slide shows into self-running EXE files, but Macs can't use those. Unless you are sure that all your clients use PCs, it may be better to look at other options. Shows in QuickTime and Flash format are better for bridging the computer-platform gap. They are universal and also can be imported into other programs for use in various projects—a DVD, for example. In this case, QuickTime is the most reliable and universal.

Every job can be presented as a slide show, and the impact is far greater than simply showing paper proofs. There are two ways to do it: the super quick way and the fairly quick but much cooler way. The quickest route to a show is directly from Lightroom. The more impressive way is to use a simple little program called TalaPhoto (www.talasoft.com) to create a QuickTime movie. Using TalaPhoto, you can control the timing and synchronize the music exactly the way you want it, providing a more emotional and impressive presentation. TalaPhoto exports standard QuickTime MOV files, which can be played from a web site, e-mailed, delivered on CD, or burned to a DVD using DVD authoring software like iDVD. Making the DVD will be covered later in this chapter.

We'll cover both methods of creating the slide shows, but an essential part of either would be a title page. It's nice to add the client's name and date of the event (in case they forgot already!), and you may also want to add a quote to help get them in the mood. We'll create these extra title pages in Photoshop and save them as separate JPEG files, which can be added to your Lightroom catalog or TalaPhoto slide show in the appropriate places.

To create the title pages in Photoshop, follow these steps:

- 1. Create a new, blank document sized to the same dimensions as your low-resolution horizontal images (e.g., 750x488 at 72 pixels/inch). Go to Edit>Fill>Color, and fill the page with black.
- **2.** Select the Text tool, set the text color as you like, add the text for your title page, then format the text. Turn the eyeball icon off for now to hide the layer visibility.
- **3.** Repeat step 2 to make a text layer for an opening quote. Turn the eyeball off for now.
- **4.** Repeat step 2 to make a "The End" page. You may also want to place your logo or studio name on the last page. Turn the layer visibility off for now.
- **5.** Now, with only the black page visible, use Save As to make a JPEG file of this black page. Save a second copy the same way. This will be your closing page.
- **6.** Turn the eyeball on for the title-page layer, use Save As to make a JPEG file of this, and call it Title.jpg. Turn the eyeball icon off again.
- 7. Turn the eyeball icon on for the quote, use Save As to make a JPEG file of this as well.
- 8. Repeat for the final text/logo page.

A title page in Photoshop sized to the proof images.

Basic slide show options, part 1.

Basic slide show options, part 2.

Horizontal images do not fill the screen, thanks to guides that are set to limit the image sizes.

To present slide shows from Lightroom, simply import these title pages as you would any other image. Drag them into the proper place in sequence, and you're ready to make the show. Here are the basic steps for the slide show:

1. In Library mode, make sure all the images you want to show are visible, and in the order you want them.

- If necessary, drag them to reorder the presentation.
- 2. Switch to Slide Show mode.
- **3.** Set up the options for a basic show as per the examples to the left (top images, left and right).

These settings will give you a nice, clean show on a black screen. Some of the options need a little explaining:

Stroke Border—This is a nice way to frame images and make sure that darker images don't fade into the background.

Show Guides—These are for image placement only and are not visible on the actual slide show. By clicking the two boxes next to the Right and Left guides, they can be linked so that moving one moves the other by the same amount. It's a good idea to create a square presentation area within your screen stage so that horizontal and vertical images will show at the same size. Otherwise, if the entire monitor area is used, horizontal images will be much larger and take on more visual importance, and it becomes disorienting to watch, which is probably not desirable. To the left (bottom image) is an example of the image on a stage within the guides.

Background Color—Black is the new white.

Soundtrack—Your iTunes playlists will be available here. Add your favorite songs to a Slide Shows playlist, and

it's always accessible. The music will simply play until the show is done, then just fade out.

Slide Duration—You guessed it.

When you have edited the settings as you wish, why not save them as a preset? Click the Add button under the Template Browser panel on the left and save your show settings. Experiment with different layouts and options and save your favorites for quick access. *Tip:* When you are working in Library mode, you can instantly start a slide show, using the currently selected template, by going to the menu Window>Impromptu Slideshow.

Slide Shows with TalaPhoto. That was easy. But darn that perfectionist in us who wants fully synchronized music—a sentimental song beginning just as the images of the first dance appear, a shift in tempo as they burst through the door to the reception, you get the idea. Additionally, to import your show into a DVD authoring program, you'll need a universal file format, like QuickTime.

Enter TalaPhoto. Getting started is easy: launch the program and go to File>Open Folder to select a folder full of JPEG images to import. This would typically be the JPEG Proofs folder that you exported your final collection into from Lightroom. Next, import the title page slides you created. They will appear at the bottom of the image thumbnails. Right-click on one of the titles and choose Move to First to move it to the top of the list. You can also drag thumbnails into any order you want.

TalaPhoto has four main tabs: QuickPrint, MultiPrint, WebDesigner, and PhotoShow. The last is used for creat-

ing the slide shows. Click on that tab, if it's not already selected. To set up the show style, click on the bottom-right icon (it looks like a magnifying glass) to open the Tools palette. Here we'll select the size for the show, the quality, and the music timeline.

First stop, Slide Properties. Click on the first pop-up to choose a frame size and image area size. Select Custom to create a new preset. We'll assume that this show will be for on-screen projection, which is typically on a 1024x768-pixel screen (this is the most common resolution for digital projectors, a.k.a. XGA). To have the slides displayed at a consistent size between horizontal and vertical images, and to provide for a slight black border around the image, we'll set the image size to fit 750x750 pixels. This should also match the size of the proofs we batched from Lightroom. Note that TalaPhoto will downsize any images you import to fit within the image size you specify, which is very handy, but it's cleaner when you feed it images that match that size to begin with.

In the Customize dialog box, click on Add and name the preset Projection. Tab in to the size fields and use the following dimensions: 1024, 768, 750, 750 respectively. Click OK when done.

TalaPhoto's main window. Click the Inspector icon to open the tool options.

Name	Frame W	Frame H	Image W	Image H	Add
iPod Video	320	240	320	240	
Small	480	360	480	360	Delete
Normal	640	480	640	480	Delete
Large	800	600	800	600	
Giant	1024	768	1024	768	Reset
Huge	1152	864	1152	864	-
HDTV	960	540	960	540	
Panorama	960	360	960	360	
DVD, border	640	480	425	425	
Normal, border	640	480	540	380	
HDTV, border	960	540	860	440	
Panorama, border	960	360	900	300	Cancel
Projection	1024				Cancer
•					
					(OK

Create reusable settings for the frame and image areas.

The preset should now appear in the list and can be selected. Select it. The background color should remain black, and the quality setting can remain at the default of Higher quality.

No slide show would be complete without mood music, so click the Timeline: Edit button to open the Timeline window.

The Timeline editor for setting music timing and slide transitions.

In the accompanying screen shot, the highlighted ball at the top right of the window zooms the view of the timeline to see individual slides. Clicking it again zooms out to show the entire timeline, with slides compressed. The other ball under the images moves the slides relative to the playhead, which remains in the center of the slide window and is indicated by three small markers. Click the zoom button to see slides closer, then move the playhead to the beginning of the show. Using the Home key on your keyboard will jump to the beginning as well.

Notice that TalaPhoto automatically includes a short black slide at the beginning. This is just a blank leader slide which is essential to let the show ease in from black. We'll adjust the length of time the leader plays in a moment. First, we'll set up the Image Transition Effect for the entire show. Click Select to open the transition window.

The Transition Effects palette. Set to Crossfade, 0.7 Time, and 4.0 Duration.

There are many transitions available, but any self-respecting photographer will limit themselves to a clean and simple Crossfade. The slide duration is negotiable, but 4 seconds seems to be about right for a client to watch their own images. If creating a show as a portfolio piece, 3 seconds or less may be appropriate. The transition time is just right at approximately 0.7 seconds. Click OK to return to the timeline.

Now we can adjust the duration of the black leader slide. Click on it to select it, then drag the tiny red box at

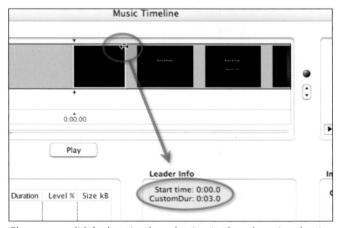

Change any slide's duration by selecting it, then dragging the tiny red dot at the top-right corner.

the top-right corner of the slide left or right to shorten or lengthen. The corresponding time will show in the Leader Info box. Any individual slide can be adjusted the same way, which is great, for example, if a particular image is special and deserves more time on the screen.

With slide durations and transitions set, it's time to add tunes. Any MP3, AIF, or WAV audio file can be added by clicking the Import File button. Songs can be dragged directly from your iTunes library as well. Keep in mind that any iTunes-protected songs will only play on your computer and will not play if the show is copied to another user's computer. Once the songs are in the library, simply drag them, in the order you want them to play, into the Music Tracks window above. TalaPhoto conveniently

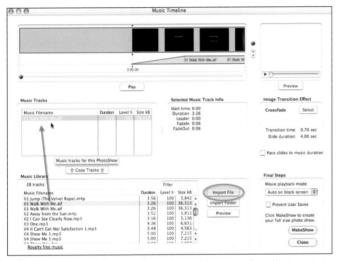

Add songs to the Library where they will remain for all eternity to be used for future projects. Drag them to the Music Tracks to add them to the current show.

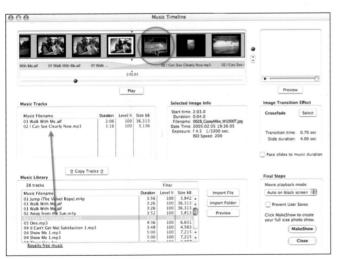

To start a song on a slide, select the slide first, then drag the song from the Library to the Tracks list. The new song will automatically fade over the previous song.

starts the dragged song at the beginning of the timeline, or directly at a slide, if one is selected. The next song dragged into the Music Tracks will automatically crossfade over the end of the previous song and continue. If the songs run past the end of the slides, the last song will automatically fade out at the last slide. Very slick and easy!

Customizing the Music Sequencing. To become a full-fledged mix master, you may want to trim the length of a song, start a song on a certain slide, or change the volume fading for a song. All of this is easily achieved. To begin a new song on a certain slide, where a previous song would still be playing, simply select the image slide and add the song to the Tracks box. It will cross-fade over the previous song and start at the selected slide.

Let's say that you want to use a song, but you really don't like the first few bars of the song and would rather it just start a little later. No problem. Select the track in the Timeline window, and red dots appear. Drag the dot on the bottom of the track to change the start, or end, time of the slide. The dot at the top will change the fading of the volume. So, if you prefer a long, slow fade out of the music at the end, simply drag the top dot at the end of the song to the left to lengthen the ramp. You can drag a track left or right on the timeline at any time too, to manually position the song under certain slides.

When done playing with music mixing, it's time to save the show to QuickTime MOV format so that it can be shared with the world. QuickTime format is universal,

The beginning of a song is trimmed off by dragging the lower red dot. The flat black line is where the song originally started.

Drag the top red dot at the end of a song to create a long, slow volume fade.

cross-platform, and easy to import into most DVD authoring programs if desired. The single MOV file can be played directly on your studio computer, copied to a CD and delivered, or embedded in a web site—assuming the size is set appropriately for online use.

To save, click on Make Show and follow the instructions to pick a location and name for your files. Keep in mind you need to save the TalaPhoto project file as well as the actual playable QuickTime MOV file. The project file is what you would open if you want to modify your project at a later time.

A good example of when you would modify the file is if you wanted an identical slide show, but in a smaller size, suitable for web site posting. This is extremely easy to do! Bring the PhotoShow Tools palette into view, and change the Slide Properties again to the new size you want. Click on MakeShow on the sequencer window, and save the new slide show. If you plan to show this on a web site, it would be a good idea to lower the quality setting as well. Smaller files play better over the Internet, but the image quality inherently goes down. Experiment to find the smallest size

To make another show at a different size, simply change the Slide Properties and click MakeShow again.

you deem acceptable for the purpose of your presentation. TalaPhoto has many other great tools and features, so it's worth reading the documentation to learn more.

Today's client expects some sort of multimedia product, and we can deliver. There are other uses for your slide shows that should be considered and capitalized on, including iPod slide shows, screen savers, cell phone slide shows and single images, digital picture frames, YouTube videos, and more. It's important to think about the things your clients look at everyday, like the computer or a cell phone, and find a way to have your images there. Oh, and make sure your logo and web site are clearly visible!

Commercial Style DVDs. Your client loves the slide show and now wants to buy a copy on DVD. You could simply put the QuickTime movie file on a CD, but that can only be played on computers. A more user-friendly product is a commercial-style DVD that can be played on most televisions as well as computers. Making the DVD will require special DVD-authoring software, which is generally fairly inexpensive. Mac computers with a built-in DVD burner have iDVD included free, and this happens to be one of the best-quality authoring pieces available. PC users have several options, ranging from cheap to fairly expensive. See the Resources chapter for a list.

Due to the wide variety of televisions out there now—standard tube TV, simulated HD, and true HD—there are some considerations when setting up images so that they look their best. Here's the deal: most traditional TV displays have a 640x480 resolution, and due to the picture tube design, an area around the edges gets cropped off. Because of this, about 50 pixels around the edges will be hidden when displayed on a tube-type TV. The area that is seen is called the "TV-safe zone." LCD TVs, plasma, and other new digital types do not have this problem. Many people still have tube-type TVs, however, so it's best to consider these users in your setup.

When we move to HDTV, it comes in not one, but two resolutions: the 720p video resolution is 1280x720 pixels, and the 1080i video resolution is 1920x1080. This makes life a little more complicated. We can never anticipate exactly what type of TV the show will be played on, but we can at least ask our client what type of TV they have. We burn two versions of the show on the same DVD: one for standard TV and the other for HDTV. The user has the option to play either.

If you create only the standard TV version and play it on an HDTV (where the resolution is higher), it will naturally try to stretch the standard TV image to the full screen to give the illusion of "big screen." With normal TV programs, we don't notice the stretching as much, and often part of the show is actually cropped and stretched to fill the screen. With still photos, however, you notice it much more. If you only create the HD version, it will appear squashed and elongated when played on a standard TV. Such is life. The bottom line is:

- 1. If showing on a standard 640x480 TV, size images to 425x425 pixels (set TalaPhoto to 640x480 with 425x425 image area).
- 2. If showing on 720p HDTV, size images to 700x700 pixels (set TalaPhoto to 1280x720 with 700x700 image area).
- **3.** If showing on 1080i HDTV, size images to 1000x1000 pixels (set TalaPhoto to 1920x1080 with 1000x1000 image area).

Including option 1 and option 2 on the DVD would cover most bases and distort less when scaling up or down. As true HDTV (1080i) becomes more mainstream, it would make sense to include the higher resolution of option 3 in place of option 2.

Putting the DVD Together. The QuickTime MOV file or files, which have been sized appropriately as above, need to be imported into a DVD authoring program for conversion to TV DVD format.

The specific instructions for making the DVD will depend on the software you use, but most are essentially the same: Drag your QuickTime movie into it, create titles and a start button, and click Burn. Here are a few extra tips for creating DVDs:

- 1. Use high-quality DVD media to avoid burn errors. Ritek brand is generally very reliable, although others work well too. You may need to experiment a little to find a brand that works best in your system. When you encounter burning errors, the first place to look is at the DVD used.
- 2. Keep in mind that not all consumer DVD players will play home authored DVDs. Most newer units will be compatible, but older machines can occasionally re-

- fuse to play them. If you continually have clients that cannot play your DVDs, consider trying another authoring program. Each implements the DVD standards slightly differently.
- 3. Printable surface DVDs are very professional looking when adorned with a nice image and your logo. Try the silver surface discs—they look really slick! Lowcost inkjet printers, designed for direct disc printing, are readily available.

The DVD is a great add-on sale item—especially right after they've seen their images in a slide show in your studio! The impression is lasting and people are generally very multimedia savvy these days—they enjoy seeing their images in this new presentation. Suggest they buy copies as gifts for family and friends. The reproduction cost is less than \$1 once you've created the master DVD. Charge appropriately for your images, however. Remember: we're still selling images, not the material they're presented on.

People are generally very multimedia savvy these days—they enjoy seeing their images in this new presentation.

Printing Proof Booklets. Booklets have become a popular alternative to loose proof prints for a number of reasons. They are less expensive to produce, allow for quick and easy browsing, clients are less likely to make reproductions of the images, and we have many stylish options for presenting them. We include a proof booklet with all our wedding collections as a complement to the online proofing and the DVD presentation. We don't normally use them for portrait clients as we prefer to have them come and view the images on our projection system and make their purchasing decisions at the meeting.

Lightroom prints great looking proof sheets directly from the program under the Print mode. The user can customize the layout and save presets as with most other modes. This assumes, however, that the user will print the pages in studio. If lab printing is preferred, other options need to be considered. The easiest means, though not the fastest or most cost effective, is to send all the images to the lab and let them do the layout and printing. Most labs

Set up proof sheets in TalaPhoto and export JPEG files for printing at a lab.

offer this service now. You can save some money by creating the layouts yourself, as individual JPEG page files, and sending these off for normal printing. They can then be spiral bound at Kinkos for the final presentation.

TalaPhoto has the ability to create nice proof sheet layouts, in the MultiPrint tab, and can export these layouts as JPEG files, ready for the lab. Set up your desired cell spacing and layout, then save the preset for future use. We always create the cover sheet in Photoshop, using a favorite image and the client's name and event date.

Printing proof booklets in-house should be fairly quick and painless. Inkjet printers work great for proofing as well as for final prints. The Canon series of printers are very fast and make excellent choices for proofing. Color laser printers can also be very effective for proofing. The cost per page is much lower than inkjets, although the quality of the photographic output is lower as well. For proofing purposes, however, many photographers consider them more than acceptable.

When presenting the final booklet, in addition to the nice cover image, be sure to include order forms and cropping information in the back of the booklet. You can then have it bound at a copy center with a clear cover and a coil binding (it looks better than spiral binding).

The debate will always go on over whether or not it is good practice to give your clients proofs to take home. Many contend that this allows them to copy the images, put off purchasing, or lose the excitement (pressure) of making decisions in the studio. Some find the proof booklet concept a reasonable compromise, as they aren't large enough to copy or use for display prints, but they give the client something tangible to look at and make buying decisions from. Each photographer has their own philosophy on this, and there is no right answer.

Online Proofing and Selling. As mentioned earlier, setting up web proofing and selling is definitely worth the time and effort. However, don't expect dramatic sales increases right away. With the right marketing and promotion techniques, many photographers have reported excellent additional sales through

the web. You can't just "put it up there," you need to put it up and promote it.

Benefits do come from increased exposure to prospective clients. When your work is good and all your clients' friends and relatives see the images, chances are they'll be calling you when they need a photographer. Consider it an ongoing marketing expense and the cost is easily justified. To ensure that as many people as possible view the images online, plan to help your clients spread the word about the web site. Some ideas include:

A Pre-Event Web Site. This can be a simple yet elegantly designed web page that is customized for your new client. They can announce their event to all the guests, have an RSVP page, and post helpful information about the event. Of course, there will also be a link to see the final images and the photographer's contact information. Make sure the client lists this web address in their invitations or on "save the date" cards.

Web Site Access Cards. These are given out at the event. Make sure that everyone there knows the images will be online for viewing or ordering. Simple cards with the web address and login information can be passed out or placed in a conspicuous place.

Give extra access cards to the client after the event. These can be put into thank-you cards by the client. An option is to create photo thank-you cards for the client for an additional charge, or include it in the package price.

The card will have your web address and the event login as well.

Another benefit to web posting is its value to your client. They really appreciate the convenience of sharing the images with friends and family online. In fact, many clients expect it these days. It is a positive selling point for your studio.

Web proofing can be used for almost any type of photography. Commercial clients are always connected via high-speed networks and are quite used to viewing images online. Clients that come from out of town (for reunions, for example) often book family portrait sessions. They come from all over the country and usually have to leave within a day or two. If you can't make a sales presentation to them while they are all local, web proofing eases their concerns and also gives your studio a booking advantage. Business portraits can be shot, then prepared and posted online almost by the time the person returns to their office. It allows for quick service but also allows the studio to edit and prepare the files properly. There are basically two types of proofing: a basic image site for viewing only, and full featured shopping cart systems.

Basic proofing sites are easy to create and post online yourself, provided you have a web site and FTP access to upload new web pages. Lightroom has really nice, readymade, templates for image proofing. Access them from the Web module, pick your layout, export, and upload the entire folder it creates to your own site, then give the client the URL. Photoshop and TalaPhoto also offer their own web site creation tools.

Most studios, however, now use some sort of image hosting and sales service. These companies have myriad

One of Lightroom's built-in Flash web galleries. Several nice ones are included.

features already incorporated, the ability to take credit cards, and pass the order information on to you. There are other host systems/labs that will host the images, take the order, and provide fulfillment services too—meaning they will package and send the prints directly to the client who orders the images. However we prefer to check the quality of the prints and package them in our own branded way before sending them to a client. It's much better quality control, customer service, and marketing.

Every service has unique features and different pricing models. Some charge a flat monthly fee and some charge commission per sale. Make sure to read the fine print. Some services worth considering include EventPix (www.eventpix.com), MorePhotos (www.morephotos.com), and StudioCart (www.studiocart.com). The following are some things that should be included your system:

- Custom branding so the site can be made to look like an extension of your own site, not an outside service.
- Easy for the client to figure out! (I can't tell you how many calls we used to get from grandmothers trying to order photos online!)
- Ability to view a photo in B&W or color.
- Ability to zoom in to see details in a photo.
- Ability to search for a particular image number.
- Flexible pricing options and package pricing options.
- Slide show feature
- Ability to save favorites to an online album for later viewing and ordering.
- Ability to e-mail friends and invite them to view the images.

A Complete Digital Sales Solution. For the busy studio, or one looking to become busy, give a more powerful sales and presentation tool a try. There are several on the market, with new ones emerging all the time. However, a product called ProSelect, from a company named timeexposure (www.timeexposure.com) in Australia, warrants a trial. The software is brilliant in its simplicity. It has a clean, elegant, uncluttered interface and is very intuitive to use. The programmers have worked closely with photographers to create a program that thoughtfully covers almost every possible scenario. We've found that ProSelect works beautifully in tandem with Lightroom and Photoshop. After our images are edited, corrected, and prepared in

Lightroom, we can quickly load them into ProSelect for the client presentation. After the presentation, the images are passed to Photoshop for final preparation for the lab.

There are myriad ingenious features in the program, but here are a few that we particularly like:

- Images loaded into ProSelect are automatically copied and converted to low-resolution versions. All these files are kept together in a single "album," so they never get separated.
- Side-by-side image comparisons are very easy to make. Up to six images at a time can be compared.
- For projection, the program can easily be calibrated so that images will display at actual size on the screen if desired.
- Composite album pages and multi-image mats can easily be created and saved. Simply drag and drop images into the preset openings, to create whole album designs, image collages, and loose print orders quickly and easily with the client.
- Images can easily be converted to black & white, sepia, or even processed with your favorite Photoshop actions, from directly within the program!
- Slide shows with music are easy to create and are beautiful.
- Multiple, fully customizable price lists and an intuitive ordering system make the ordering process quick and

A COOL TRICK

Here's a cool trick for users of Lightroom and ProSelect. When you are done with your adjustments and editing in Lightroom, and ready to make a presentation to the client, there's a quick way to get the images into ProSelect. If you recall the Export Actions folder in Lightroom, from the earlier section on Actions and Droplets (see chapter 10), then all you have to do is put an alias, or shortcut, to ProSelect in this folder. Then, when you batch process your images into low resolution JPEG files, add the option in the export dialog to post process with ProSelect. When used this way, the images will be converted then automatically passed to ProSelect and added to a new album, ready to present! If an album is currently open in ProSelect, then the images are added to the active album.

painless. A summary of the order, along with thumbnails of the images, can easily be printed for the client and production person.

This program actually makes the sales and presentation process fun! The beautiful interface and simplified order system are impressive to clients as well.

Albums and Other Presentations. With all this multimedia tantalizing our clients' senses, you might think the album would disappear forever. Not true. People still love to have something to hold in their hands, flip pages, and to touch and feel. The look of the album and the presentation style is changing, however, much for the better. No longer are we locked into traditional post-bound books with standard mat openings and gold-tipped pages. The sky's the limit now, and our product lines have taken a major leap forward in quality.

New products are being introduced at every major trade show, and here are some items and ideas that are particularly interesting:

- **1.** Hand-made and bound albums using fine art inkjet paper prints.
- **2.** Wood and metal covers. Fun and funky colors in silks and leathers.
- **3.** Magazine-style layouts within any style album.
- **4.** Book-bound albums that look like store-bought art books.
- **5.** Collections of image mats, instead of albums, that can be displayed in rotation.
- **6.** Images in bevel-cut mats within albums.
- 7. Unlimited layout flexibility. No more pre-made openings!

Digital photography really opened the door for what is commonly referred to as "magazine style" layouts. This refers to pages that are designed in Photoshop, often with multiple images, but printed out as one print. This is cost effective for the photographer, since only one print is made, and the design options are unlimited. Layouts can be as graphic and modern as desired, or kept simple and timeless. Though the graphically exciting books may be fun today, they have the potential to look very dated, very soon. While designs with more of a classic feel may not be as "modern bride," they will more likely stand the test of

Select View>Snap To>Guides so that images can be quickly aligned on a page layout.

Drag out a box with your Text tool to define an area for type.

time. You certainly don't want people looking at your current albums ten years from now and saying, "oh, those are soooo new millenium." Neither design style is *bad*, just keep it in mind.

Designing Magazine-Style Albums and Collages. Now that you're an expert in Photoshop, you can create beautiful page layouts. Though having Photoshop skills won't necessarily make you a graphic designer, you can create basic layouts for magazine-style albums and image collages, both of which are very popular and cost effective to produce. A course in album design could fill an entire book, but some helpful tips for creating your own layouts are presented below.

Images can be dragged onto a page layout and arranged as needed.

Fading the type layer is a nice, subtle effect.

Begin with the proper page specifications from your album company. Generally you only need to know the print size, the trimmed sized, and the gutter amount (if any). Print size will be a standard print dimension, like 10x10 inches. Trimmed size may be $\frac{1}{8}$ inch smaller all around or similar. If there is a center gutter, you may need to allow an extra $\frac{3}{8}$ - $\frac{1}{2}$ inch or so in the center to accommodate the gutter, so important image details aren't swallowed up when the book is bound.

Set up a blank page in Photoshop, selecting the proper resolution and color profile for the lab you will be sending the pages to. Make your rulers visible (shortcut Cmd/Ctrl-R) and drag guides in from the rulers on the edges for

your trim lines. It is often a good idea to add additional guides about ½ inch in from the trim as well. This is your true "safe" zone; important image information should not go beyond this point. Select View>Snap To>Guides, then drag out a vertical and horizontal center line. They should "snap" at the center of the page.

With multiple images on a page, it can become confusing trying to select the appropriate layer to move images around and try different positions. Here's a trick: Select your Move tool (V), then click the check box on the tool options bar called Auto Select Layer. Now, when you click on any image, its layer will be automatically selected so you can drag it where you please. Ctrl-click (right-click on

PC) on an image to see a menu of all the layers beneath the top image to select a different one if needed.

You can also Shift-click on multiple images to group them in the Layers palette. This allows you to move them as a unit. Shift-click again on each image to deselect them.

When you have completed your page design, save a PSD master file with the layers intact, and make a copy in JPEG format to send to your lab. The same techniques can be used to create image collages for framing. By the way, these collages are excellent promotional items to give any vendors you work with. Display images of their products or services, along with your logo, and give them a free print. It's a win–win deal.

Creating a photo collage for a vendor is great marketing for you and is much appreciated by them.

12. THE BIG PICTURE

Nothing is worth more than this day. -Goethe

it's easy to get caught up in the day-to-day process of just keeping up. So when do we find time to think about the future? When do we do some marketing and planning? How can we make time, even in the busiest of seasons, to give back to our communities? This is always a struggle, but we all have a responsibility to make the world a better place, so "giving back" needs to be a normal and regular part of our business practice.

■ MAKE TIME TO GIVE BACK

There's a movie called *Pay it Forward* about a young boy who decided to try an experiment for a school project. He wanted to see what would happen if everyone did just one nice thing for someone and asked in return only that the receiving person "pay it forward," doing the same for someone else. The results were amazing, and "miracles" started to spread all over the world.

So what can you do? Start in your own hometown. Call your favorite charity or cause right now (okay—wait until you finish the book), and ask if they need photos for any of their promotional events or projects. Offer to take some really nice portraits of their staff or volunteers to display; a great, professional photo makes people feel good and important—a key to keeping volunteers motivated.

Whenever a charity has a community awareness project, offer to be there to take documentary photos for their newsletters and web sites. Donate gift certificates for photography services to any legitimate fund-raising auctions in your community (a win–win proposition that will also bring you new clients).

Give the gift of a family portrait to families that cannot afford it. Portraits make people proud and give them a joy-

ful reminder when life is especially challenging. Every year, we coordinate and host an event called "Family Photos in the Park." We contact a list of charitable organizations in our community (Habitat for Humanity, the Family Resource Center, Sparrow Clubs, Grandmother's House, HeadStart, church shelters, etc.) and ask them to sign up families who they feel are in difficult situations. These families can come down to the park on a specified date and time and receive a free family portrait and print package. There are no strings attached, and we even give them the digital files to take to Costco for cheap reprints.

Portraits make people proud and give them a joyful reminder when life is especially challenging.

We enlist the help of other local photographers to photograph families and receive donations from local caterers and stores for supplies. We make a big party of it and spend a Sunday in the park taking pictures together—it's great fun. The families are extremely thankful, the photographers bond as a group, and they go home knowing they've used their gifts to better the world.

The Sparrow Clubs (www.sparrowclubs.org) is another charitable project that deserves attention, if only because it goes straight to the core of what is needed to build a better future for our world. Sparrow Clubs USA promotes school-based service projects where kids help kids in medical need. A child with a serious medical crisis is chosen as the "sparrow," then children in a local school form a club to support this sparrow through service projects, fund-

raisers, and all-around moral support. It is truly amazing how effectual these kids can be. They raise surprising amounts of money and give the sick children the support and camaraderie that is so vital to their mental well-being.

A few years ago, a past wedding client called and, with some hesitation in her voice, told us she was the new coordinator for the Sparrow Clubs. She wanted to know if we'd be interested in taking portraits of the sick children to use at a fund-raiser event. We were honored and gladly took the project. I was hesitant, however, because I knew that what I had to photograph would be painful for me.

What I discovered, contrary to my expectations, was an amazing beauty and strength in the children and families. They all opened their homes and their hearts to us—and those who could smile, smiled brightly. The parents were full of hope, and the children showed courage and acceptance. It put my whole world in perspective.

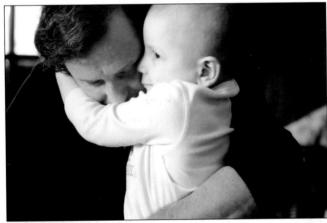

Hannah from the Sparrow Clubs passed away about a year after these photos were taken. Her family was deeply grateful for the time we spent creating the images, and we were infinitely grateful that they opened their home and arms to us and shared Hannah's amazing spirit. We wouldn't have traded this opportunity to be a part of their lives for anything.

It has been a life-changing experience, for both my wife and me, to be involved with the Sparrow Clubs. They are graciously thankful for the ongoing photography work we do for them, and we are grateful to be humbled and enlightened by these precious little sparrows. As the club motto says, "we have found our wings."

Photography can change the world, just as every little person can change the world with a simple action or suggestion. Each thing we do to make the world a better place becomes contagious—it spreads and grows. Set the example by doing whatever you can, and soon you'll see others doing the same. It's time for us all to pay it forward.

■ THE KEYS TO SUCCESS

We've identified some keys to success and have used them to grow our business every year. It helps us to feel a deeprooted sense of happiness and satisfaction for our place in this world. Everyone, of course, has their own set of goals and values—a mission statement for life, if you will. The statement could be written down or internalized, but it helps to recognize it and ensure that it is an active part of your life and business. Here are our keys to success:

- 1. Show integrity in everything you do.
- 2. Commit to giving back to your community. This involves charitable work locally and sharing your knowledge with peers in business.
- **3.** Trust in your intuition and creative voice.
- **4.** Find balance in your work and personal life. In business there should a be balance of creativity, inspiration, technology, technique, and presentation.

One of the most satisfying things in life is to have a business doing what you love; your business will contribute to making people happy and bettering your little corner of the universe.

I hope that this book has been valuable to you and your business. I enjoy teaching and sharing my experience as much as I enjoy creating images. If you've learned something great, pay it forward. Help someone else out, if for no other reason than to see them prosper. If you have any experiences or feedback to share, I'd love to hear about it. Please e-mail me at kevin@kubotaimagetools.com.

And remember, you can't create in a vacuum—unless you want to suck.

RESOURCES

■ ALBUMS AND PRESENTATION PRODUCTS

Asukabook—www.AsukaBook.com
Albums Australia—www.Albumsaustralia.com.au
Leather Craftsmen—www.leathercraftsmen.com
Stone Editions self-print albums—www.inkjetart.com

■ PROFESSIONAL RESOURCES

Digital Wedding Forum www.digitalweddingforum.com

Wedding and Portrait Photographers International (WPPI)—www.wppi-online.com

Professional Photographers of America (PPA)—www.ppa.com

Digital Photography Review (resource for latest information on new cameras and technology)—www.dpreview.com

Kubota Image Tools Forum (tech support for our products and others we use, tips and software downloads)—www.kubotaimagetools.com

■ LCD MONITORS AND COLOR MANAGEMENT TOOLS

Chromix (Eizo monitors & color profiling tools and profiles)—www.chromix.com

DryCreekPhoto (custom color profiles)—www.drycreekphoto.com

Apple (beautiful, quality monitors)—www.apple.com LaCie (high-quality monitors for photographers) www.lacie.com

■ CAMERA EQUIPMENT AND ACCESSORIES

Lensbabies (inexpensive tilt-swing selective focus lenses)—www.lensbabies.com
StickyFilters (removable sticky colored gels to balance flash temperature)—www.stickyfilters.com

Tamrac (camera bags and accessories)—
www.tamrac.com

Dust Aid (easy-to-use sensor cleaning product; no liquids needed)—www.dust-aid.com

■ MUSIC FOR SLIDE SHOWS

TripleScoopMusic (high-quality music for photographers)—www.triplescoopmusic.com

PPA.com (FAQs and licensing information, general photographers' resource)—www.ppa.com

MusicBakery.com (royalty-free music at reasonable, fixed prices)—www.musicbakery.com

ASCAP (American Society of Composers, Authors and Publishers; info on music licensing for in-studio use)—www.ascap.com.

BMI (Broadcast Music Inc.; info on music licensing for in-studio use)—www.bmi.com

SESAC (performing rights organization, info on music licensing for in-studio use)—www.sesac.com

■ SOFTWARE

ProSelect (sales and presentation software) www.timeexposure.com

TalaPhoto (slide show creation software for Mac or PC)—www.talasoft.com

Photoshop Actions, training software, workshops—www.KubotaImageTools.com

Adobe (Lightroom, Photoshop, and other programs)—www.adobe.com

DVD Authoring Software
iDVD for Mac—Free with Mac of

iDVD for Mac—Free with Mac computers Roxio for PC DVD authoring—www.roxio.com Ulead DVD movie factory for PC—www.ulead.com

TROUBLESHOOTING

PROBLEM	POSSIBLE SOLUTION
Camera times not correct or synchronized after job is shot	You can adjust the actual capture date that is embedded in the image file. Put a little sticker on your camera that says, "Time sync!" If that doesn't help and you still messed up, see page 39 for how to fix it in Lightroom.
Memory cards won't read in computer	Unplug and re-plug the card reader. Also try reading the cards on a different computer or using a different method—like camera direct to computer through a USB cable.
Camera locks up while shooting	Bad memory card. Make a note of which card was in use each time the camera locks. Try to narrow it to the suspect card. Pull the card and do not use it again until images are downloaded. Also, a low or old battery can cause erratic behavior. Check with camera manufacturer to see if newer firmware is available for your camera.
Soft black spots on images	Dust on the CCD. Send to repair service for cleaning or do it yourself using products specifically made for cleaning the CCD. Products available at www.Photosol.com and www.dust-aid.com.
RAW files won't open in Photoshop	Make sure you have the latest update to the ACR (Adobe Camera Raw) plugin. Visit www.Adobe.com for updates.
Image colors don't look right	Ensure proper white balance at capture time using a custom white balance. Use a gray card or ExpoDisc. Use a high-quality monitor designed for photographic work. Check that your monitor is properly calibrated and profiled using a hardware device on a regular basis (three to four weeks).
Prints never match the monitor	Use a high-quality monitor designed for photographic work. Check that your monitor is properly calibrated and profiled using a hardware device on a regular basis (three to four weeks). Formac (www.Formac.com) makes great LCD monitors (Mac and PC compatible). Use printer profiles properly with inkjet printers (see chapter 6).
I accidentally deleted images from the card!	Doh! Do not use the card! Adding new images could make the others permanently unrecoverable. Use image-recovery software to restore the images. Try PhotoRescue from www.Datarescue.com.
My kids know more about Photoshop than I do!	This is totally unacceptable! Get yourself some training as soon as possible. Visit www.kubotaimagetools.com.
When I hang upside-down from my ankles, I lose consciousness	Don't hang upside-down from your ankles.

INDEX

Α	(Adobe Lightroom, cont'd)	(Adobe Photoshop, cont'd)
Actions, 6, 65, 101-6	rejects, tagging, 41-42	Gaussian Blur, 91, 97
assigning function keys to, 65	renaming images, 40-41	general preferences, 63-64
batch processes with, 102-3	saturation, 46	Gradient Map 71–73, 96, 103
creating, 103-5	sorting images by time, 39	Gradient tool, 95
downloading, 6	target adjusters, 47-48	Healing Brush, 83-84, 88
droplets, 105-6	tonal range, adjusting, 46	histogram, 68–69
insert menu item, 102	white balance, 45-46	Hue/Saturation, 94, 104
insert stop, 102	workflow overview, 29-31	Info palette, 99
loading, 102	Adobe Photoshop, 48, 59, 62–106	keyboard shortcuts, 64–65
palette, 102	actions, see Actions	Lasso tool, 85
saving, 102	Add Noise filter, 96	layer blending mode, 79, 93, 99
Adjustment layers, 69–71, 73–74,	adjustment layers, 69-71, 73-74,	layer masks, 80–82, 86, 90, 91,
90, 91–93, 96, 98, 103,	90, 91–93, 96, 98, 103,	93–95, 97
104	104	layers, 74, 79, 103
Adobe Lightroom, 27–54, 118	batch processing,	layer sets, 82
batch processing, 40-41, 52-53	see Batch processing	layers, linked, 82
cropping, 48	Canvas Size, 98	layer styles, 98
develop mode, 45-48	Change Layer Contents, 94	Lens Blur filter, 95
downloading images, 38-39	channels palette, 91	Levels, 69–70, 79, 97, 99
enhancing images, 43-54	clarify, 82	Liquify filter, 87–88
exporting, 51–53	clipping, 70	Marquee tool, 97
exposure, adjusting, 46	Clone Stamp, 84–85, 88	master files, saving, 74
features, 27–29	Color Balance, 71	Move tool, 86
folders, setting up, 30	Color Picker, 70, 98	opening images from Lightroom,
importing images, 38-39	cropping, 74–75	48
labeling images, 43	cursor preferences, 64	printing from, 59–61
opening images in Photoshop	Curves, 80, 91–93, 94, 96, 103	16-bit mode, 66–68
from Lightroom, 48-51	droplets, 105–6	sharpening, 76–78
outtakes, reviewing, 42-43	8-bit mode, 66–68	sizing images, 75–76
preferences, setting, 31–34	embedding color profile, 74, 76	Smart Sharpen, 77–78
presets, applying, 44-45	eyedropper tool, 70	stroke, 98–99
presets, creating, 34-38	function keys, assigning to	tonal range, setting, 68–70
previews, rendering, 38	actions, 65	Transform, 86, 96, 100
	***************************************	,,

(Adobe Photoshop, cont'd) underexposure, correcting, 79–82 Unsharp Mask, 76–78, 82–83, 104, 105 white balance, 70–71 workflow overview, 65–66 working color space, 59 Adobe RGB, 20, 56–57 Albums, designing, 118–20 Artistic mastery, 6	(Color management, cont'd) Adobe RGB, 20, 56–57 camera settings, 20, 57–58 CMYK conversion, 57 color profile warnings, 102 color spaces, 56–57 digital, 55 embedding a color profile, 74, 76 monitor profiles, 58–59 printer profiles, 60–61 sRGB, 57	F File formats, 7–9, 74, 76, 79, 104 Filters, 76–78, 87–88, 91, 95, 96, 97 Add Noise, 96 Gaussian Blur, 91, 97 Lens Blur, 95 Liquify, 87–88 Smart Sharpen, 77–78 Unsharp Mask, 76–78 Flash, TTL, 14–15, 23 Function keys, assigning to
_	working color space, 59	actions, 65
В	Color Picker, 70, 98	actions, 03
Batch processing, 40–41, 52–53,	Color profiles, see Color	G
102–3	management	Gaussian Blur filter, 91, 97
destination, 102–3	Color space, 20, 56–61	Gels, adding to flash, 23
file naming, 102	Compression, 7–9 Contrast, 8–9, 20	Gradient Map, 71–73, 96, 103
overriding action "save as"	, ,	Gradient tool, 95
commands, 103	Creativity, sources of, 11–18	Graphic tablet, 65
playing, 102	Cropping, 48, 74–75 Curves, 80, 91–93, 94	Grapine tablet, oo
source, 102	Curves, 80, 91–93, 94	Н
suppressing color profile	D	Healing Brush, 83–84, 88
warnings, 102	Develop mode, 45–48	Highlight warning, 19
Black & white images from color, 71–73	Digital, benefits of, 5–6	Histograms, reading, 19, 68–69
Gradient Map method, 71–73	Digital dark, 91–93	Hot Yellow FX, 83
Adjustment layer method, 73	Digital fill flash, 91–93	Hue, 8
Blending modes, 79, 93	Digital projectors, 108	Hue/Saturation, 94, 104
Body parts, swapping, 85–86	Digital slide shows, 108–14	,
Borders, adding, 98–100	Downloading images, 24–25, 38–39	Ī
Bolders, adding, 76–100	Downsizing images, 75–76	Image catalogs, 27
С	Droplets, 105–6	Image quality, evaluating, 68–71
Canvas Size, 98	Dust on image sensor, 20	Image viewers, 27
Catalog software, 27	DVDs, 115–16	Info palette, 99
Channels palette, 91		Internet proofing, 116–17
Charitable work, importance of,	E	Interpolation, 75–76
121–22	Edges, adding, 98–100	ISO setting, 8–9
Clarify, 82–83	8-bit mode, 66–68	
Clipping, 70	Enhancing images, 43-54	J
Clone Stamp, 84–85, 88	Exposure, adjusting, 46	JPEG format, 7–9, 79, 104
Color, adding to black & white	Exporting images, 51-53	
images, 73-74, 90	Exposure compensation, in-camera,	K
Color Balance, 71	23	Keyboard shortcuts, 64–65
Color management, 20, 55-61, 74,	Eyedropper tool, 70	Keyline border, 98–99
76, 102	Eyes, retouching, 93–94	

126 DIGITAL PHOTOGRAPHY BOOT CAMP

	D 0 21 24	-
L	Preferences, Lightroom, 31–34	T
Lasso tool, 85	Preferences, Photoshop, 63–64	TalaPhoto, 53, 111–15
Layer blending mode, 79, 93, 99	Presenting images, 53–54, 107–20	Target adjusters, 47–48
Layer masks, 80–82, 86, 90, 91,	albums, 118–20	grayscale mix, 48
93–95, 97	creating a mood, 107–8	hue, 48
Layer sets, 82	digital projectors, 108	luminance, 47
Layers, linked, 82	digital slide shows, 108-14	saturation, 48
Layer styles, 98	DVDs, 115–16	tone, 47
LCD, checking, 21	online, 116–17	Technical mastery, 6
Lensbaby, 14	proof booklets, 115-16	Teeth, retouching, 93–94
Levels, 69–70, 79, 97, 99	Presets, creating, 34–38	TIFF format, 76
Lightroom, see Adobe Lightroom	Previews, rendering, 38	Time-syncing cameras, 19, 39
Liposuction, digital, 87–88	Printer profiles, 60–61	Tonal range, setting (Lightroom),
Liquify tool, 87–88	Printing, 59–61, 107–20	46–47
brush selection, 87, 88	from Photoshop, 59–61	Tonal range, setting (Photoshop),
freeze mask, 87, 88	printer profiles, 60–61	68–70
forward warp, 87, 88	proofs, 61, 107–20	Transform, 86, 96, 100
reconstruct, 88	Profiles, see Color management	Troubleshooting tips, 124
thaw mask, 87	Programmable mouse, 65	
Lens Blur filter, 95	Proof booklets, creating, 115–16	Ū 4
Lens Blat Inter, 70	Proofing, 61, 107–20	Underexposure, correcting, 79–82
М	ProSelect, 117–18	Under-X Fix, 79–82
Marquee tool, 97	PSD format, 74, 100	Unsharp Mask, 76–78, 82–83, 104,
Masks, layer, 80–82	13D Ioimat, 74, 100	105
Master files, saving, 74	R	amount setting, 76–77
		Clarify technique with, 82–83
Megapixels, 9–10	RAW format, 7–9, 79	radius setting, 76–77
Memory cards, formatting, 20	Rejects, tagging, 41–42	threshold setting, 76–77
Mindset, 6	Renaming images, 40–41	
Monitor profiles, 58–59	Resampling, 75–76	Upsizing images, 75–76
Monitor size, 65	Resolution, 9–10	
Move tool, 86	Resources, 123	V
Movies, 14		Viewer software, 27
	S	Vignetting, 97–98
N	Saturation, 8, 46, 48	
Noise Ninja, 46	Scaling images, 75–76	W
Numbering images, 19	Sharpening, 8, 20, 76–78	Wacom tablet, 65
	16-bit mode, 66–68	Web-based proofing, 116–17
0	Sizing images, 75–76	White balance, 8–9, 20, 21, 45–46,
Online proofing, 116–17	Slide shows, digital, 108–14	70–71
Organizing images, 24–25	Sloppy border, 98–100	Workflow, 24–54
Outtakes, reviewing, 42-43	Smart Sharpen, 77–78	Working color space, 59
	Sorting images by time, 39	
P	sRGB, 57	
Photoshop, see Adobe Photoshop	Storing images, 25–26	
Pixelation, 9–10	Stroke, 98–99	

OTHER BOOKS FROM

Amherst Media®

PHOTOGRAPHER'S GUIDE TO

WEDDING ALBUM DESIGN AND SALES, 2nd Ed.

Bob Coates

Learn how industry leaders design, assemble, and market their outstanding albums with the insights and advice provided in this popular book. \$34.95 list, 8.5x11, 128p, 175 full-color images, index, order no. 1865.

THE KATHLEEN HAWKINS GUIDE TO

SALES AND MARKETING FOR PROFESSIONAL PHOTOGRAPHERS

Learn how to create a brand identity that lures clients into your studio, then wow them with outstanding customer service and powerful images that will ensure big sales and repeat clients. \$34.95 list, 8.5x11, 128p, 175 color images, index, order no. 1862.

MASTER LIGHTING GUIDE

FOR WEDDING PHOTOGRAPHERS

Bill Hurter

Capture perfect lighting quickly and easily at the ceremony and reception—indoors and out. Includes tips from the pros for lighting individuals, couples, and groups. \$34.95 list, 8.5x11, 128p, 200 color photos, index, order no. 1852.

MONTE ZUCKER'S

PORTRAIT PHOTOGRAPHY HANDBOOK

Acclaimed portrait photographer Monte Zucker takes you behind the scenes and shows you how to create a "Monte Portrait." Covers techniques for both studio and location shoots. \$34.95 list, 8.5x11, 128p, 200 color photos, index, order no. 1846.

THE PHOTOGRAPHER'S GUIDE TO COLOR MANAGEMENT

PROFESSIONAL TECHNIQUES FOR CONSISTENT RESULTS

Phil Nelson

Learn how to keep color consistent from device to device, ensuring greater efficiency and more accurate results. \$34.95 list, 8.5x11, 128p, 175 color photos, index, order no. 1838.

RANGEFINDER'S PROFESSIONAL PHOTOGRAPHY

edited by Bill Hurter

Editor Bill Hurter shares over one hundred "recipes" from *Rangefinder's* popular cookbook series, showing you how to shoot, pose, light, and edit fabulous images. \$34.95 list, 8.5x11, 128p, 150 color photos, index, order no. 1828.

PROFESSIONAL PORTRAIT LIGHTING

TECHNIQUES AND IMAGES FROM MASTER PHOTOGRAPHERS

Michelle Perkins

Get a behind-the-scenes look at the lighting techniques employed by the world's top portrait photographers. \$34.95 list, 8.5x11, 128p, 200 color photos, index, order no. 2000.

MORE PHOTO BOOKS ARE AVAILABLE

Amherst Media®

PO BOX 586 BUFFALO, NY 14226 USA

INDIVIDUALS: If possible, purchase books from an Amherst Media retailer. Contact us for the dealer nearest you, or visit our web site and use our dealer locater. To order direct, visit our web site, or send a check/money order with a note listing the books you want and your shipping address. All major credit cards are also accepted. For domestic and international shipping rates, please visit our web site or contact us at the numbers listed below. New York state residents add 8.75% sales tax.

DEALERS, DISTRIBUTORS & COLLEGES: Write, call, or fax to place orders. For price information, contact Amherst Media or an Amherst Media sales representative. Net 30 days.

(800)622-3278 or (716)874-4450 Fax: (716)874-4508

All prices, publication dates, and specifications are subject to change without notice. Prices are in U.S. dollars. Payment in U.S. funds only.

WWW.AMHERSTMEDIA.COM

FOR A COMPLETE CATALOG OF BOOKS AND ADDITIONAL INFORMATION